P9-DBW-752

ELEMENTAL 2
The world's best Autodesk art

Edited by

Daniel Wade & Paul Hellard

Publishers

Mark Snoswell & Leonard Teo

ELEMENTAL 2

Published
by

Ballistic Publishing

Publishers of digital works for the digital world

Aldgate Valley Rd
Mylor SA 5153
Australia

www.BallisticPublishing.com

Correspondence:
info@BallisticPublishing.com

First Edition published in Australia 2005 by Ballistic Publishing

Hardcover Edition ISBN: 1-921002-24-7
Limited Edition ISBN: 1-921002-25-5

Managing Editor
Daniel Wade

Assistant Editor
Paul Hellard

Art Director
Mark Snoswell

Design & Image Processing
Stuart Colafella, Lauren Stevens

Advisory board
Benoit Girard, Pascal Blanché, Michael Flynn, Peter Moxom, Susannah Skerl, Robert Stava, Vincent Brisebois, Marcin Wasko, Maurice Conti

Printing and binding
Everbest Printing (China)
www.everbest.com

Partners
The CG Society (Computer Graphics Society)
www.CGSociety.org

Also available from Ballistic Publishing
EXPOSÉ 1 Softcover/Hardcover ISBN 0-9750965-2-4/0-9750965-1-6
EXPOSÉ 2 Softcover/Hardcover ISBN 0-9750965-9-1/0-9750965-8-3
EXPOSÉ 3 Softcover/Hardcover ISBN 1-921002-14-X/1-921002-13-1

Visit www.BallisticPublishing.com
for our complete range of titles.

Cover image credits

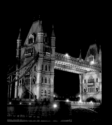

Tower Bridge at night
3ds Max, PhotoPaint
Luciano Neves, INFINITE CG, BRAZIL
[Front cover: ELEMENTAL 2 Hardcover edition]

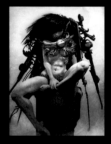

Valkyrie
3ds Max, ZBrush, Photoshop
Pascal Blanché, UBISOFT, CANADA
[Back cover: ELEMENTAL 2 Hardcover edition]

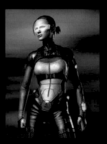

**Natalia Pilot Uniform:
MechAssault 2**
3ds Max, Photoshop
Josh Nizzi, Day 1 Studios, USA
[Front cover: ELEMENTAL 2 Limited Edition cover]

ADVISORY BOARD AND JURY

For the second edition of ELEMENTAL, we appointed an advisory board to assist in nominating and judging images for the ELEMENTAL 2 awards. All of these people are either leading artists in their own right or are experienced and respected members of the Autodesk product team.

Benoit Girard is the founder and President of Digital Dimension and has over 53 motion pictures to his credits. He is a a four-time Emmy Award Winner, a two-time Visual Effects Society Award Winner, an expert in Business Process Management and production pipelines, was a featured success story in Microsoft Executive Circle Magazine, and his recent movie credits include: Mr. and Mrs. Smith, Blade Trinity, The Last Samurai, and Final Destination II.

Pascal Blanché is an Art Director at Ubisoft Canada based in Montreal. His most recent game project was 'Myst IV: Revelation', the fourth in the cult adventure game series. Pascal started on the path towards a career in art/design for games at the Art School of Luminy, Marseille. Following art school, he freelanced for TILT magazine, an early video games magazine and then worked in modeling, concept art, texturing, lighting and animation for various French gaming companies.

Marcin Wasko was born in 1979 in Bialystok, Poland. He is a 3D graphic designer and animator who presently works for Platige Imaqe, a post-production house in Warsaw. His debut animated film Undo won Grand Prix and Special Prize by the public at DigiTechMedia workshop and also came first at Animago 2003 Film Festival. Recently working on TV commercials, and occasionally as a 3D artist in productions such as Tomek Baginski's Fallen Art.

Michael Flynn was born in Wimbledon, United Kingdom and grew up in Wagga Wagga, Australia. After years of toil at various facilities studying science, fashion design and pattern-making, fine arts and finally architecture he found a niche as a designer and 3D modeler. Currently he lives in Phuket instigating a virtual 3D office, which allows people to work anywhere anytime. Michael also setup the P2P training sessions for multimedia gurus at QUT in Brisbane.

Robert Stava is the Creative Director for Arup's 3D Media Group based in New York. After studying fine arts at Buffalo State College in New York, Stava spent several years working in the art department of prominent advertising agency Young and Rubicam and later as an Art Director with J. Walter Thompson designing campaigns and multimedia presentations. Stava joined Arup in 2002 to rebuild the visualization department and form the 3D Media Group.

Vincent Brisebois studied both Architecture and Computer Engineering in college and university. He then moved to do 2D/3D production work for many years while teaching 3ds Max in Montreal. He was hired at Discreet in 1998 as Technical Support Specialist and Trainer for Lightscape and has been an Applications Specialist for 3ds Max since 2002. In the past few years he has worked on projects ranging from video games and engineering to film and broadcast.

Susannah Skerl is active as IGDA Vancouver Chapter Coordinator and full-time instructor at Ai (The Art Institute Vancouver), in Project Management and Student Portfolio classes. Susannah has worked in the game industry since 1996, with credits as a developer and on the publishing side including multiple triple-A titles for studios such as Electronic Arts, Barking Dog (now Rockstar Vancouver), Microids Canada (now Ubisoft), Strategy First and Paris-based Wanadoo Edition.

Peter Moxom is the Industry manager for Animation, Autodesk Asia Pacific. He worked as an instructor teaching animation for seven years prior to joining Autodesk and now works as a conduit between customers and the technical, sales and marketing organizations for Autodesk. He remains a passionate advocate for keeping the Teapot Button in 3ds Max for many years to come.

Special guest judge

Maurice Conti, Autodesk's Creative Director, is responsible for the look and feel of the Autodesk brand as it's seen around the world. Before coming to Autodesk 4-1/2 years ago, Conti was Managing Director at frog design, inc., where he worked on shaping products and brands for global companies, including Microsoft, Acura, Motorola, SAP, Lufthansa, and Alfa Romeo. At Autodesk, Conti is extremely passionate about celebrating the innovative and incredibly creative work achieved with Autodesk software.

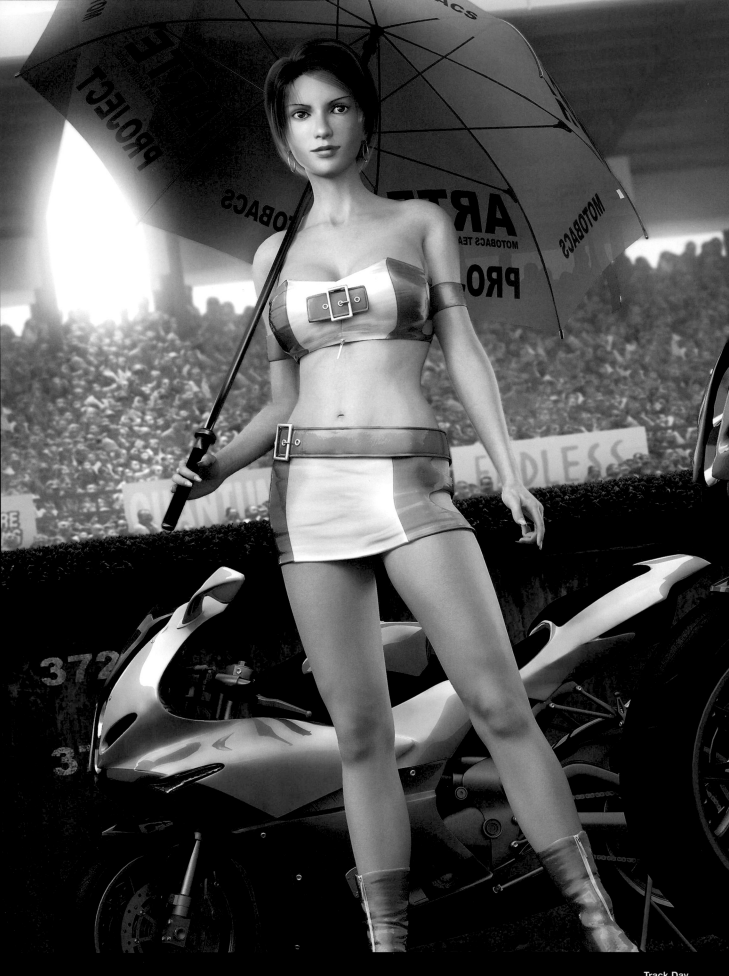

Track Day
3ds Max, Photoshop
Olli Sorjonen,
FINLAND

EDITORIAL

Daniel Wade | Managing Editor & Mark Snoswell | Publisher

The first ELEMENTAL book was created in partnership with Autodesk almost eighteen months ago. It showcased the world's best images created with Autodesk 3D visualization and animation software. Since it launched at SIGGRAPH 2004 in Los Angeles, it has been a huge success and hailed as one of the best of our digital art publications.

ELEMENTAL 2 adds to the success of the first volume by featuring much more architectural work—the field that Autodesk dominates. In the last few weeks, Autodesk announced a definitive agreement to acquire Alias. With this acquisition Autodesk moves to the forefront of automotive design and 3D film effects, both significant fields in addition to the CAD, games, TV, film effects and product design areas Autodesk currently leads. With ELEMENTAL we are proud to celebrate the artistic talents of the diverse and growing community of Autodesk artists.

The success of the original ELEMENTAL book not only made this book possible, but also guaranteed an even larger selection of superbly realized artwork from some of the best-known artists and companies across the gaming, architectural visualization, and visual effects fields.

ELEMENTAL 2 is a completely independent production of Ballistic Publishing, with images being selected solely on their artistic merit. We appointed an independent advisory board of high profile artists in the fields of visual effects, game development, architecture and software development. We also offered a minority of positions to Autodesk to occupy including Maurice Conti, Autodesk's Creative Director. With the advisory board's help we then sorted through over 1,500 entries (50% more than the original ELEMENTAL) to select just 214 images from 159 artists. The artists came from 36 different countries.

Images were allocated to one of 11 categories: Architectural Exterior; Architectural Public Interior; Architectural Residential Interior; Architectural Reconstruction; Character in Repose; Character in Action; Product Design; Transport; Gaming/Broadcast Design; Abstract & Design; and Environment. By category, the best images were awarded Master Awards and depending on merit 1-3 images received Excellence Awards.

As with our EXPOSÉ series, the hardest part of the whole process was agonizing over all the fantastic images entered that we just did not have room to print. The quality of the entries was great with less than one in seven images making it to print. You are encouraged to go to our web site to see all the images entered for this and other books from Ballistic Publishing.

ELEMENTAL 2 CATEGORIES

CHOOSING CATEGORIES

A total of 1,500 images were entered for ELEMENTAL 2 covering a wide range of subject matter. Images were collected into categories which best described the subject matter. With entries growing 50% over those of the original ELEMENTAL book, it was necessary to choose categories that reflected the increased entries. Like the original ELEMENTAL, the architectural entries continued to dominate for ELEMENTAL 2. Rather than having one huge Architectural category, we decided to split it into four categories: Architectural Exterior; Architectural Public Interior; Architectural Reconstruction; and Architectural Residential Interior. The Environment, Character in Repose, Character in Action, Product Design, Transport and Abstract & Design categories all remained popular and remain in ELEMENTAL 2. The Humorous, Still Life, Humanoid and Creature in Repose categories received fewer entries and the Beauty category was wound back into the Character in Repose category.

ARCHITECTURAL EXTERIOR

Steel Bioclimatic Technological Center, VIZ, VRay
Thomas Klischies, CHILE

The Architectural Exterior category mainly focused on building designs and visualizations. The criteria for the category was to create the best exterior architectural visualization independent of style or setting. The category tested the artist's ability to create a space that was not just believable, but inspirational and evoked a desire to visit the location/building/space. The majority of entries featured modern high-rise buildings, though there were several exceptions including residential apartments, boat marinas, luxury dwellings and low-rise buildings. Notably, the Master Award winner, Thomas Klischies of EKarquitectos LTDA, visualized a 'Steel Bioclimatic Technological Center' as part of an urban renewal project for client Juan Carlos Valdebenito (Arch.) in Chile. The Excellence Award winners for the Architectural Exterior category were András Onodit of ZOA Architecture for 'Digital Filming Studio' and Niall Browne for 'Streetscape Study'.

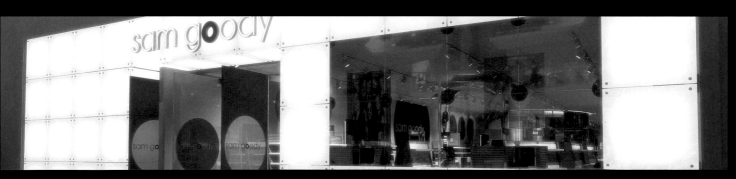

ARCHITECTURAL PUBLIC INTERIOR

Sam Goody, 3ds Max
John Pruden, Phil Van Haitsma, Digital-X, USA

For ELEMENTAL 2, the architectural interior and exterior entries doubled making it necessry to further refine them. While the majority of interior entries were residential, there were still a sizable number of entries which focused on public interior spaces. These spaces mainly included public building interiors such as lobbies and atriums, but also included restaurants, museums, offices, galleries, sporting and retail venues. Successful entries were able to create spaces which were not only functional, but also welcoming to the general public. Scale and perspective were important elements for the award winning entries along with skilled lighting solutions providing realism. The Master Award went to Karuna Karan of Chandavarkar & Thacker Architects for 'Ando (Church of light)', with Excellence Awards going to Niall Browne for 'Commercial Lobby Study' and Geoffrey Packer of Spiral Staircase Systems for 'Proposed Porcelenosa Staircase'.

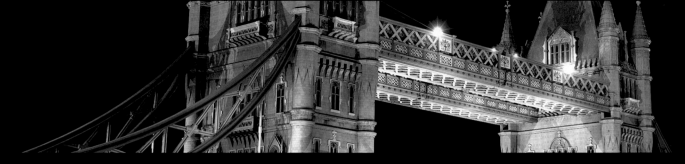

ARCHITECTURAL RECONSTRUCTION

Tower Bridge at night, 3ds Max, PhotoPaint
Luciano Neves, INFINITE CG, BRAZIL

The Architectural Exterior category was originally conceived as a category for commercial project designs such as buildings or other structures which might someday become a reality. For ELEMENTAL 2, a number of entries partially satisifed the requirement, except they had actually been built, only hundreds of years ago. So with a number of entries not visualizing, but recreating architectural landmarks, it was necessary to create the Architecural Reconstruction category. This category also helped to alleviate the many entries that might otherwise be put into the Environment category which also saw a surge of entries for ELEMENTAL 2.

A surprisingly high level of artistry was shown by entries in the category with the notable 'Tower Bridge at night' by Luciano Neves of INFINITE CG taking out the Master Award. Very worthy Excellence Award winners were Nelson Martins of desenho3d.com for 'Monastery of Alcobaça' and Juan Siquier for 'The Phoenix building'.

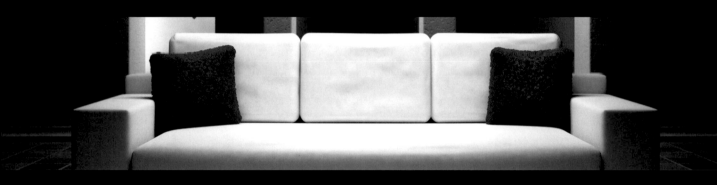

ARCHITECTURAL RESIDENTIAL INTERIOR

Sofa: Design and visualisation exercise, 3ds Max, Photoshop,
Krystian Polak, AUSTRALIA

The interior architectural entries were significant for ELEMENTAL 2 with most of them falling into the residential category. The order of popularity for settings went to loungerooms, with bedrooms, kitchens and bathrooms coming next. The successful entries in the category met several criteria including the believability of the setting, from scale, perspective and camera position to the all-important lighting solutions. Several otherwise great entries in this category fell down with the choice of lighting. As humans we are quite capable of knowing when something doesn't quite fit, and cast shadows and reflected light are two big signposts for realism. Setting an atmospheric scene was the Master Award winner Krystian Polak of Arterra Design with 'Sofa: Design and visualization exercise'. The Excellence Awards went to Dionissios Tsangaropoulos of Delta Tracing for 'Yacht Interior', a visualization for client Ferretti-Yachts and Adrian Cristea for his 'Bathroom' visualization.

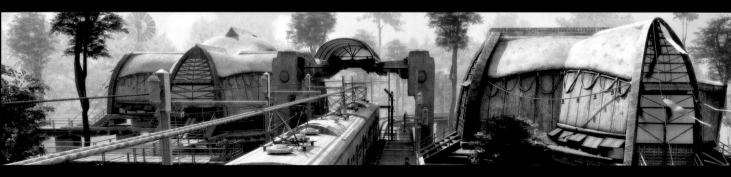

ENVIRONMENT

The Station built in the Lake, 3ds Max, VRay, Photoshop
Wei Weihua, CHINA

The Environment category featured a truly wide selection of genres, from well-known locations like Venice, to futuristic space docks, medieval castles, fantasy worlds with Babylonic-architecture, barren and mechanical fish-inhabited worlds, and humble street and alleyway scenes. The Environment category recognizes the best set or location whether indoors, outdoors, underwater, or in space. The judging criteria focused on the artist's ability to evoke a sense of wonder and a wish to see more. Successful entries combined artistic interpretation with detail and lighting to create believable and enticing environments. The standout entry in the category was 'Venice: Another look' by Oleg Karassev which satisfied all criteria. Excellence Awards went to four artists in this category including Raphael Lacoste for 'Dark Castle inspired by Sparth', Benjamin Leitgeb for 'Arcadia', Andre Surya for 'Somewhere in the Sky' and Weiye Yin for 'Babylon'.

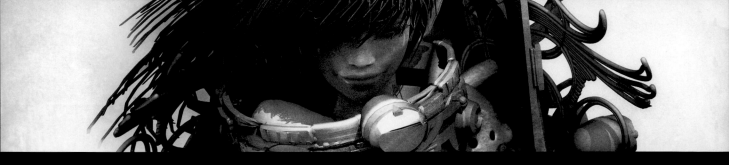

CHARACTER IN REPOSE

Valkyrie, 3ds Max, ZBrush, Photoshop
Pascal Blanché, UBISOFT, CANADA

The Character in Repose category was not as heavily entered as the original ELEMENTAL. Part of the reason for the original heavy character representation was the 'Machineflesh' CG Challenge which produced a great deal of Creature in Repose and Humanoid in Repose entries. The Beauty category from ELEMENTAL was also folded into Character in Repose giving it a healthy number of beautiful female character entries. Overall, the character entries for ELEMENTAL 2 moved to a human majority though there were successful exceptions with the odd creature and aliens entered. The category was also enlivened with humor and caricatures to keep things amusing. The Master Award went to Wenxian Huo for his wonderfully real 'This is a girl who loves eating tomato'. The Excellence Awards went to well-known artists including Jonas Thornqvist for 'Gladiator', Alexis Smadja for 'Wisdom' and Pascal Blanché for 'Valkyrie'. Olivier Ponsonnet was another notable talent in this category.

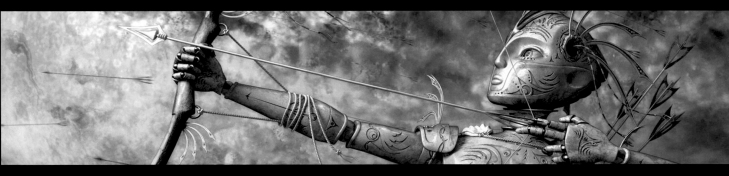

CHARACTER IN ACTION

Sagittarius, 3ds Max, VRay, Photoshop
Balazs Papay, HUNGARY

The Character in Action category is a difficult category to be successful in purely because it is difficult to create the illusion of motion in a still image. The criteria for the category was to capture the sheer power, energy and elegance of a character in motion. Although many digital artists aspire to create animations that come to life, it is a rare talent to capture expressive motion frozen in a moment in time. It was no coincidence that several of the successful entries in this category were from games, tv spots or animated features. These are all areas where artists need to have the ability to animate characters. The Master Award went to the comical, and slightly disturbing 'Dogs' by Laurent Pierlot of Blur Studio Inc. The Excellence Awards went to Blur Studio Inc. for its 'Unreal T/ Spot' and Balázs Pápay for 'Sagittarius'. Other high profile Blur Studio projects in this category included 'Warhammer ?: Dawn of War', 'Everquest', 'In the Rough', and 'Gopher Broke'.

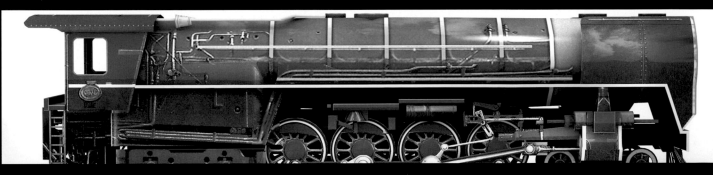

GAMING/BROADCAST DESIGN

RedDevil, 3ds Max
Steve Mohesky, PopTop Software, USA

The Gaming/Broadcast Design category was added to ELEMENTAL 2 to cater to the growing importance of the gaming and broadcast advertising areas. The category included in-game artwork such as the low-poly characters and vehicles, high res renders from games for magazine covers and features, in-game environments, cinematics and trailers for high-profile game titles, special effects and compositing for television commercials, and futuristic environments for music videos and space-age environments for featurettes. A number of well-known game franchises were entered for ELEMENTAL 2 including game artwork from next-generation consoles such as the Xbox 360. The Master Award went to Josh Nizzi of Day 1 Studios for 'Mech Warrior: MechAssault 2'. Excellence Awards went to Antonio Avila Membrives of Studio Stortuga for 'Mexus Marines' and Josh Nizzi of Day 1 Studios again for 'Natalia Pilot Uniform: MechAssault 2'.

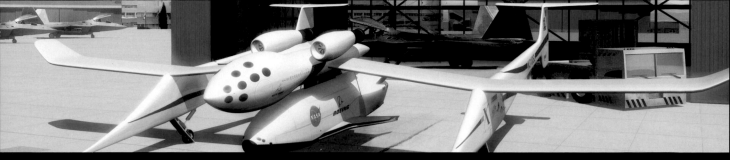

TRANSPORT

White Knight and X-37, 3ds Max
Kareem Marquez, USA

The Transport section was a popular category with entries covering the complete gamut of transportation. The main criteria was to create the best device for moving about in. The defining quality sought was the artist's ability to capture and evoke the desire to travel to a place, or by a mode of transport or to travel in a particular way. Among the modes of transportation entered were modern, vintage, classic and concept motor vehicles, sailing boats, World War II-era aircraft, military vehicles, and present-day spacecraft. The Master Award went to Piotr Kosinski for 'Nissan Skyline: concept' for client Theory7 Ltd. The Excellence Awards went to Thibaut Milville for 'Romance', a homage to the original Mini, Giorgio Vecchio of Absolute 2001 for 'Sailing boat in the Wind' and Mark Van Haitsma for '1965 Excalibur SSK Roadster Series 1'. A notable artist in this category was Ronnie Olsthoorn for his great aircraft.

PRODUCT DESIGN

Architecture of Color and Coded Identity, 3ds Max, VRay, Photoshop,
Le Richard Minh, AUSTRALIA

The Product Design category was stronger than the previous ELEMENTAL making the selection of award winners quite challenging. The criteria for this category was to create the most outstanding image that demonstrated excellence in technical design and execution. This included the intricacy of the product design and the technical excellence of the modelling, texturing, and lighting. The Product Design category was by far the most original category with no entries focusing on the same subject. Unique products included color markers, a guitar, a digital camera, a lava lamp, a measuring device, a microscope, a syringe, a vacuum cleaner, audio effects equipment and football boots. The Master Award convincingly went to Le Richard Minh for 'Architecture of Color and Coded Identity'. Excellence Awards went to Daniel Alejo for 'PRS-GN Guitar' and Roberto Cardile for the 'Exilim' digital camera product visualization.

ABSTRACT & DESIGN

Typosphere, 3ds Max, VRay
Franck Farget FRANCE

Abstract & Design was another unusually strong category based on the number of entries for the original ELEMENTAL. The majority of entries focused on the Abstract, rather than Design. The criteria for the category was to create the most outstanding image that was predominantly abstract. The artist's design and artistic expression were paramount in creating an image that defied categorization and excelled in pure design and visual appeal. Entries in the category included abstract sculpture pieces, print advertising design, calendar illustrations, spheres of unlikely materials, and LED lights. The Master Award went to the wonderfully strange sculpture piece by Sam Al Nassar for the equally strangely named 'Fight Club'. The Excellence Awards went to Lee Lam and Nick Hunter of Emerald City for 'Nurofen Car Robot', Christos Magganas for 'Autumn' for client 365-Calendar, and Andre Kutscherauer for 'Broken Mind'.

Realizing Ideas.

The power of ideas is the greatest force known to humanity. Ideas created civilizations, changed the course of history, and saved lives. They're the currency of our age. And they open the door to the future.

Autodesk makes solutions for companies revolutionizing the way products are designed, manufactured, and built; solutions for government agencies and utility companies building and managing the infrastructure that supports our world; solutions for companies wanting to control every bit of data produced from an idea's evolution; and solutions for companies using animation and visualization to turn imagination into breathtaking realities.

Imagination and the ability to turn an idea into reality is all that's needed. Autodesk helps businesses reach that goal.

Stretching the Boundaries of Imagination

Welcome to the second annual compilation of outstanding work done by Autodesk's visualization customers. This book is a testimonial to their incredible creativity and virtuoso skill.

Once again, our customers are really pushing the envelope. They're always up for a challenge. They're always looking to outdo themselves. And they're always stretching the boundaries of imagination.

At Autodesk, we're also stretching boundaries. We continue to add powerful new capabilities to our visualization solutions. And just as quickly, customers put them to work creating dazzling new results, as this book so clearly illustrates.

On behalf of Autodesk, it's very gratifying to see our design and visualization tools put to such inspired use. Our customer community continually resets the bar to a higher level. Their work inspires us to further empower them to realize their ideas.

Carol Bartz
Chairman and CEO
Autodesk, Inc.

Carl Bass
COO
Autodesk, Inc.

Autodesk

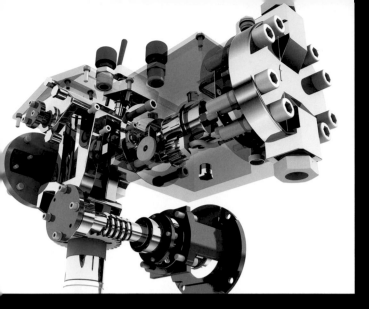

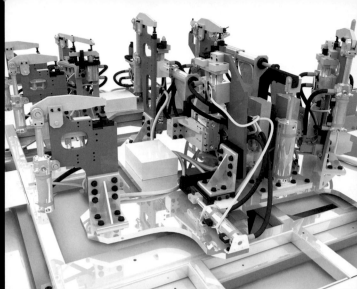

Manufacturing

Manufacturers need design software that helps them create quality products, a data management solution that optimizes design data, and industry-specific solutions tailored to meet any business challenge.

Autodesk helps companies create, manage, and share design data across the entire manufacturing process, delivering better-quality products to market faster. Companies spend less time on detail work and more time realizing their ideas with our design software. And with a new, pragmatic

approach to data management, manufacturers using an Autodesk manufacturing solution accelerate product development cycles and gain an advantage over the competition.

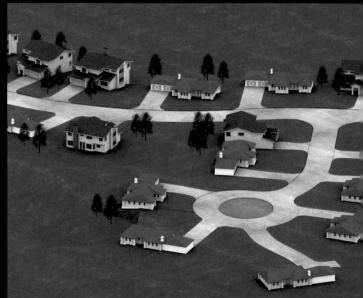

Infrastructure

From documenting what's on the earth to creating structures to be part of it, Autodesk infrastructure solutions help government agencies, utility companies, and emergency response professionals make the most of valuable mapping, civil engineering, and design data.

Autodesk meets the needs of infrastructure professionals—from plan creation, surveying, and design to construction and maintenance—with greater efficiency than ever before possible. Autodesk infrastructure solutions for mapping and GIS deliver the industry's best data interoperability and the only fully integrated toolset for managing assets. We even help emergency response teams plan for, respond to and manage disasters quickly and with confidence

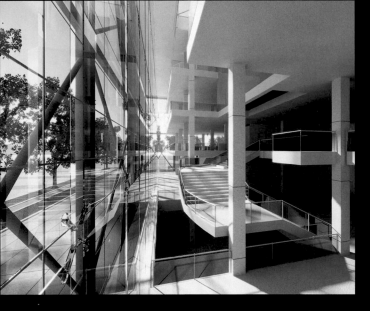

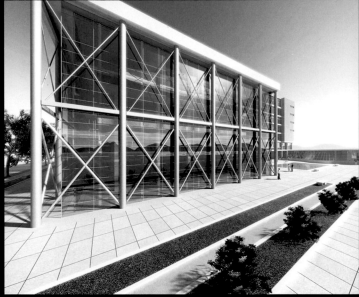

Building

From the most advanced technology for building information modeling to the most widely adopted design and documentation solutions, Autodesk building solutions give architects, engineers, builders, and owners the tools to realize their ideas.

Autodesk is committed to helping the industry increase profitability, reduce risk, and eliminate inefficiencies in the building, design, construction, and management of a project.

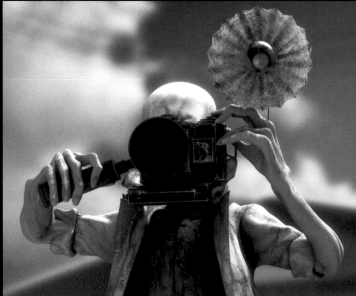

Media and Entertainment

Media and entertainment professionals are redefining the industry, and Autodesk solutions are designed to help them do it with innovative, industry-leading tools. We deliver solutions that accelerate collaborative digital content creation workflow. From visual effects, color grading, and editing to animation, game development, and design visualization, Autodesk solutions are changing the way entertainment is produced and enabling our users to turn great ideas into breathtaking reality.

Over the last 10 years, digital artists have used Autodesk digital media solutions to create Academy Award®–winning visual effects in feature films. And this year was no exception. Digital artists used Autodesk solutions to help shape their clients' films into the summer blockbusters of 2005.

These guys rock!

The engineering and design professionals who have used our software to create the art on these pages are truly in a league of their own. These elite artists are blowing minds and pushing the boundaries of what's possible. They've faced the challenge of visualizing their ideas beyond the functional and into the artistic realm where beauty is as much a factor as form, function, and purpose.

Throughout this entire book, you'll see work created by artists in the building, manufacturing, infrastructure, and media and entertainment industries. As Autodesk employees, it's the kind of work that floods our imaginations and makes us proud to be a part of their creative process. It's work we not only brag about, but work we proudly hang on our walls—beautiful, passionate work.

It's an extraordinary honor for me to be a judge on the submissions committee for this book. Our wish is to showcase the world's most stunning Autodesk-created artwork.

I hope the images on these pages inspire you as they have inspired us, and I invite you to join me in celebrating the passion and talent of these artists.

Maurice Conti
Creative Director
Brand Services, Worldwide Marketing
Autodesk, Inc.

Maurice Conti, Autodesk's Creative Director, is responsible for the look and feel of the Autodesk brand as it's seen around the world. Before coming to Autodesk 4-1/2 years ago, Conti was Managing Director at frog design, inc., where he worked on shaping products and brands for global companies, including Microsoft, Acura, Motorola, SAP, Lufthansa, and Alfa Romeo. At Autodesk, Conti is extremely passionate about celebrating the innovative and incredibly creative work achieved with Autodesk software.

About Autodesk

Autodesk, Inc. (NASDAQ: ADSK) is wholly focused on ensuring that great ideas are turned into reality. With six million users, Autodesk is the world's leading software and services company for the building, manufacturing, infrastructure, media and entertainment, and wireless data services fields. Autodesk's solutions help customers create, manage, and share their data and digital assets more effectively. As a result, customers turn ideas into competitive advantage by becoming more productive, streamlining project efficiency, and maximizing profits.

Founded in 1982, Autodesk is headquartered in San Rafael, California. For additional information about Autodesk, please visit **www.autodesk.com**.

Autodesk, Autodesk Inventor, Civil 3D, and 3ds Max are registered trademarks of Autodesk, Inc., in the USA and other countries.

Autodesk®

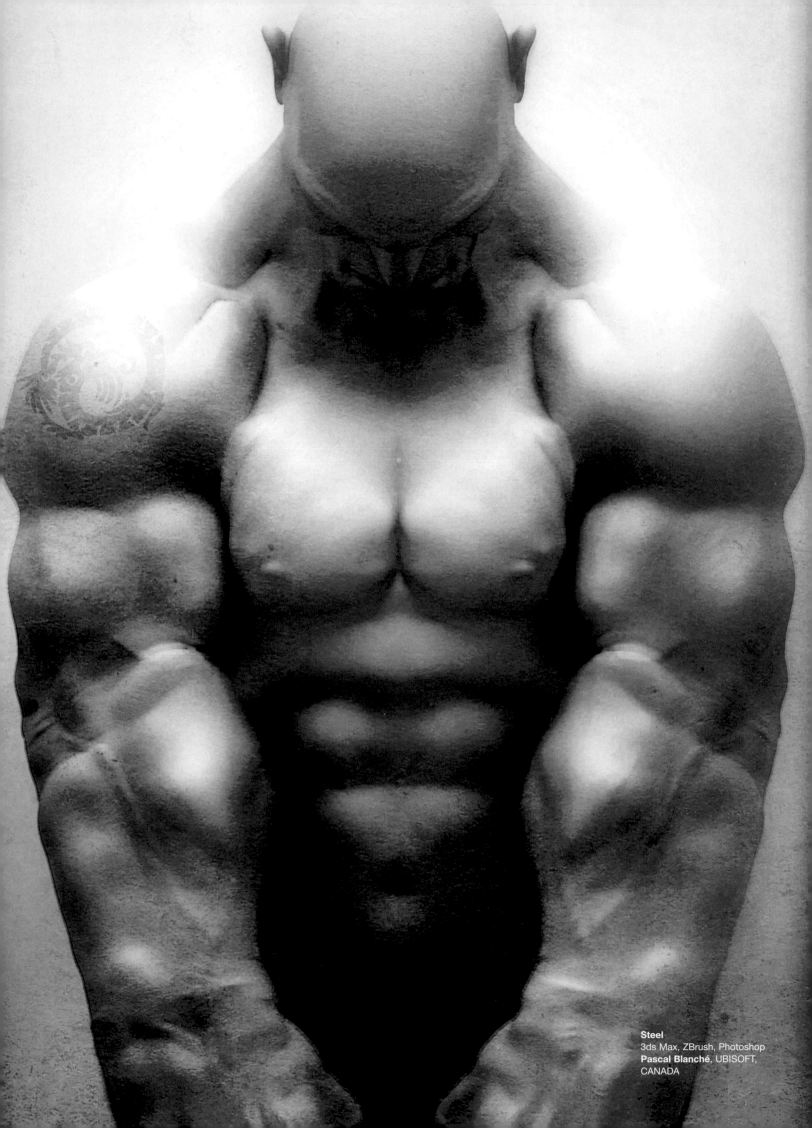

Steel
3ds Max, ZBrush, Photoshop
Pascal Blanché, UBISOFT,
CANADA

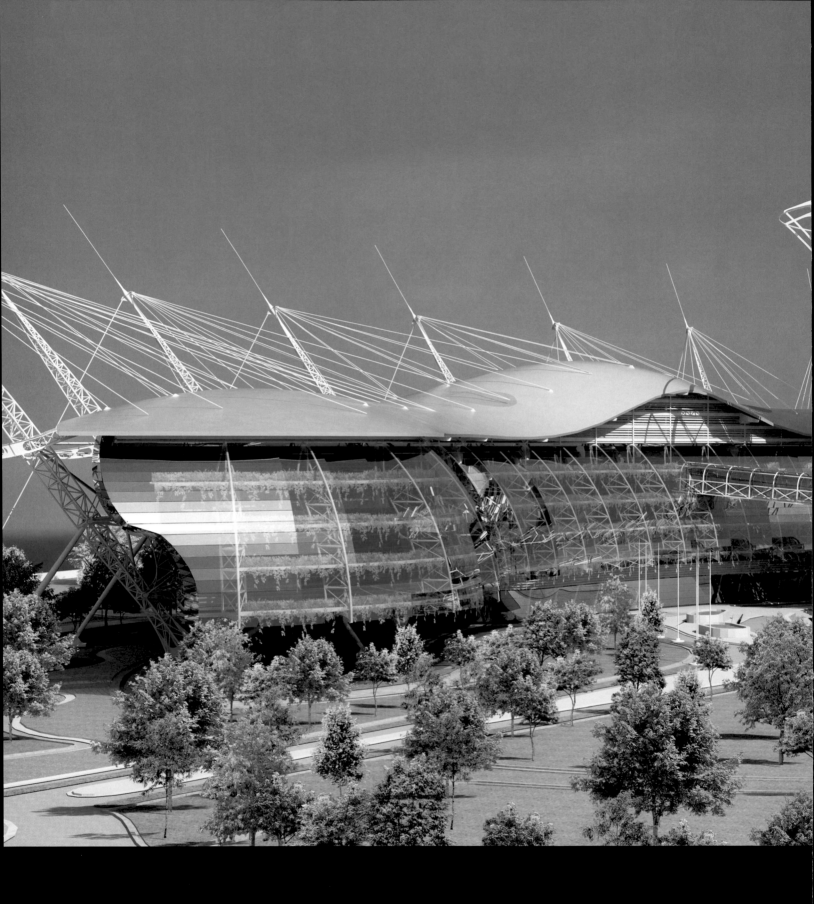

Master
Architectural Exterior

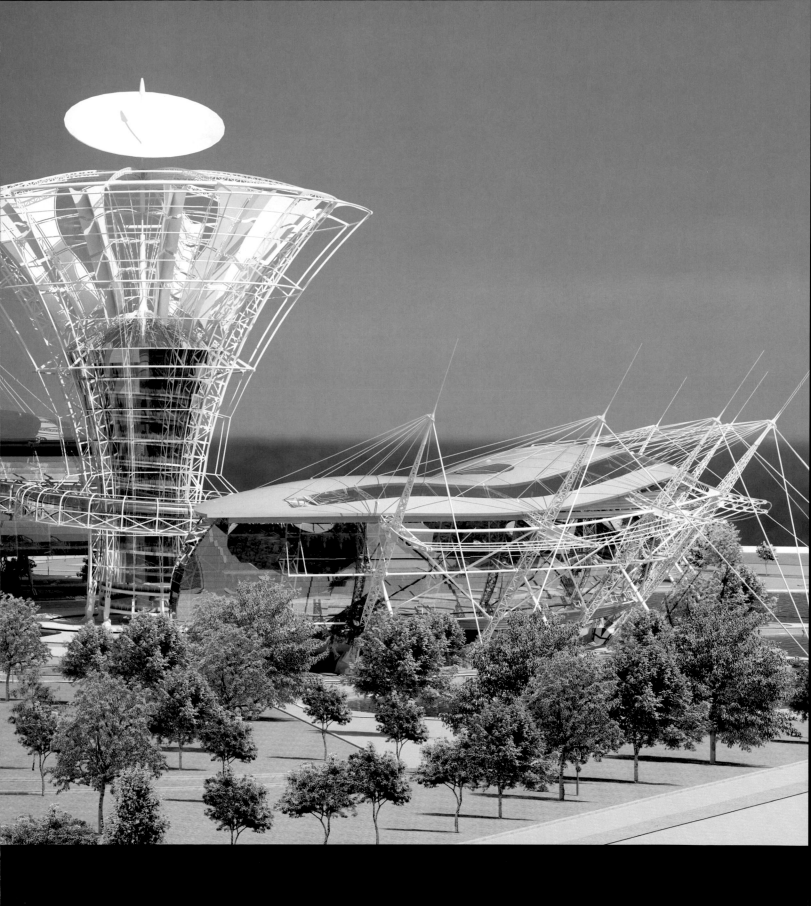

Steel Bioclimatic Technological Center
VIZ, VRay
Thomas Klischies, EKarquitectos LTDA,
CHILE

17

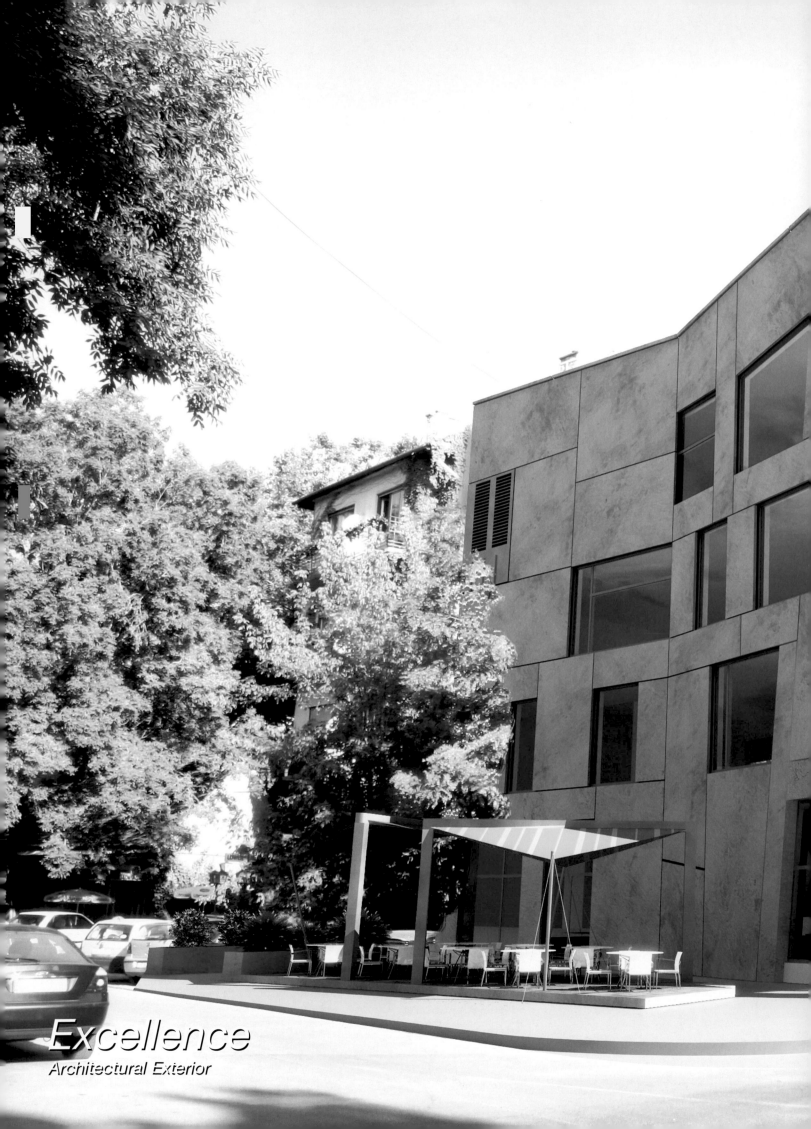

Excellence
Architectural Exterior

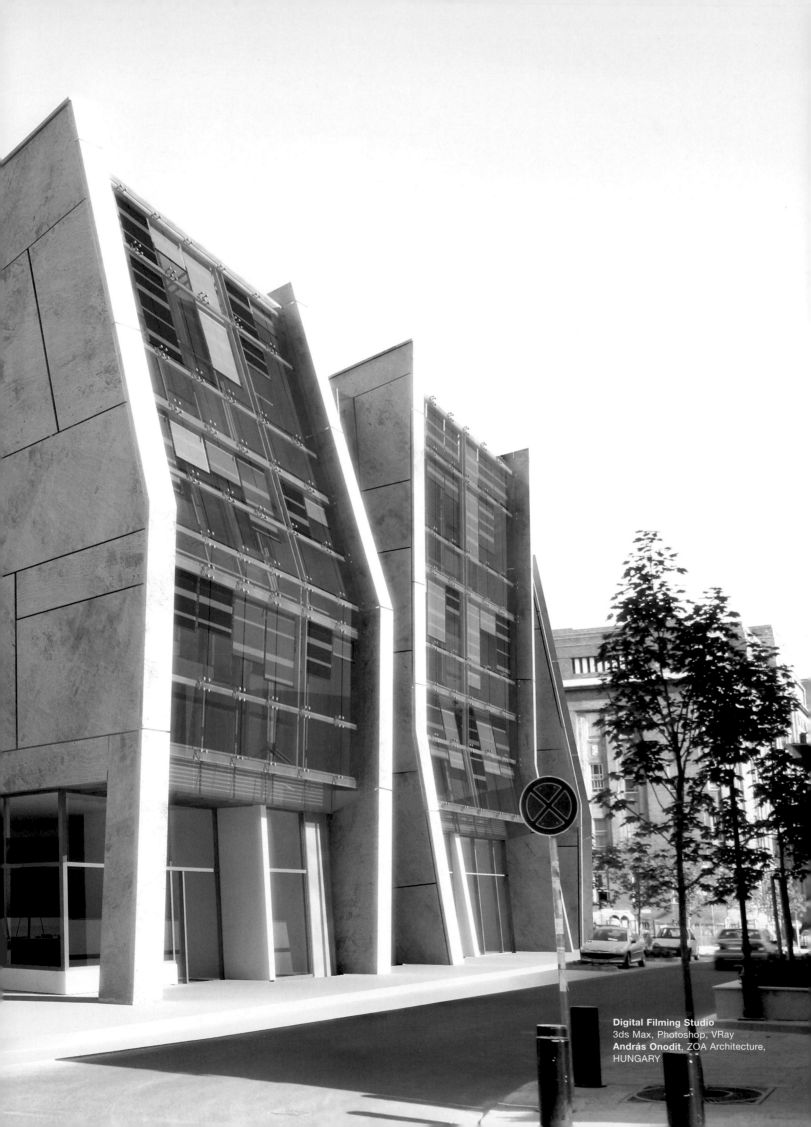

Digital Filming Studio
3ds Max, Photoshop, VRay
András Onodit, ZOA Architecture,
HUNGARY

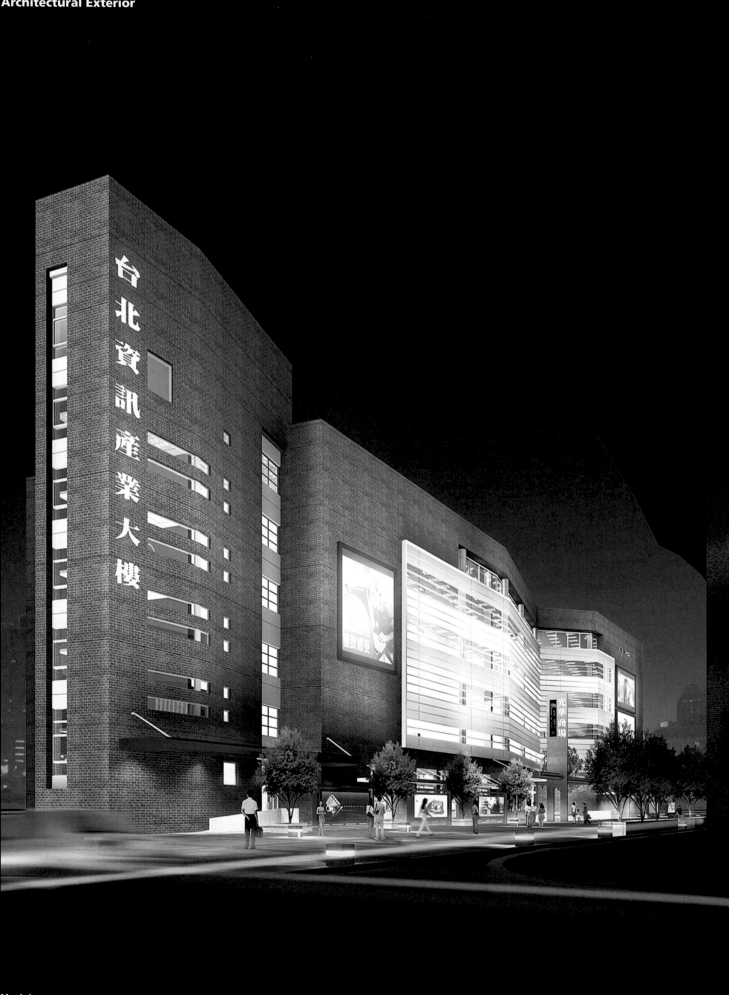

台北資訊產業大樓

光華商場

My Job
3ds Max, Photoshop
Grahm Chen,

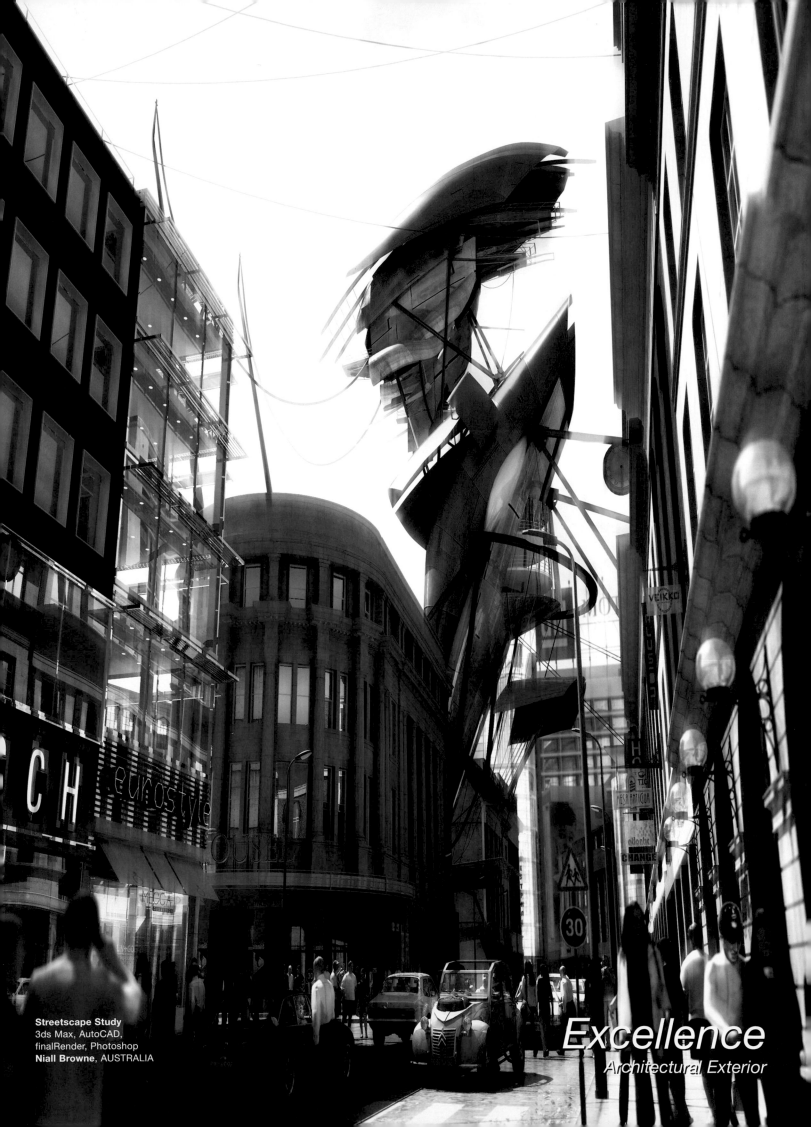

Streetscape Study
3ds Max, AutoCAD,
finalRender, Photoshop
Niall Browne, AUSTRALIA

Excellence
Architectural Exterior

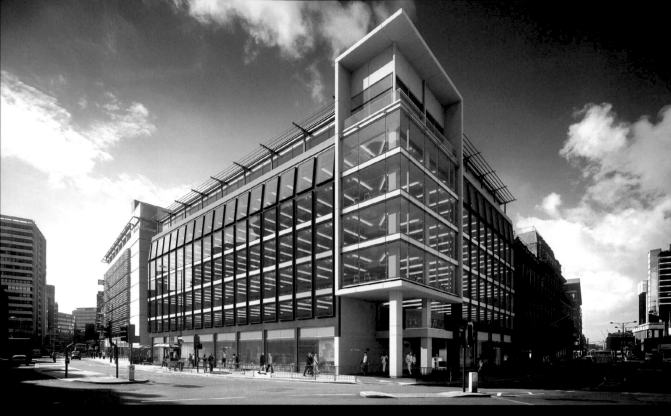

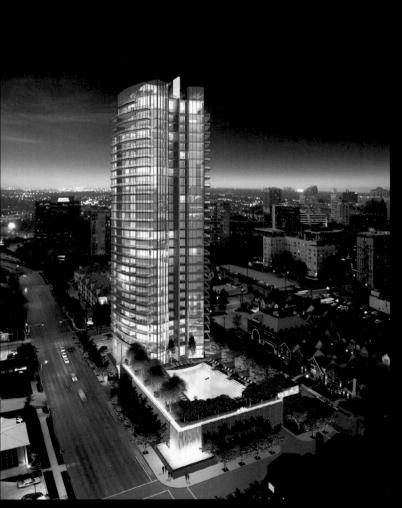

Portland Street
3ds Max
Anthony Hartley-Denton,
AHD-Imaging,
GREAT BRITAIN
[top]

Azure Dusk
3ds Max, VRay
Eugene Radvenis,
E.V. Radvenis Inc.,
CANADA
[above]

King Street Wharf
VIZ, ArchiCAD, VRay, Photoshop
Client: ANZ Bank
Jacek Irzykowski,
Cox and Richardson Architects,
AUSTRALIA
[above right]

World Square - Sydney
3ds Max, VRay, Photoshop
Client: Multiplex Developments,
Ivolve Studios,
AUSTRALIA
[right]

Conference Center
3ds Max, Combustion, finalRender
Client: Autodesk
Dionissios Tsangaropoulos,
Delta Tracing,
ITALY
[top]

Hong Kong and Shanghai Bank
3ds Max, VRay, Photoshop
Jesse Sandifer, Green Grass Studios, LLC,
USA
[above]

West End - Bratislava
3ds Max, Photoshop, VRay
Client: Auket Slovensko s.r.o
Jan Rybar, imagesFX,
CZECH REPUBLIC
[right]

The End of the World
VIZ, VRay
Luke Novotny,
AUSTRALIA

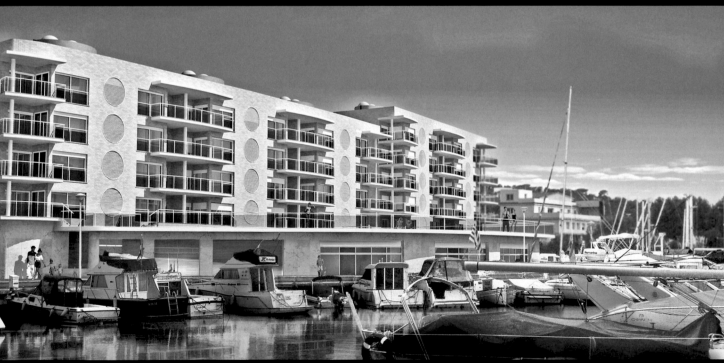

Far Beach - Mackay
3ds Max, VRay, Photoshop
Client: Pacific Coast Developments
Ivolve Studios,
AUSTRALIA
[top]

Apartments
3ds Max, VRay
Client: FormaDisseny
Gustavo Enrique Capote,
Marcos Martin, GREAT BRITAIN
[above]

Oasis
3ds Max, finalRender, Photoshop
Wolfgang Ortner,
mm-vis,
AUSTRIA
[right]

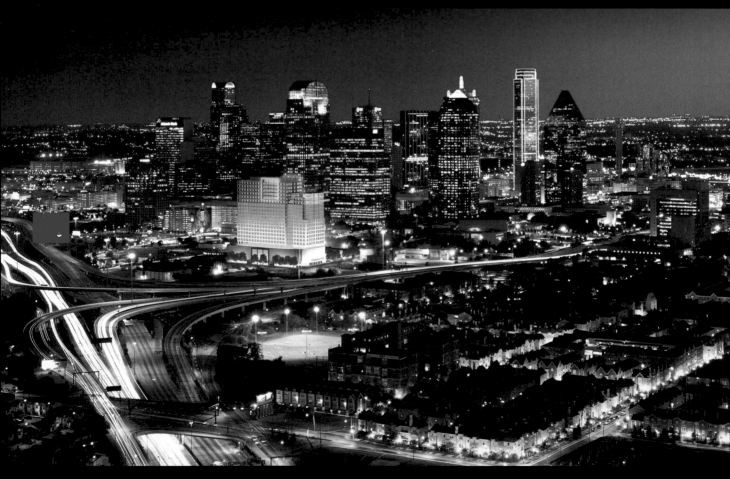

Crystal Square
AutoCAD, 3ds Max
Client: ████████krawala Dekatama
Alex Gunawan,
3DesignArchitect (3DA),
AUSTRALIA/INDONESIA
[top]

Dallas Skyline
3ds Max, VRay, Photoshop
Ben Ortiz, Green Grass Studios,
USA
[above]

Tower
3ds Max, finalRender, Photoshop, AutoCAD
Client: Memorial Hermann
Devin Johnston, Kirksey,
USA
[right]

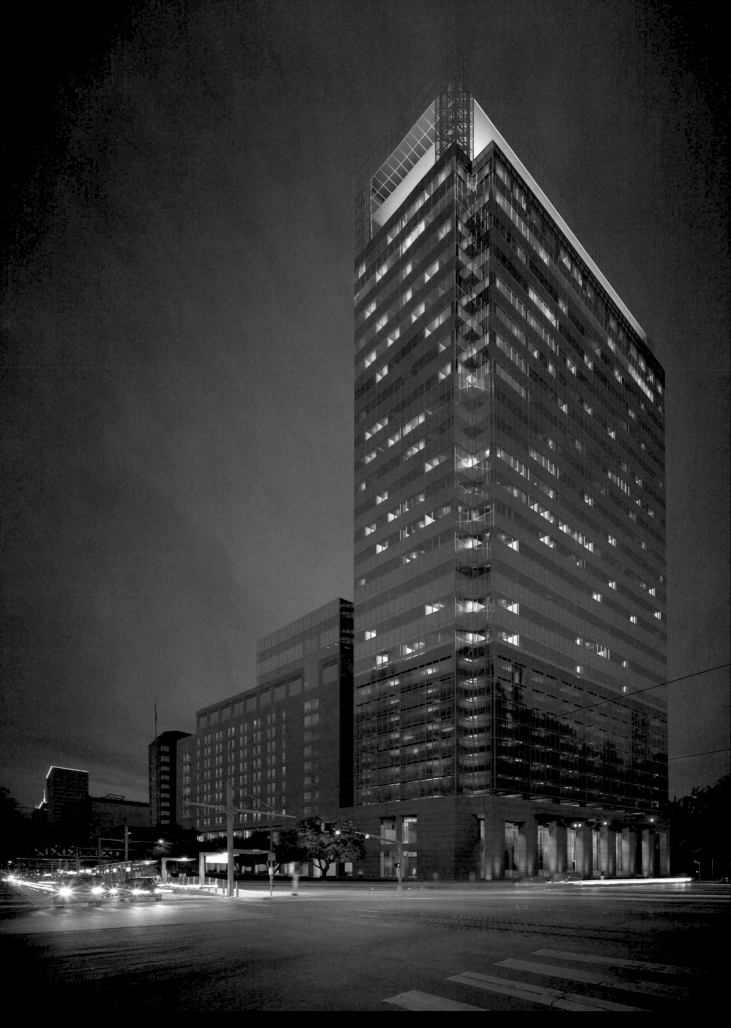

Hatton Gardens
3ds Max
Anthony Hartley-Denton,
AHD-Imaging,
GREAT BRITAIN
[top]

Blue Sky
VIZ, Lightscape
Chen Qingfeng,
CQFCQF,
CHINA
[above]

21-24 Chesham Place, London
3ds Max, finalRender, Photoshop
Alex Morris, Hayes Davidson,
Hayes Davidson,
GREAT BRITAIN
[above]

Store Street
3ds Max
Gareth Thatcher,
AHD-Imaging,
GREAT BRITAIN
[right]

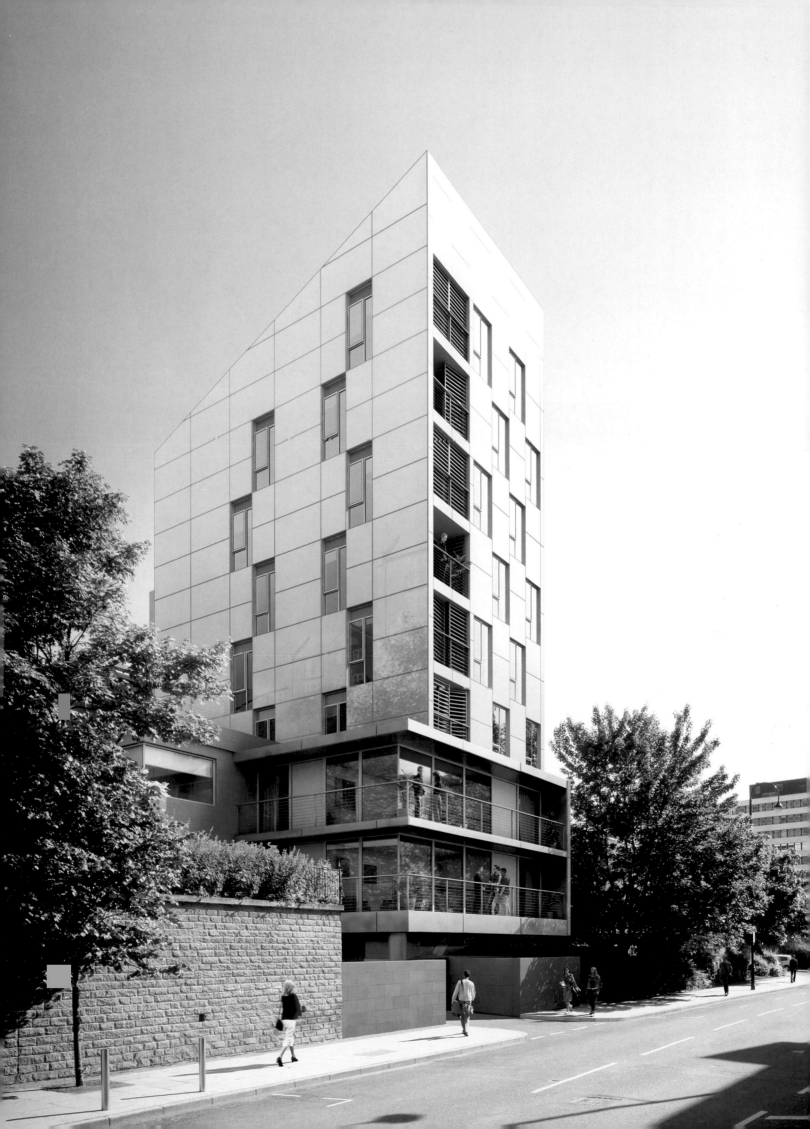

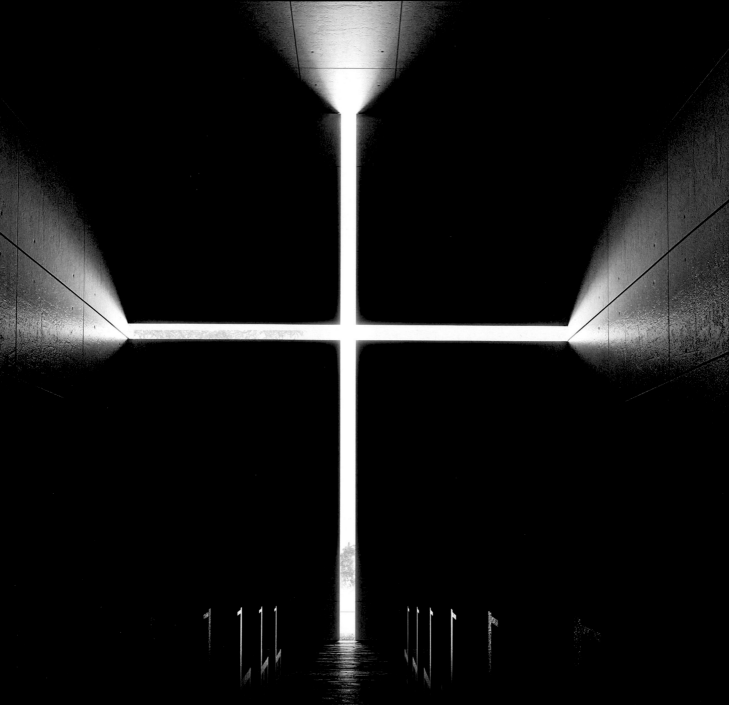

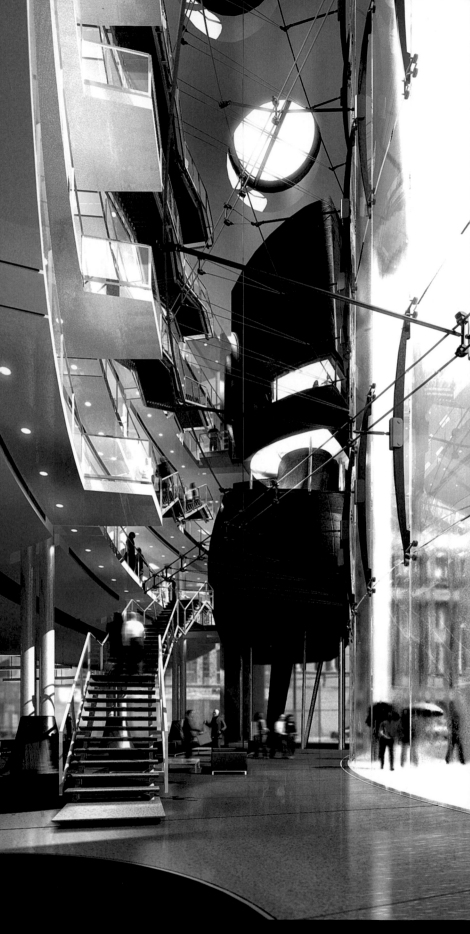

Commercial Lobby Study
3ds Max, AutoCAD, finalRender,
Photoshop
Niall Browne,
AUSTRALIA

Excellence
Architectural Public Interior

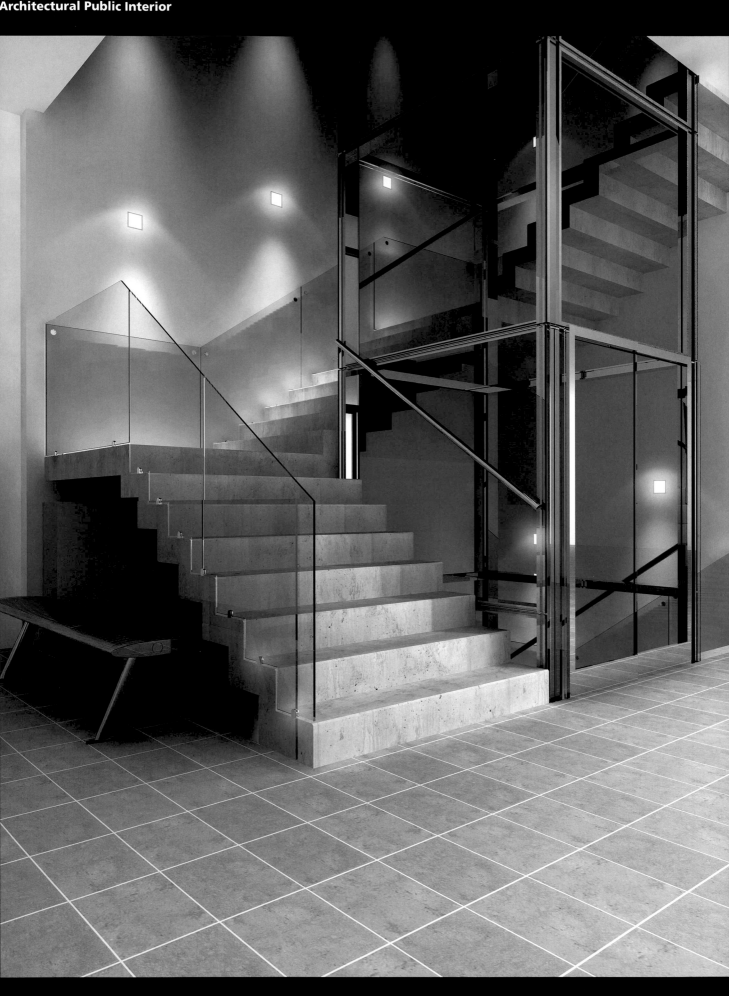

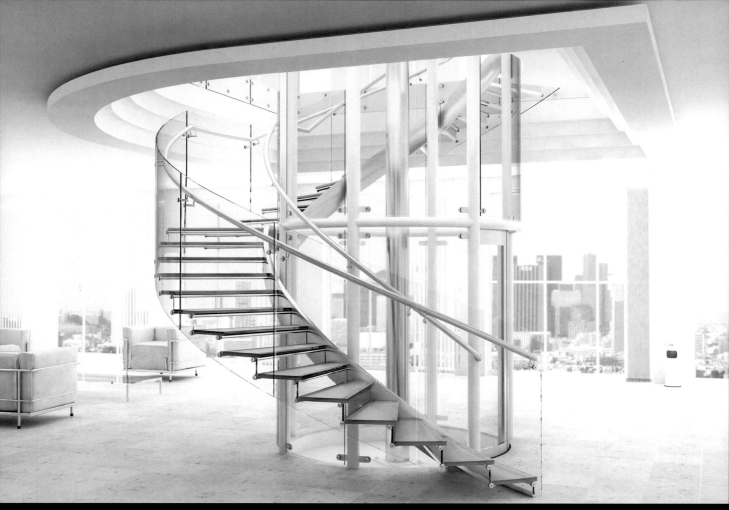

Proposed Porcelanosa Staircase
VIZ, VRay, Photoshop
Client: Porcelenosa
Geoffrey Packer, Spiral Staircase Systems,
GREAT BRITAIN

Excellence
Architectural Public Interior

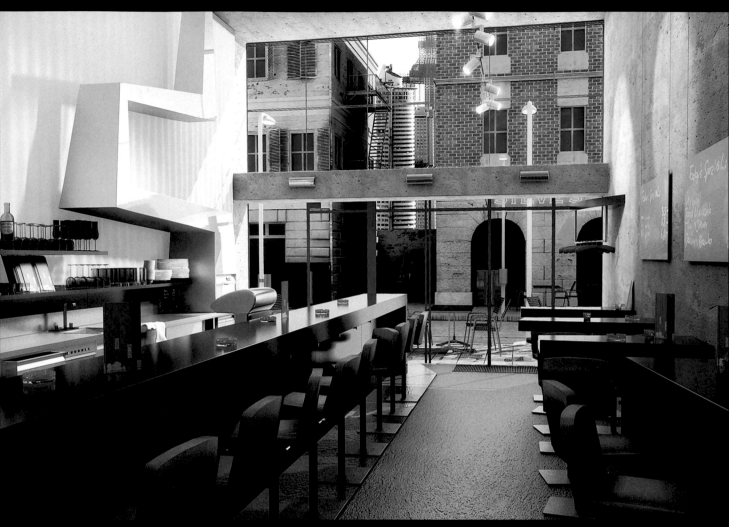

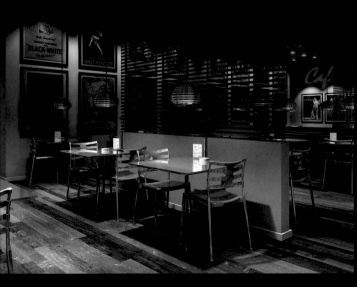

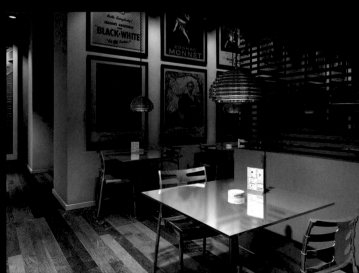

Bar
3ds Max, Photoshop, VRay
Jürgen Rabatscher,
AUSTRIA
[top]

Cafe Nordlys
3ds Max
Jørgen Bork,
DENMARK
[above series]

Proposed Restaurant
3ds Max, formZ, Photoshop, VRay
Lon Grohs, Neoscape, Inc.,
USA
[right]

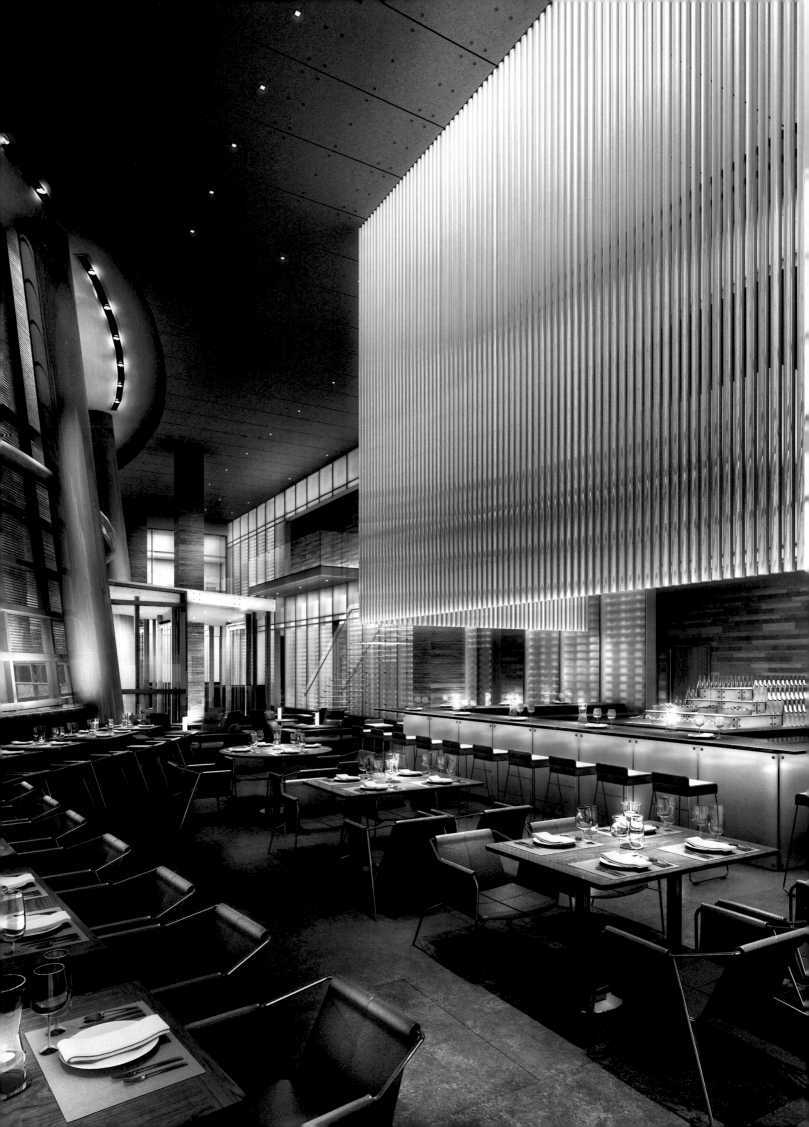

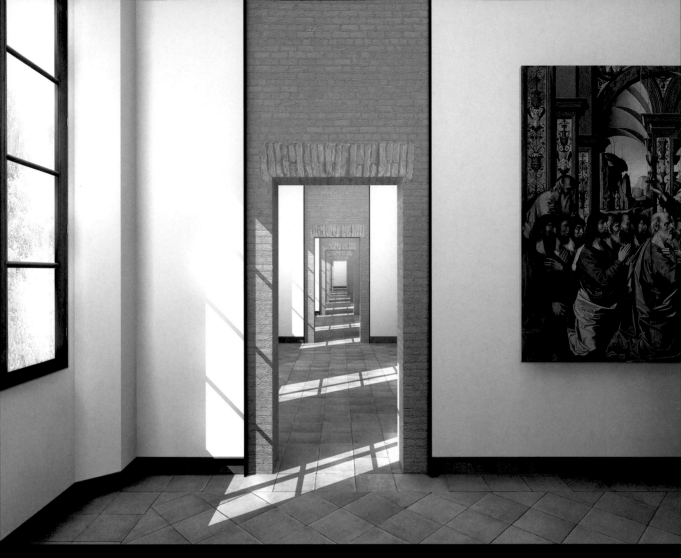

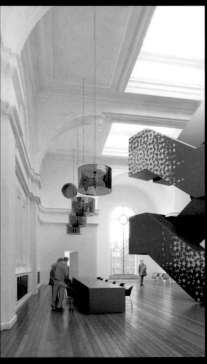

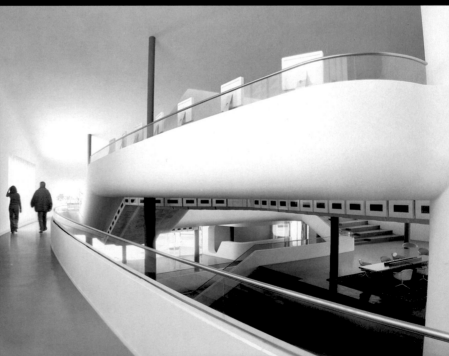

Museum
3ds Max, Combustion, Photoshop
Client: Wilmotte & Associes.
Studio Lucchi & Biserni
Andrea Bertaccini, Tredistudio,
ITALY
[top]

Baby
3ds Max, VRay, Photoshop
Olivier Campagne,
FRANCE
[above left]

Intérieur
3ds Max, VRay, Photoshop
Client: Meyer en Van Schooten
Olivier Campagne, CIIID,
FRANCE
[above]

Wuxi Natatorium
3ds Max, VRay
Xu Zhelong,
Magic Stone Inc.
CHINA
[right]

Customer Service Center 1
3ds Max, Photoshop, VRay
András Onodi, ZOA Architecture,
HUNGARY
[top]

Customer Service Center 2
3ds Max, Photoshop, VRay
András Onodi, ZOA Architecture,
HUNGARY
[above]

Myths & Legends
3ds Max, VRay, PhotoPaint
Jorge Seva and Sergio Miruri,
SPAIN
[right]

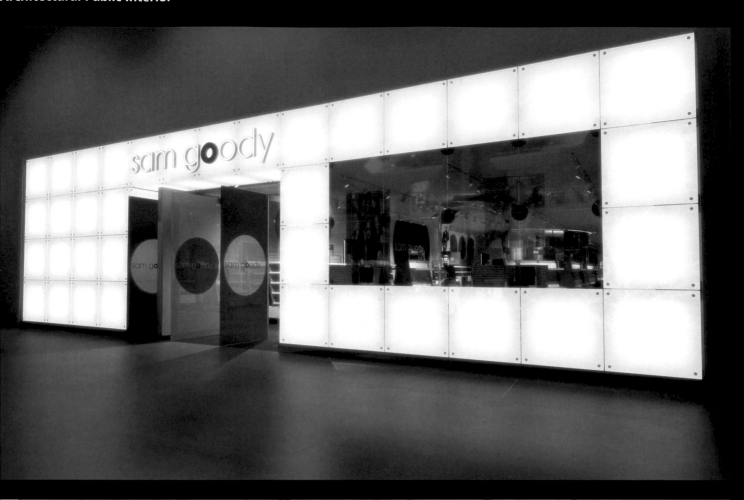

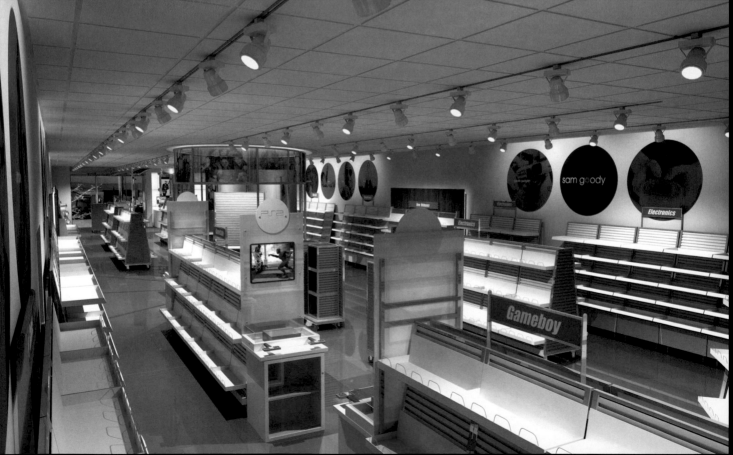

Sam Goody (outside)
3ds Max
Client: JGA
John Pruden and Phil Van Haitsma,
Digital-X, USA
[*top*]

Sam Goody (inside)
3ds Max
Client: JGA
John Pruden and Phil Van Haitsma,
Digital-X, USA
[*above*]

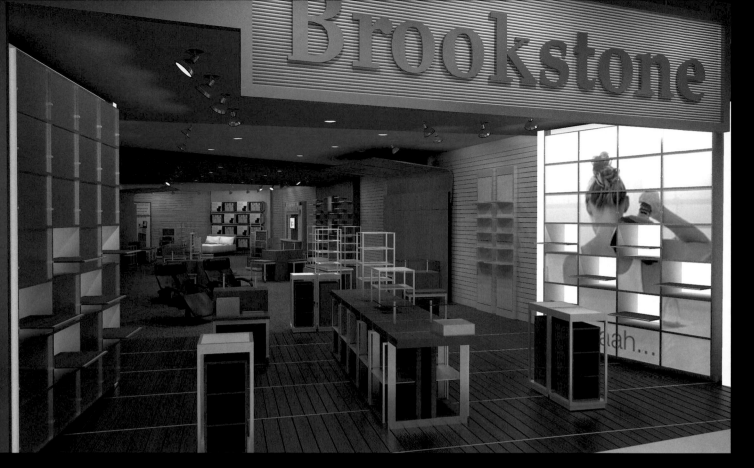

Brookstone Retail Interior
3ds Max
Client: JGA
John Pruden, Digital-X, USA

Meeting Room
3ds Max, Photoshop, VRay
András Onodi, ZOA Architecture,
HUNGARY

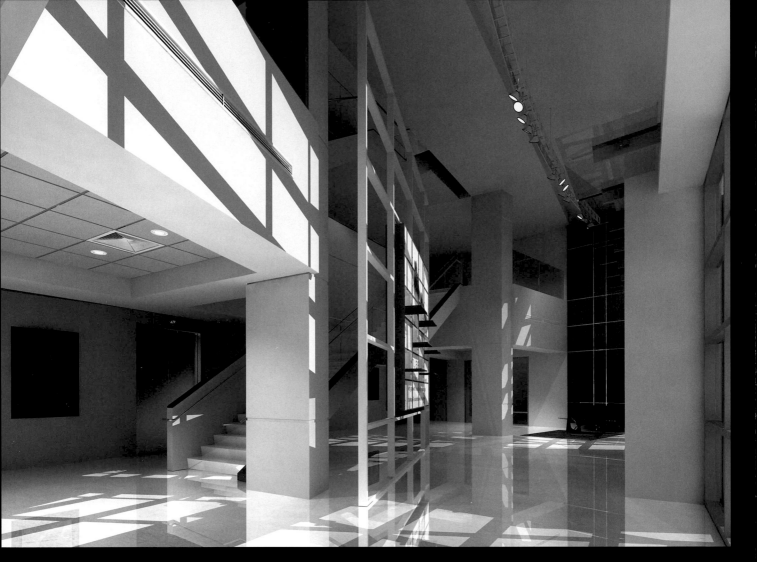

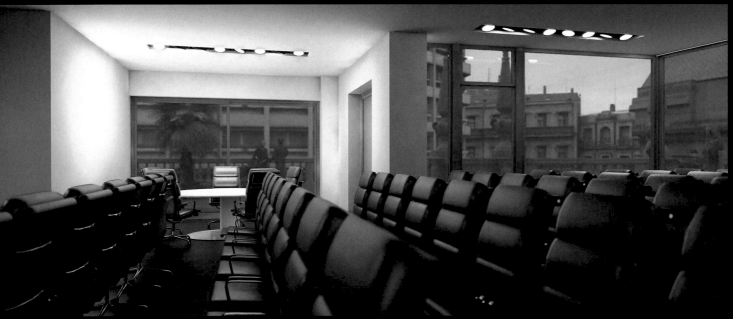

Brookstone Headquarters Entrance
3ds Max, Photoshop
Client: PDA
John Pruden, Digital-X,
USA
[top]

Cine Fraga VIII
3ds Max, VRay, After Effects
Client: Caixa Galicia
Luis Rivero, Carlos Ponte,
Pablo Castro, Fabian Mendez,
urbansimulations,
SPAIN

DMotion Media Hall
3ds Max, VRay, Photoshop
Kasimir Szekeres, DMotion,
THE NETHERLANDS
[right]

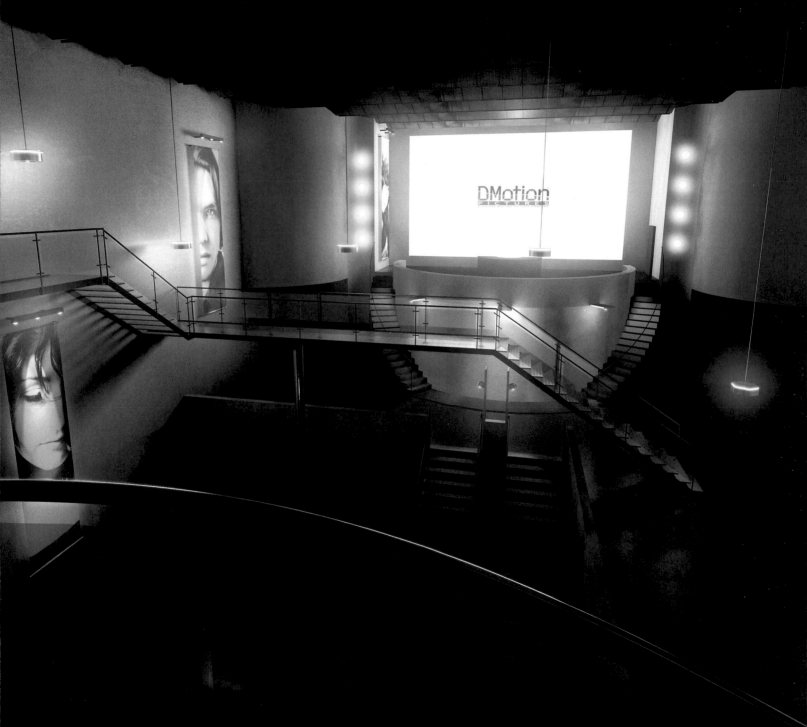

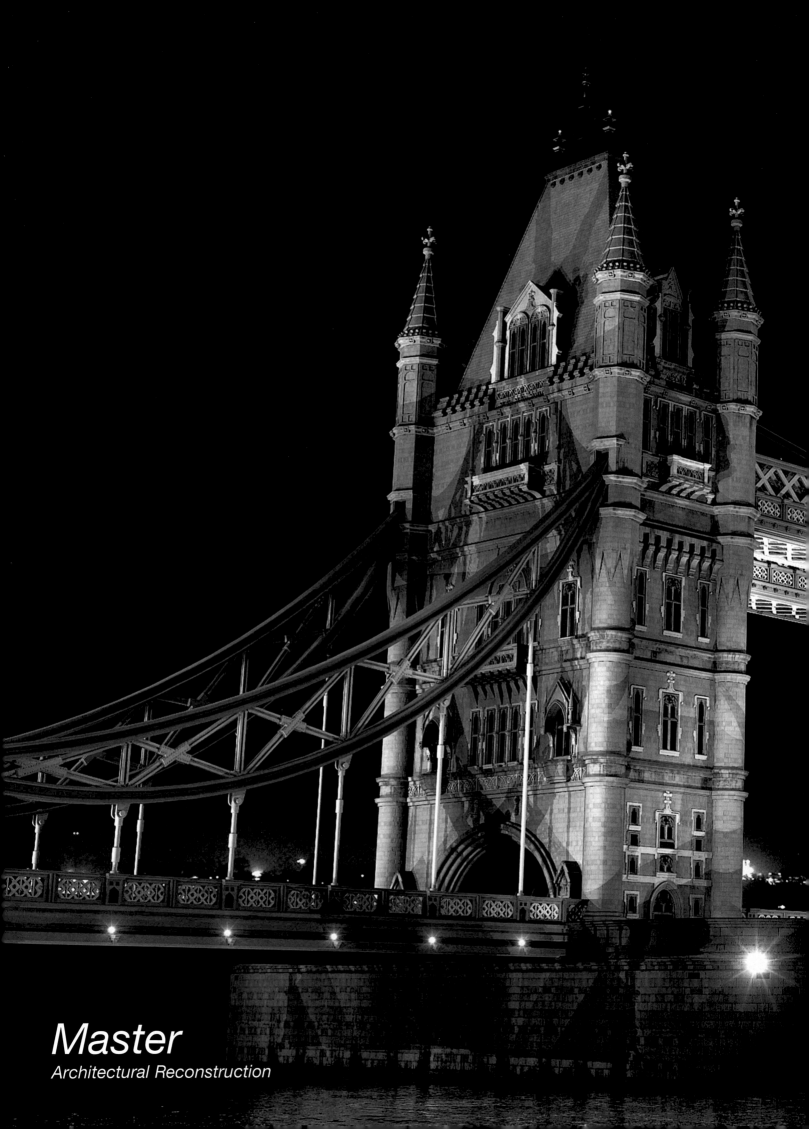

Master
Architectural Reconstruction

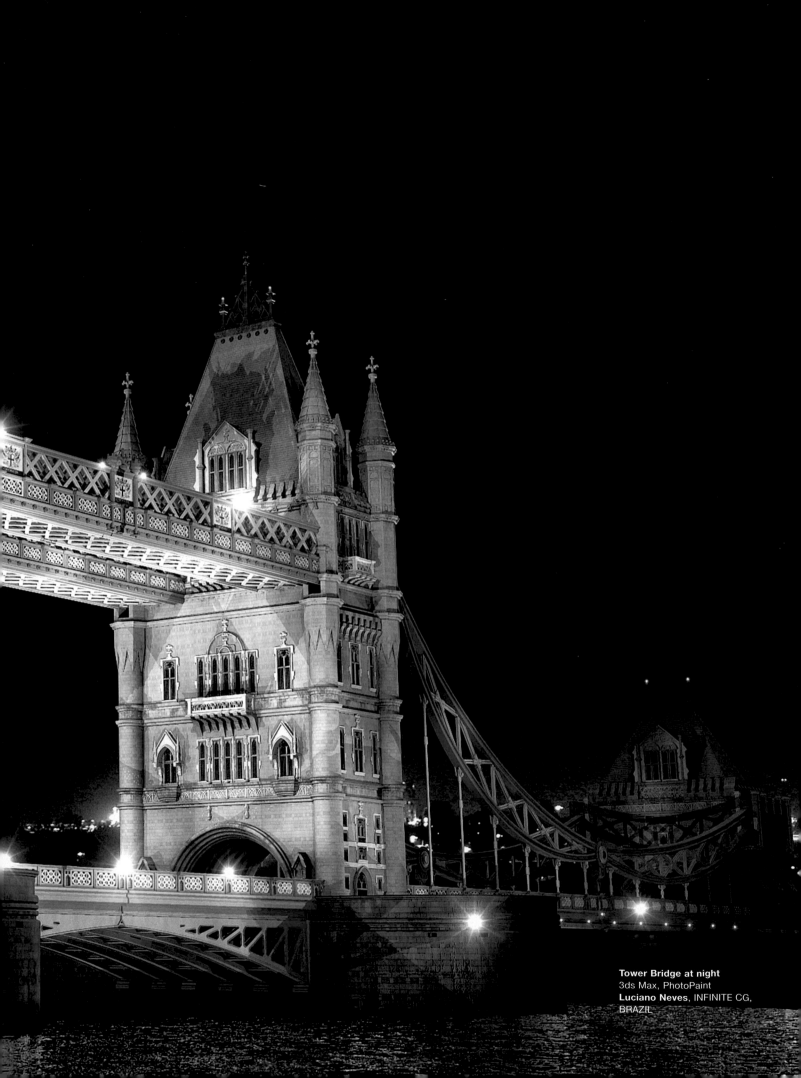

Tower Bridge at night
3ds Max, PhotoPaint
Luciano Neves, INFINITE CG,
BRAZIL

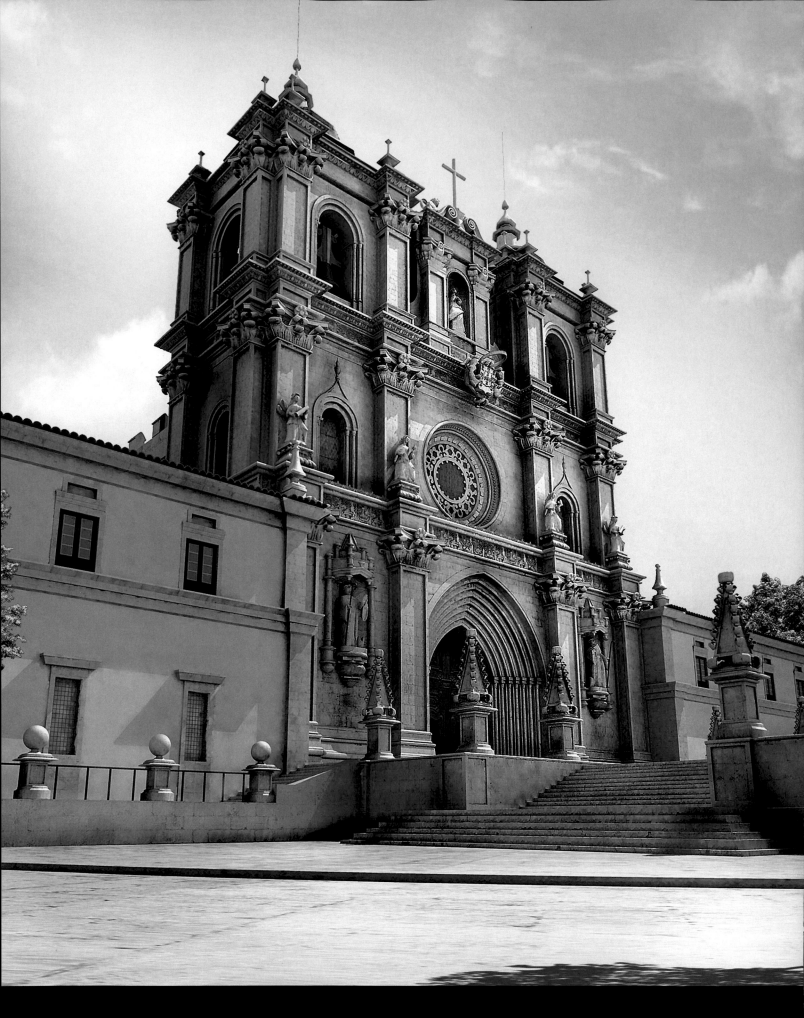

Excellence

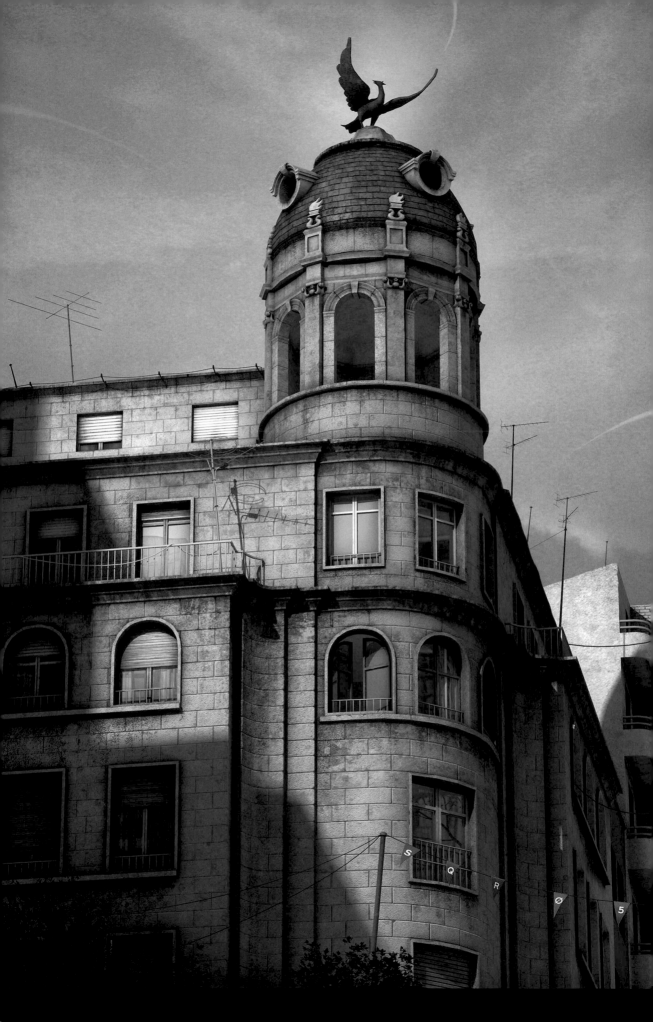

The Phoenix building
3ds Max, Photoshop, BodyPaint
Juan Siquier,
SPAIN

Excellence
Architectural Reconstruction

Excellence
Architectural Reconstruction

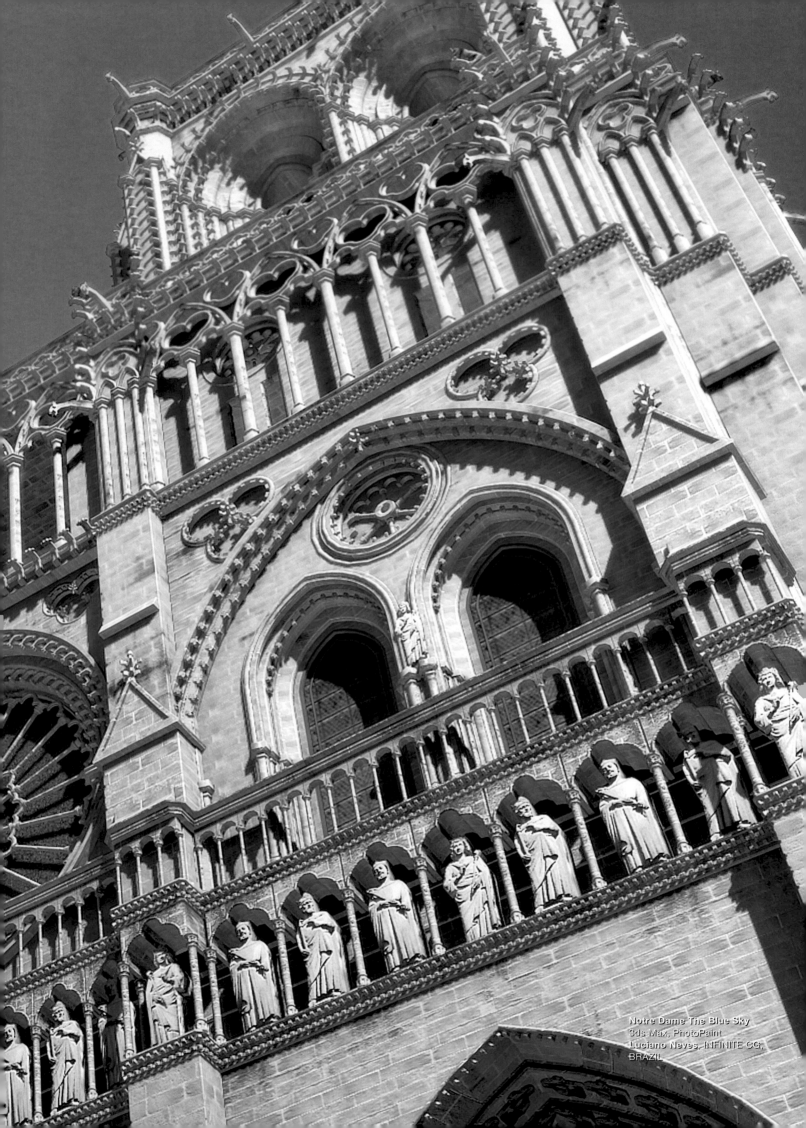

Notre Dame The Blue Sky
3ds Max, PhotoPaint
Luciano Neves, INFINITE CG,
BRAZIL

Cine Fraga I
3ds Max, VRay, After Effects
Client: Caixa Galicia
**Luis Rivero, Carlos Ponte,
Pablo Castro, Fabian Mendez,**
Urban Simulations, SPAIN
[top]

Cine Fraga II
3ds Max, VRay, After Effects
Client: Caixa Galicia
**Luis Rivero, Carlos Ponte,
Pablo Castro,**
Urban Simulations, SPAIN
[above]

Courtyard
3ds Max, Brazil r/s
Weiye Yin,
CHINA
[right]

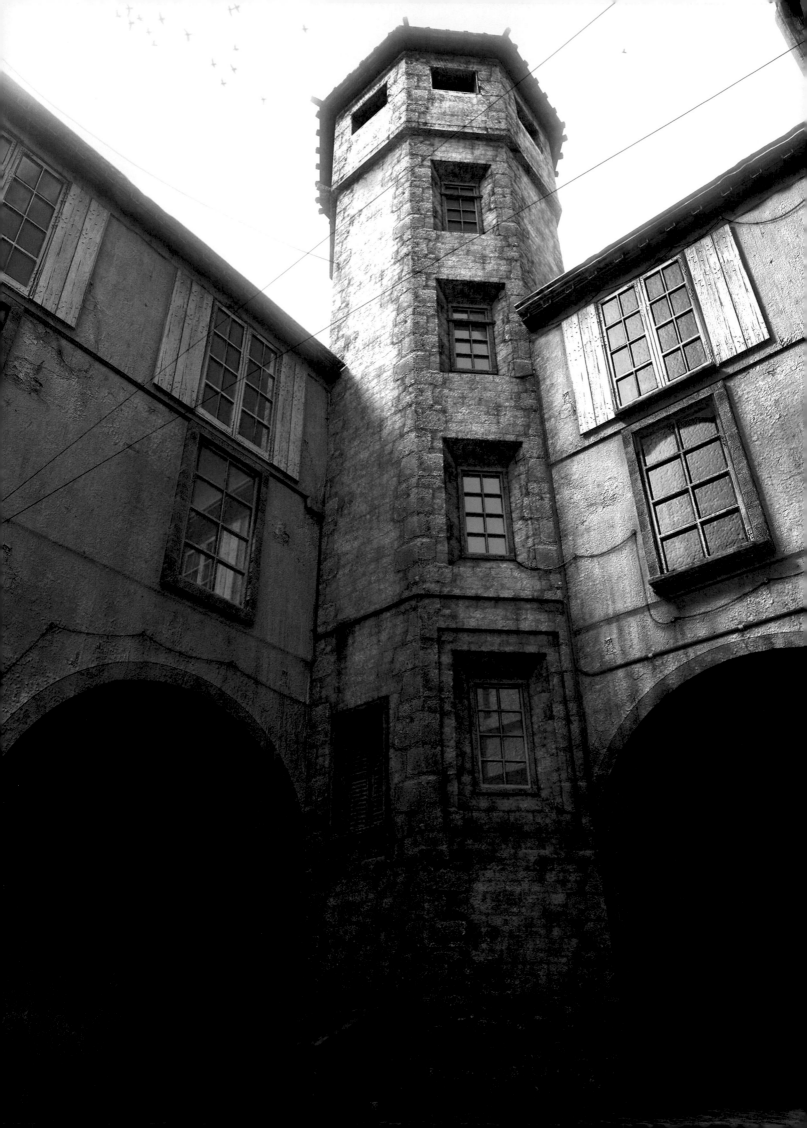

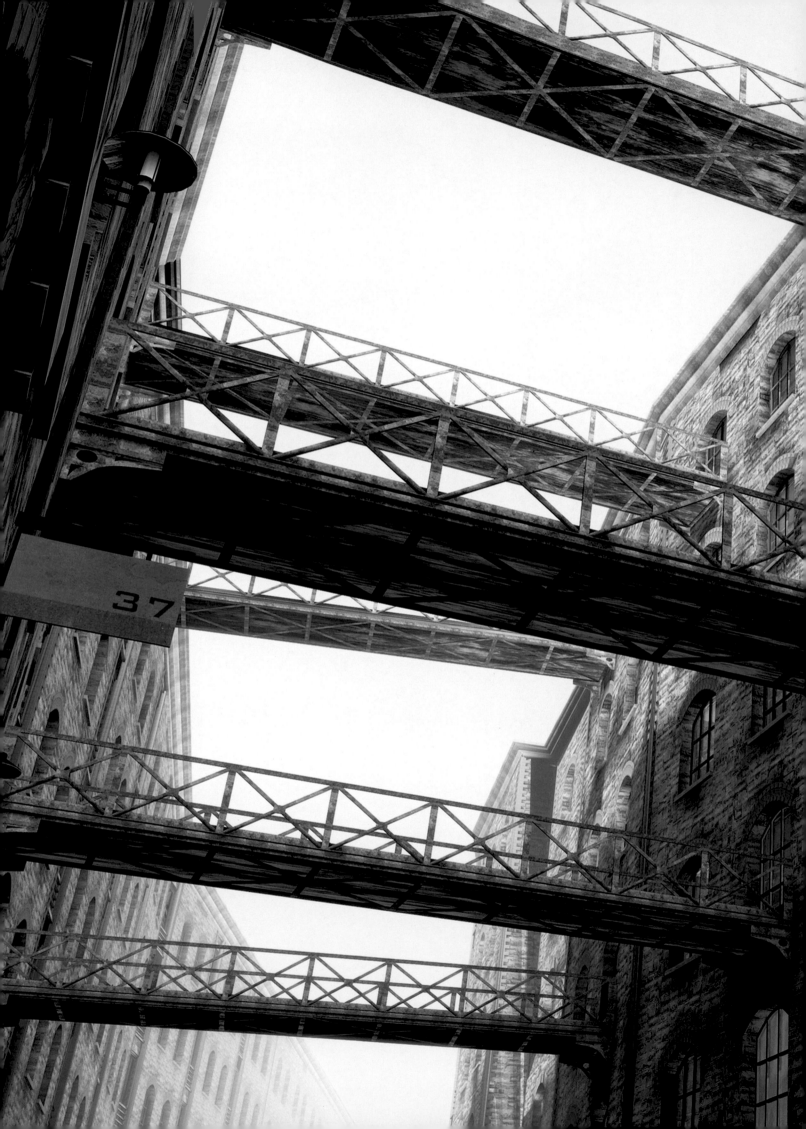

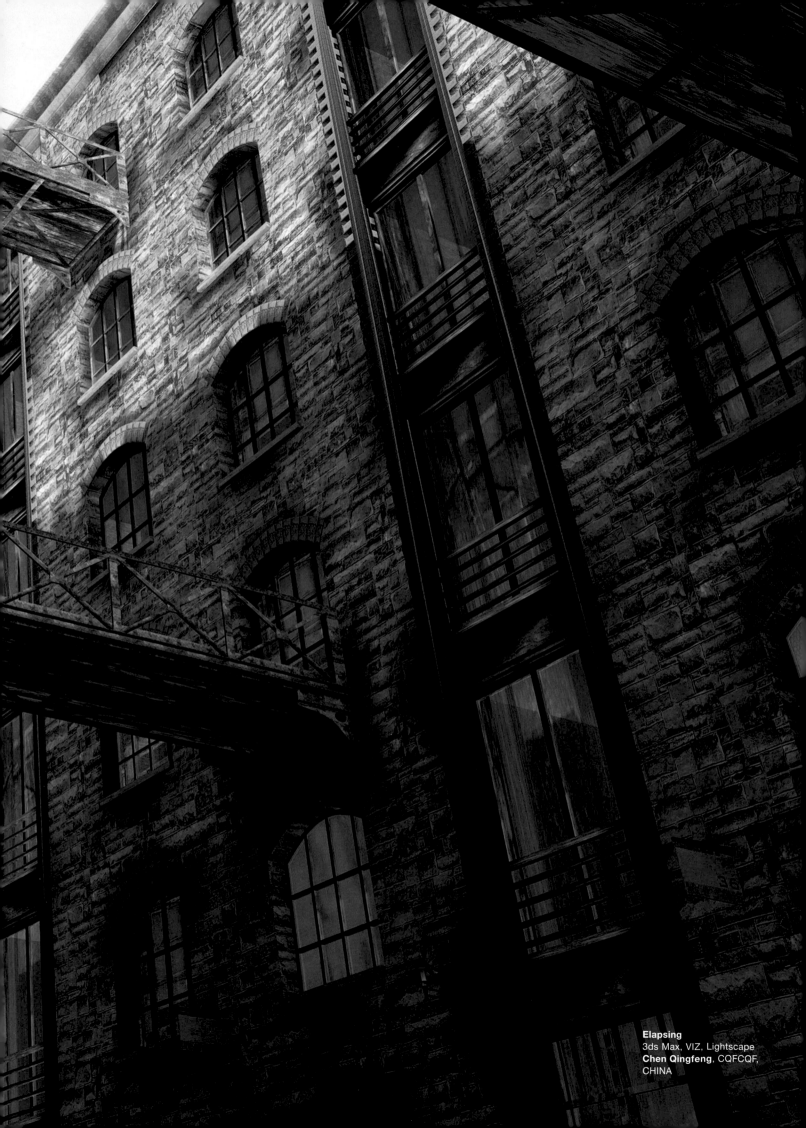

Elapsing
3ds Max, VIZ, Lightscape
Chen Qingfeng. CQFCQF,
CHINA

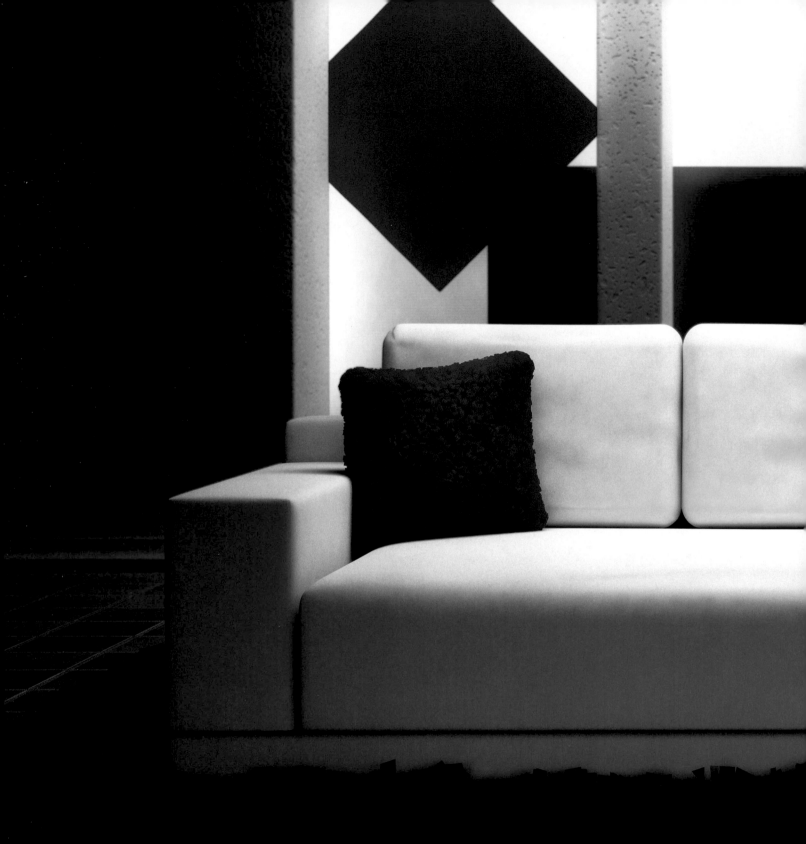

Master
Architectural Residential Interior

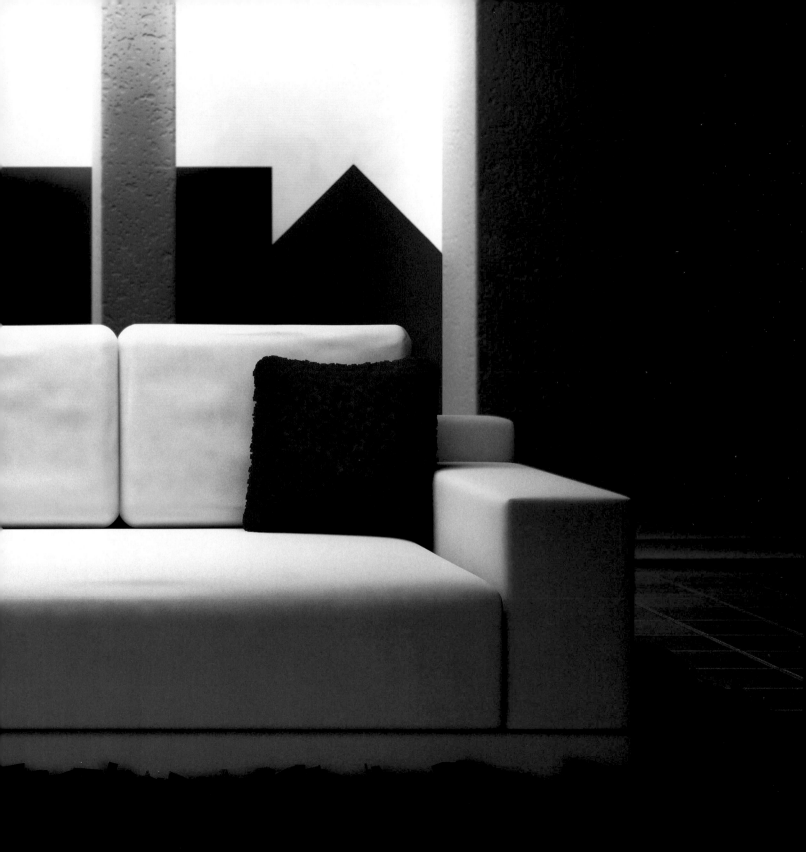

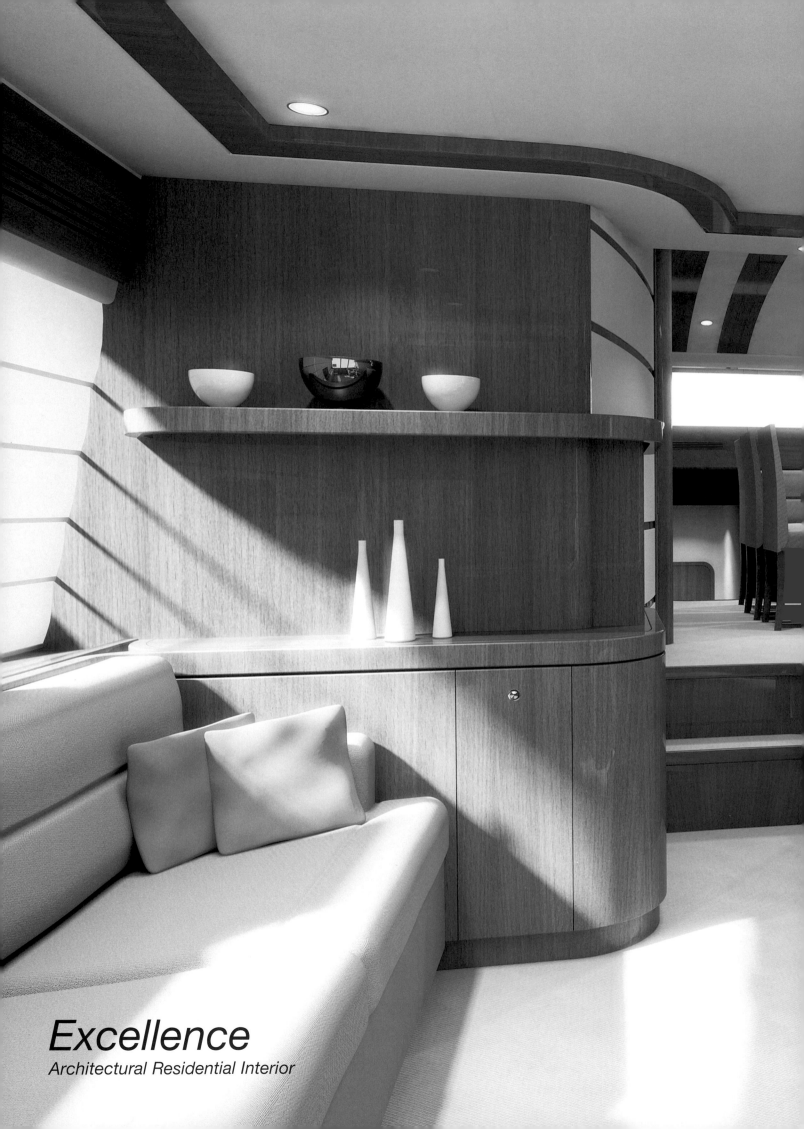

Excellence
Architectural Residential Interior

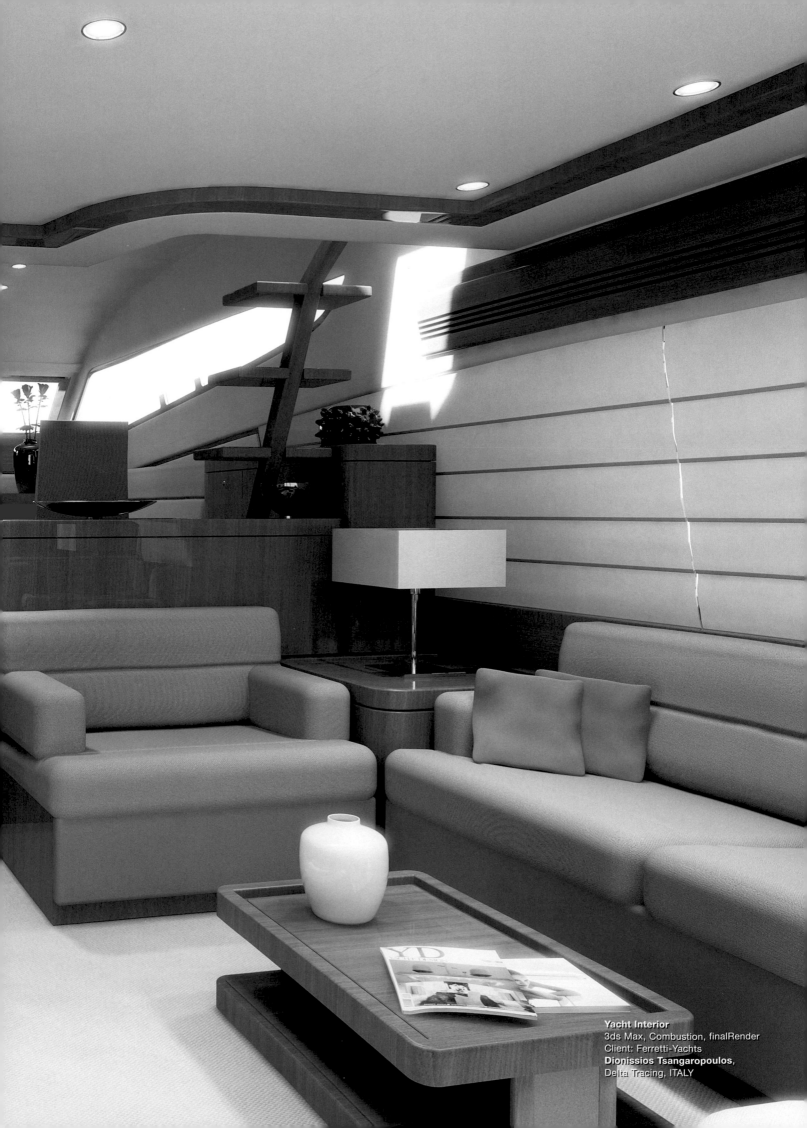

Yacht Interior
3ds Max, Combustion, finalRender
Client: Ferretti-Yachts
Dionissios Tsangaropoulos,
Delta Tracing, ITALY

Italian Sink

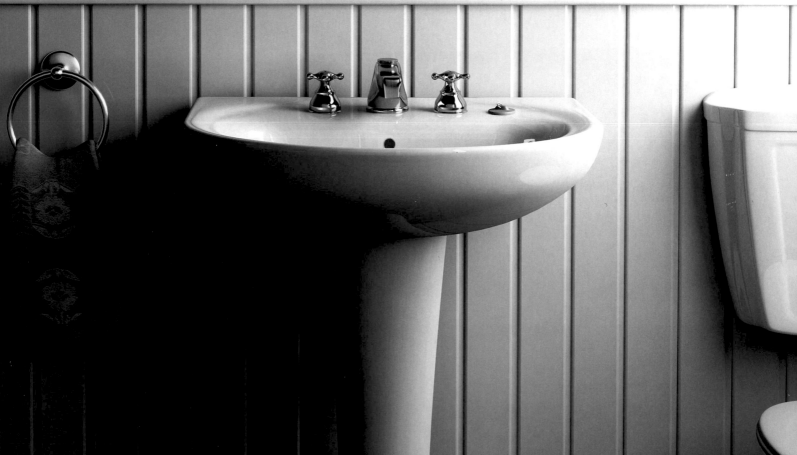

Bathroom
3ds Max, VRay, Photoshop
Adrian Cristea,
ROMANIA

Excellence
Architectural Residential Interior

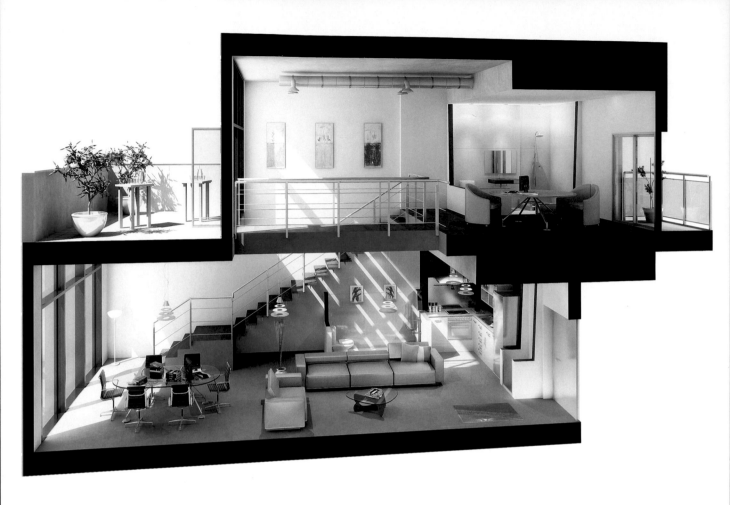

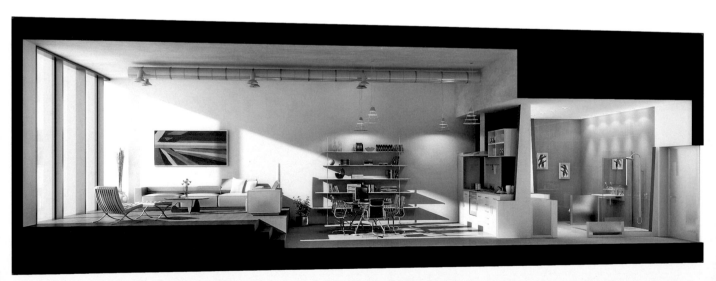

Seccion Rivas 02
3ds Max, VRay
Victor Loba, Neosmedia,
SPAIN
[above series]

Apartment interior2
3ds Max
Leandro Raskin, dnamiq.
ARGENTINA
[right]

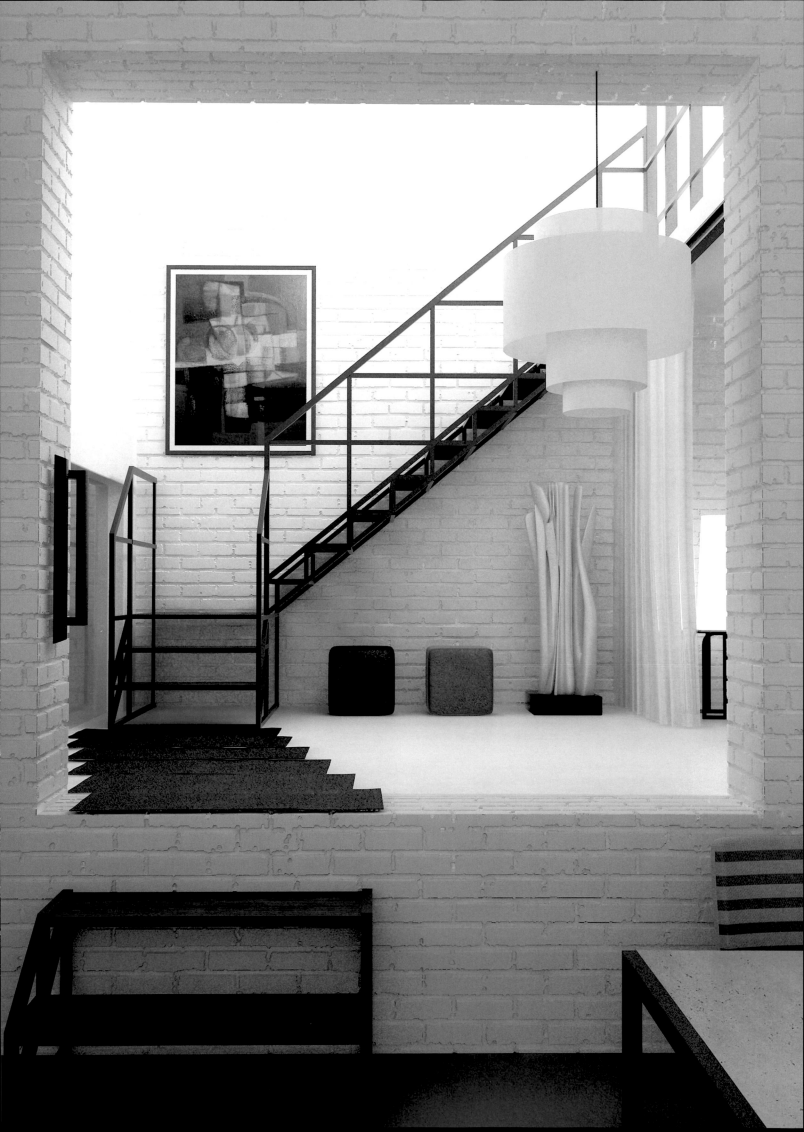

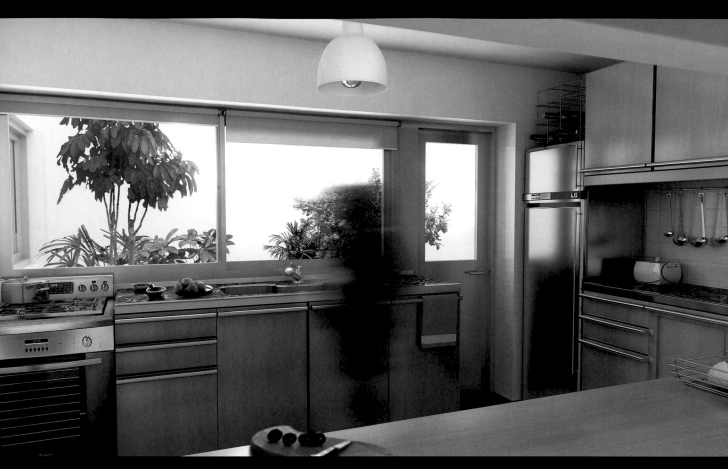

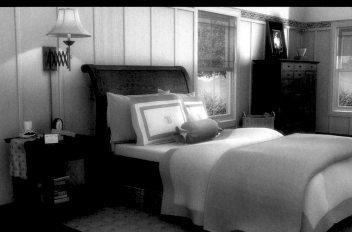

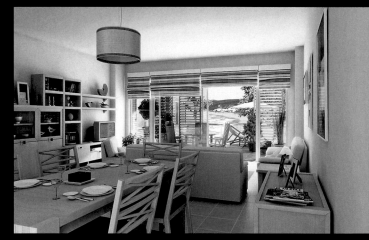

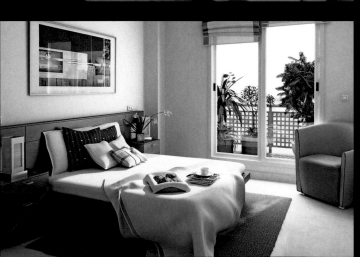

Bedroom Scene
3ds Max, VRay
Mark Van Haitsma,
Tin Cactus Studios LLC,
USA
[above left]

Dormitorio Realia
3ds Max, VRay
Victor Loba, Neosmedia,
SPAIN
[left]

Small Kitchen
VIZ, 3ds Max, Photoshop
Juan Altieri, A2T,
URUGUAY
[top]

Salon Torredembarra
3ds Max, VRay
Victor Loba, Neosmedia,
SPAIN
[above]

Minimalism Interior
3ds Max
Jørgen Bork,
DENMARK
[top]

June
3ds Max, VRay, Photoshop
Wolfgang Ortner, mm-vis,
AUSTRIA
[above right]

Light Room
3ds Max
Wolfgang Ortner, mm-vis,
AUSTRIA
[above]

Living Room
3ds Max, VRay
Omar Fernandes,
PORTUGAL
[right]

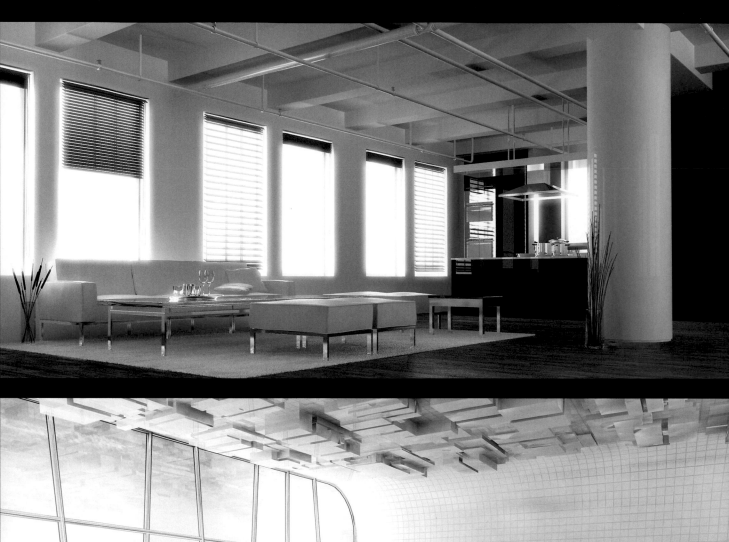

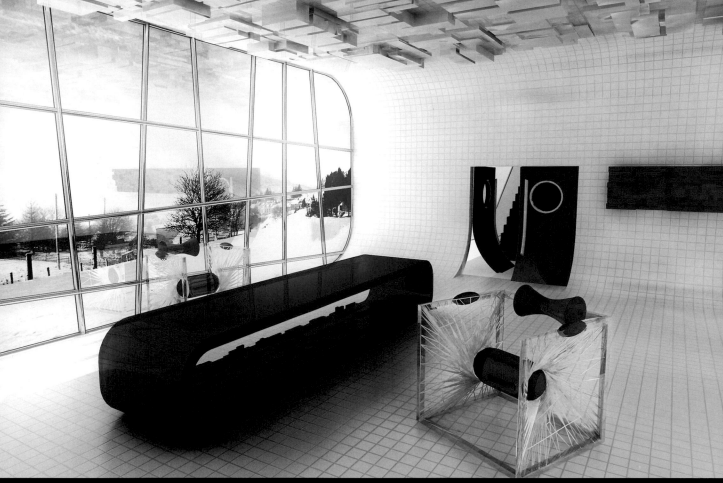

Chelsey
3ds Max, VRay, Photoshop
Wolfgang Ortner, mm-vis,
AUSTRIA
[top]

Red House
Photoshop, VRay, 3ds Max
Rachdi Manal,
FRANCE
[above]

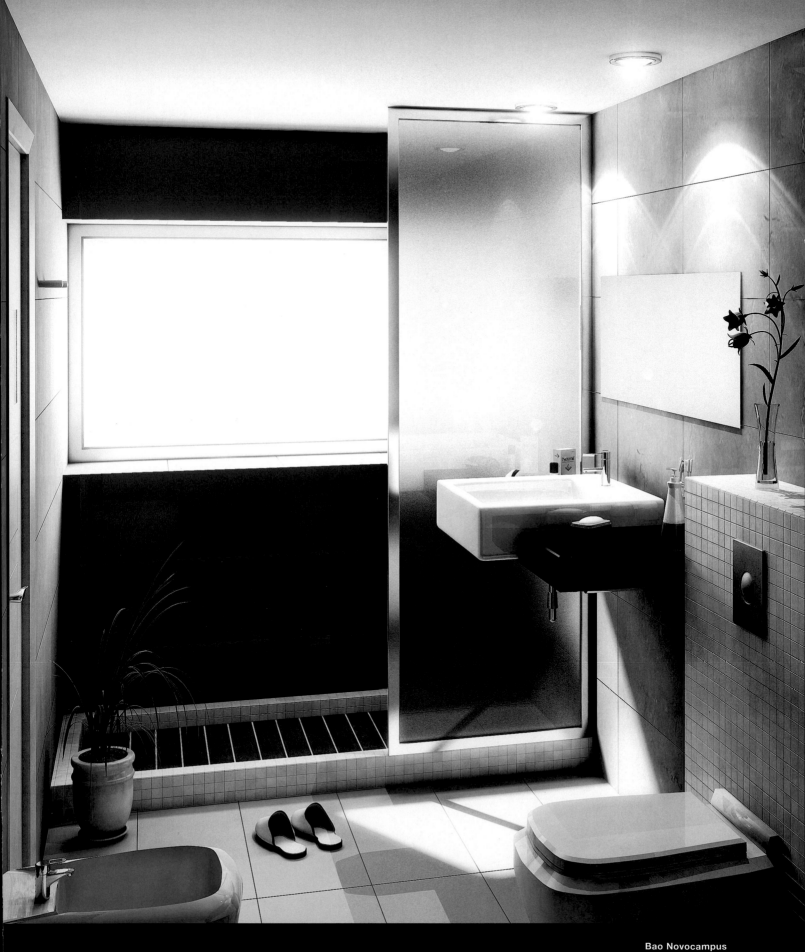

Red Room

Korunni Dvur - Appt. 2
3ds Max, VRay, Photoshop
Jan Rybar, imagesFX,
CZECH REPUBLIC

The Room
3ds Max, VRay
Omar Fernandes,
PORTUGAL

Twin-Windows
3ds Max
Roberto Cardile,
ITALY

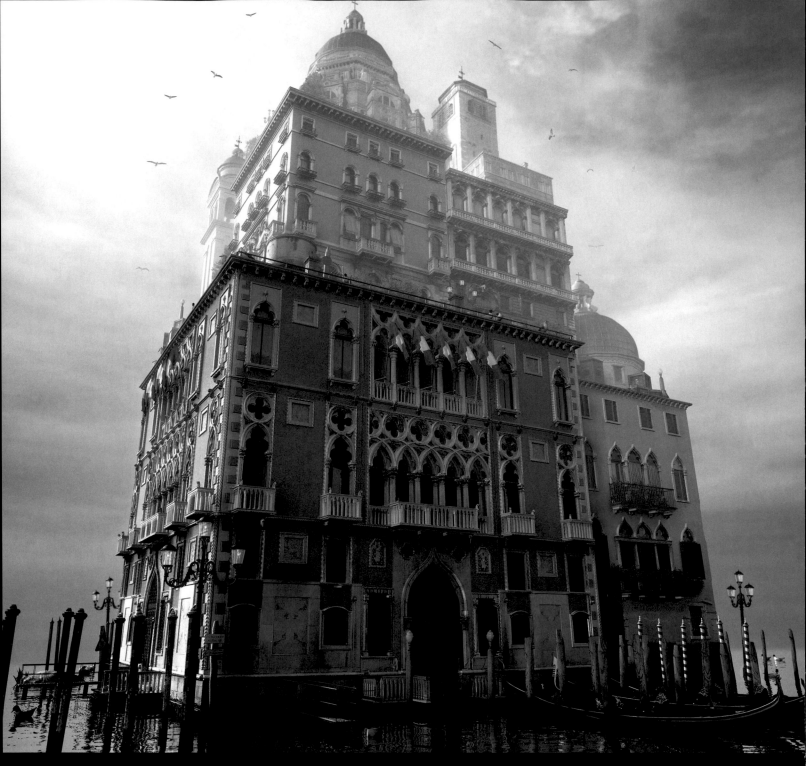

Master
Environment

Venice: Another look
3ds Max
Oleg Karassev, RUSSIA

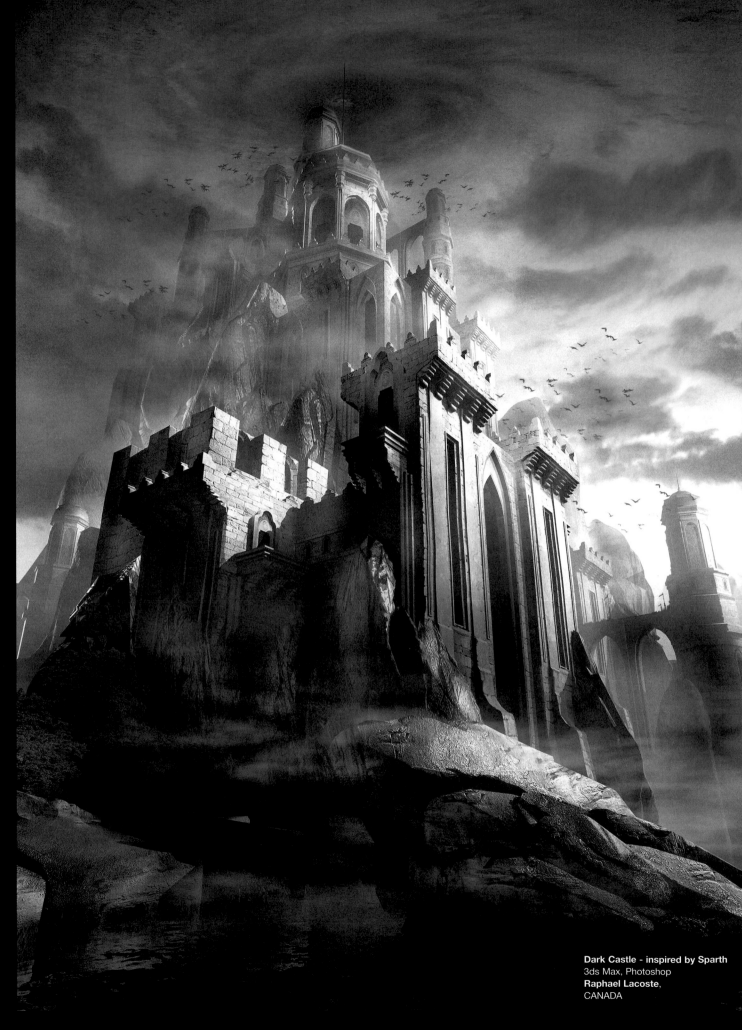

Dark Castle - inspired by Sparth
3ds Max, Photoshop
Raphael Lacoste,
CANADA

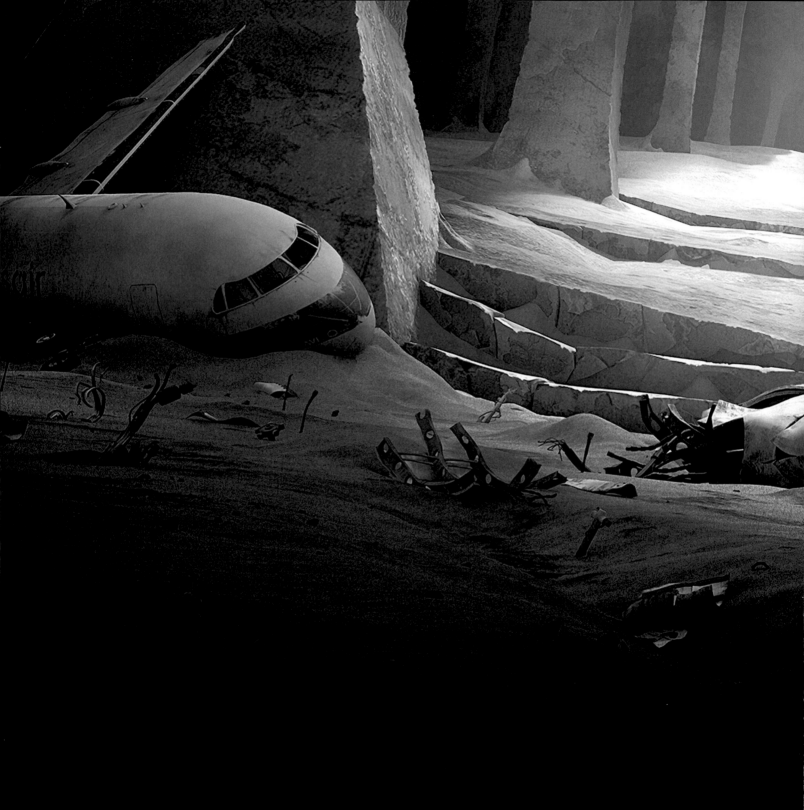

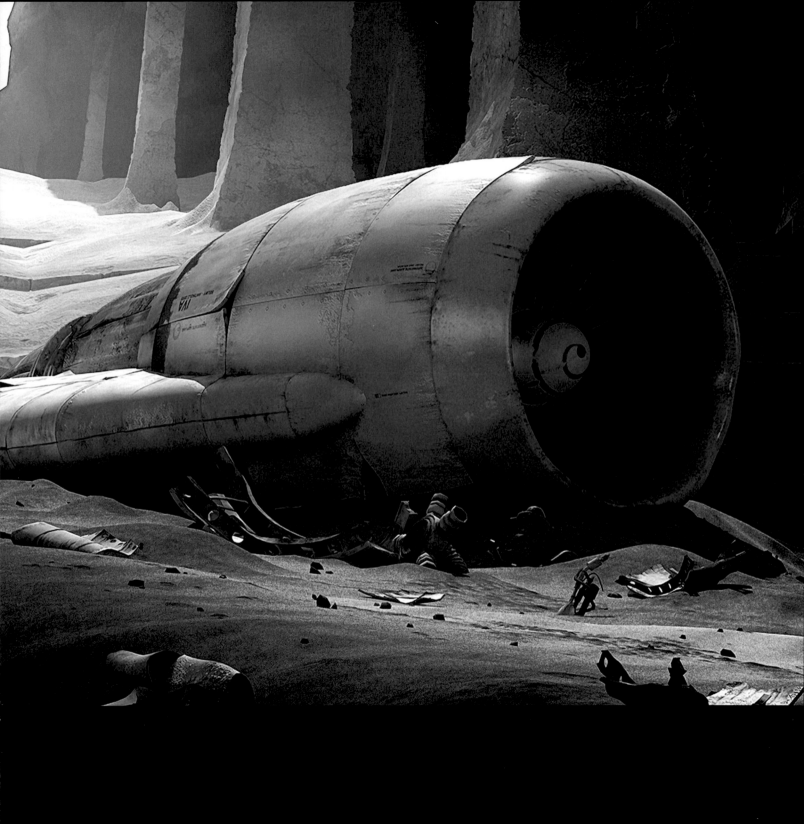

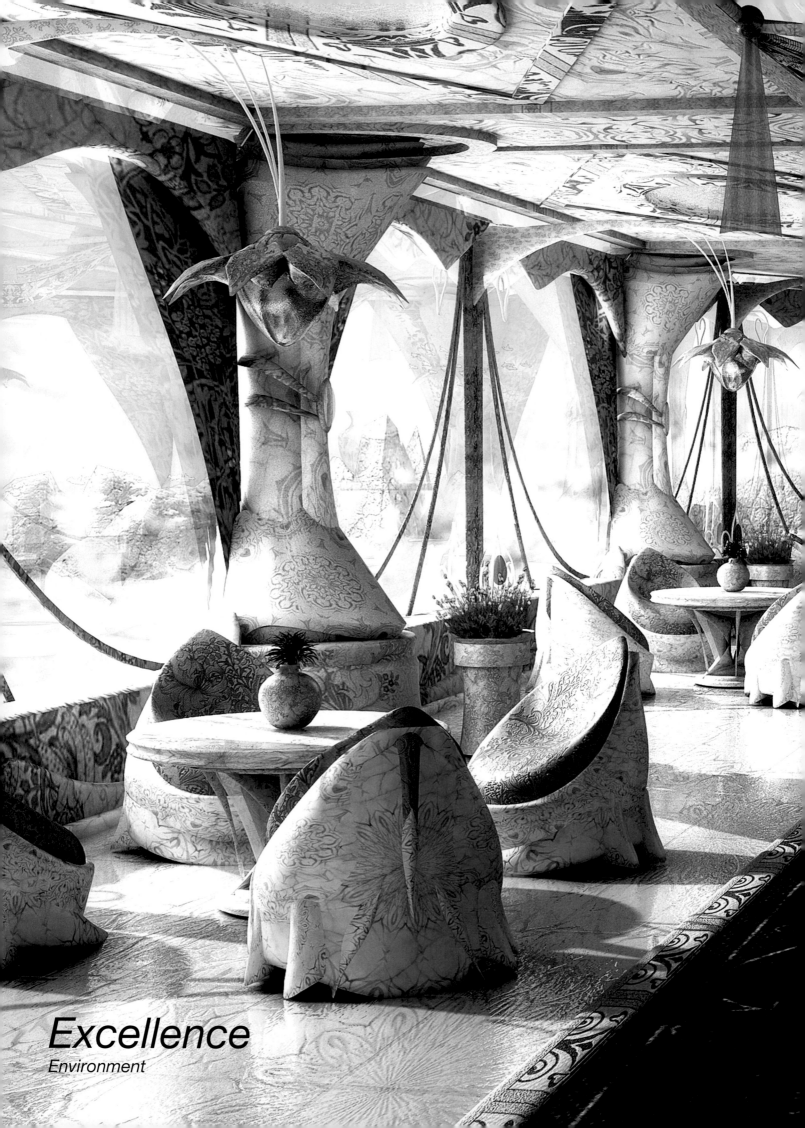

Excellence

Environment

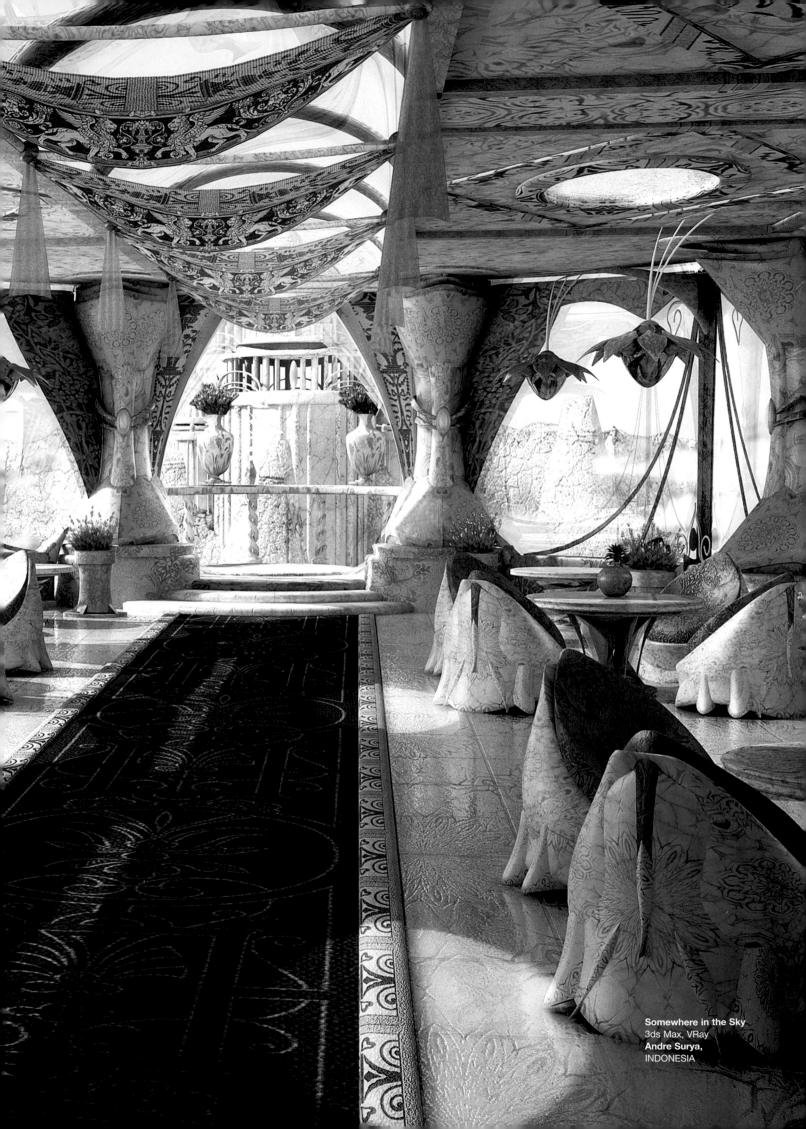

Somewhere in the Sky
3ds Max, VRay
Andre Surya,
INDONESIA

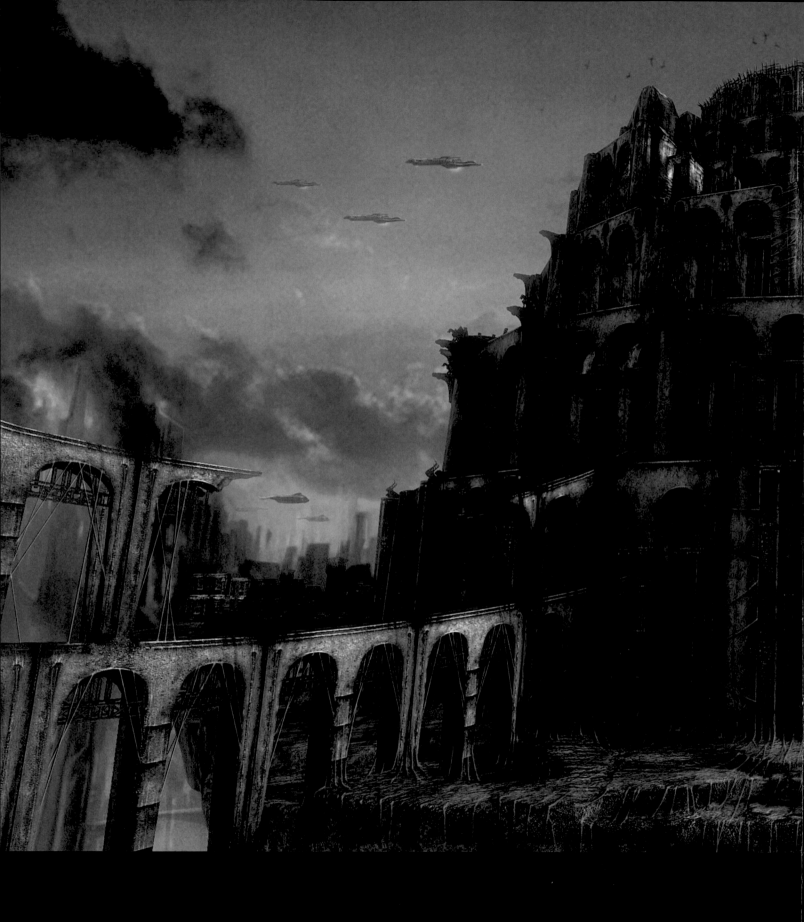

Excellence

Environment

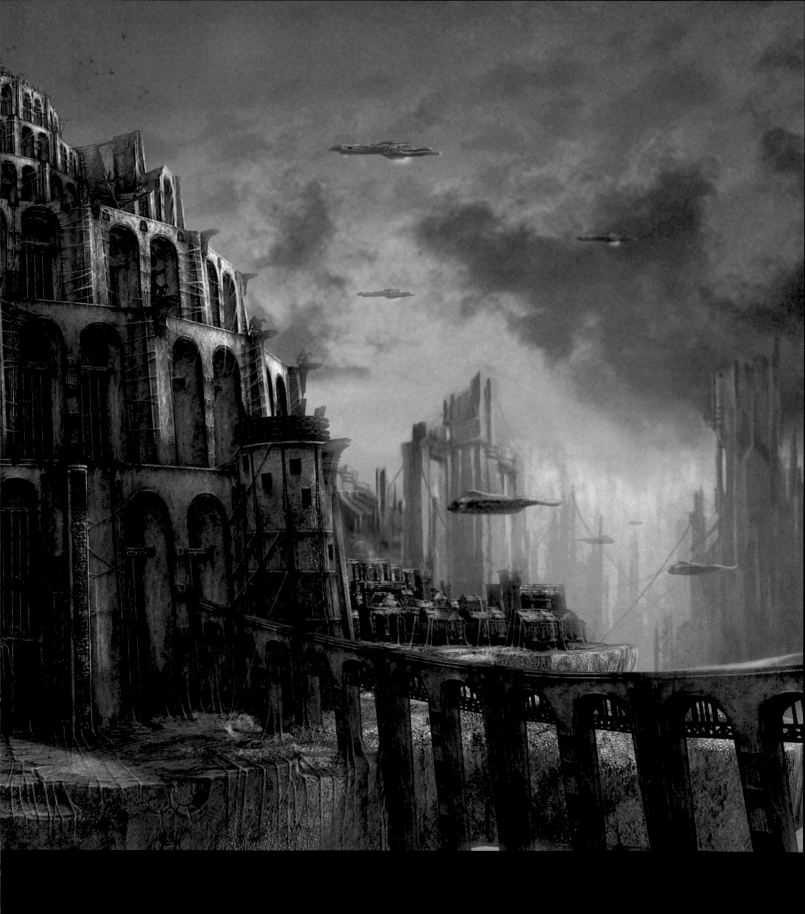

Babylon
3ds Max
Weiye Yin,
CHINA

Centuried Street
3ds Max
Weiye Yin,
CHINA
[above]

Sad Street
3ds Max, Photoshop
Çetin Tüker,
TURKEY
[left]

Holidays
3ds Max, VRay, Photoshop
Christophe Robert,
FRANCE
[right]

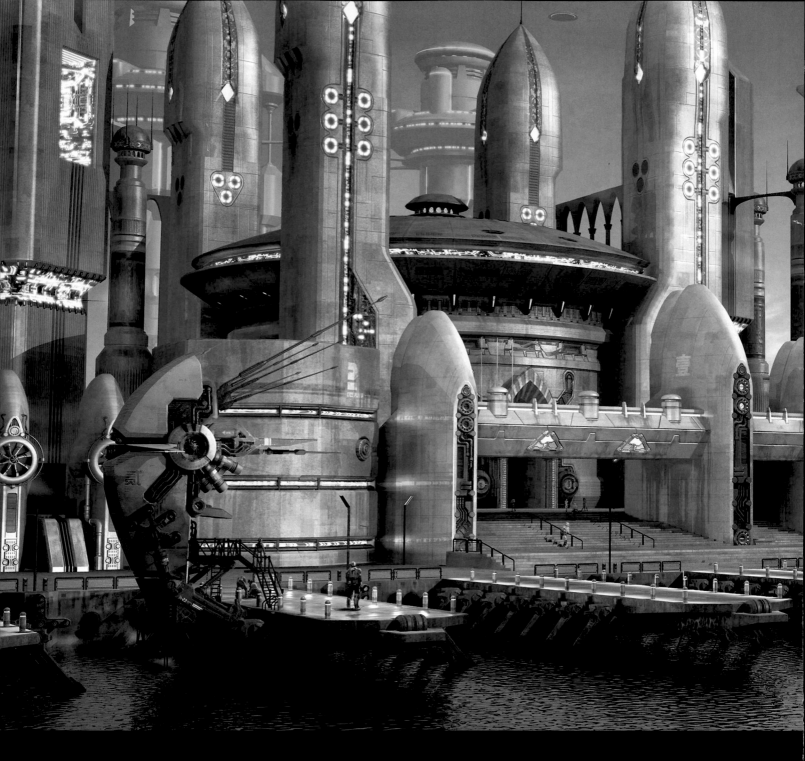

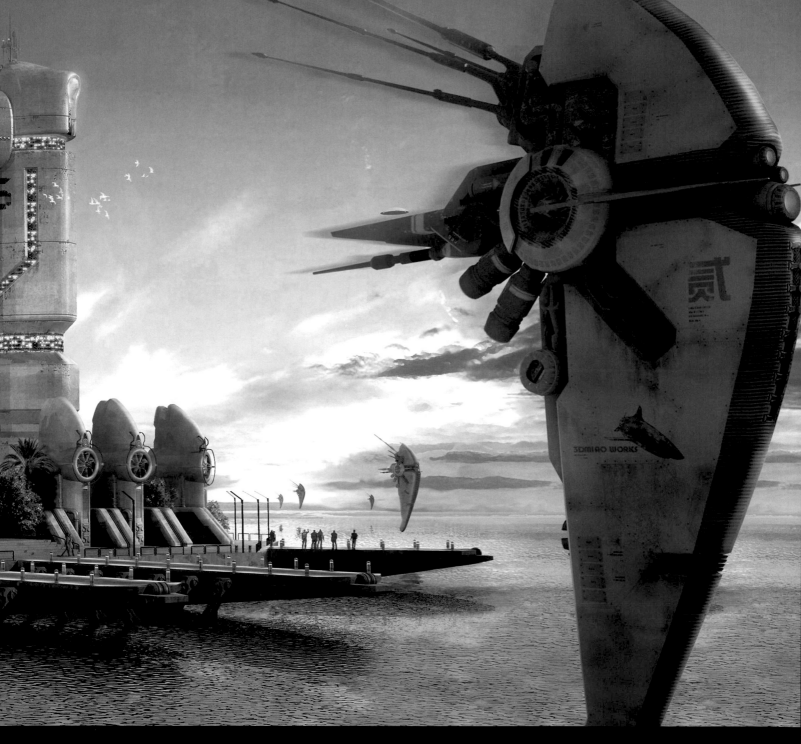

C.city
3ds Max, Photoshop, VRay
Miao He,
GERMANY

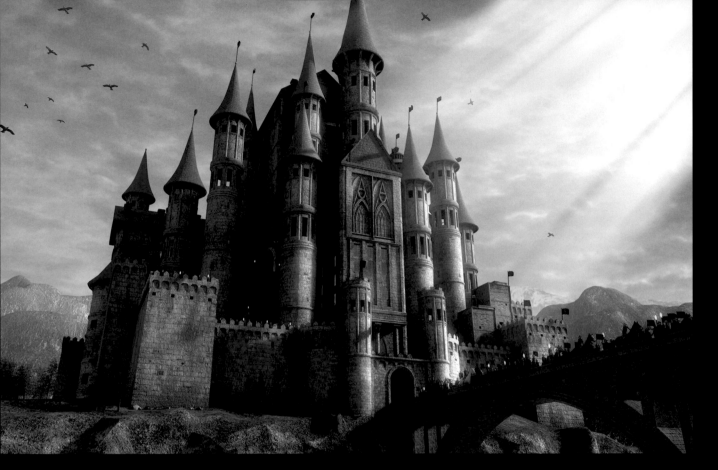

Medieval Castle
3ds Max, VRay, Photoshop
David Lavoie,
CANADA

Landscape
VRay, 3ds Max
Greg Petchkovsky, Monkeylab,
AUSTRALIA

They Came From The Sea
VIZ, PaintShop Pro
Danny Falch, 3d-empire,
DENMARK

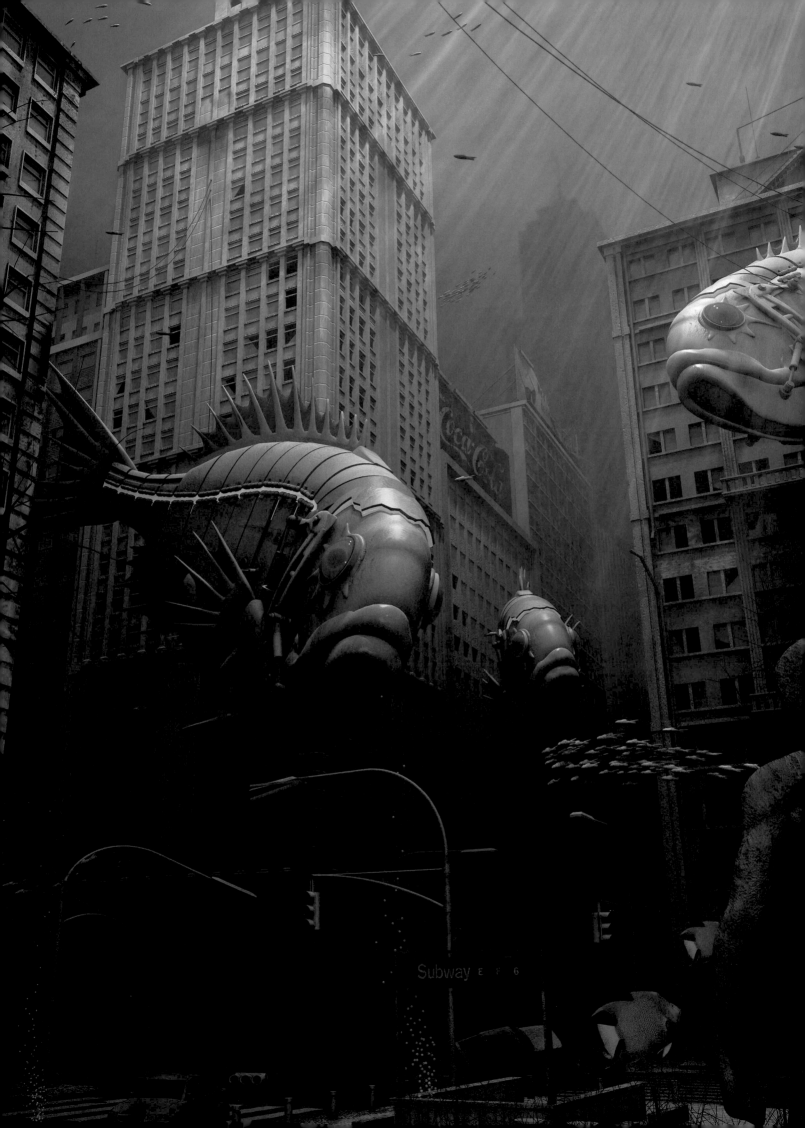

Subway E F 6

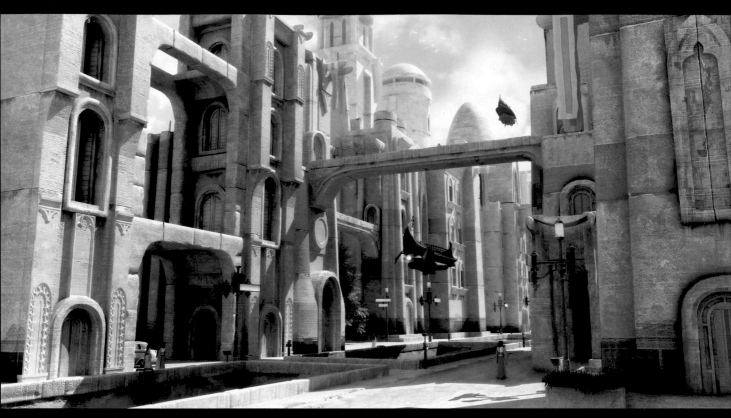

The Old City Shuyi
3ds Max, VRay, Photoshop
Wei Weihua,
CHINA
[top]

Bornes
3ds Max, Photoshop
Gregory Georges,
FRANCE
[above]

The Lost Alien World
3ds Max, Photoshop
Francesco Paduano,
Raylight Studios srl,
ITALY

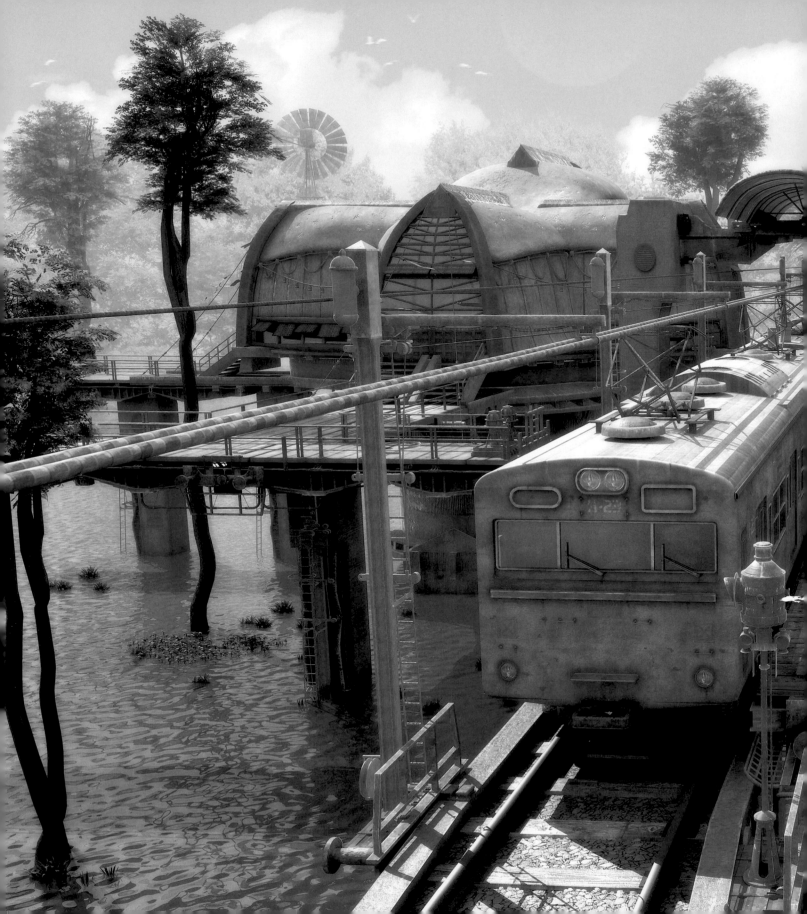

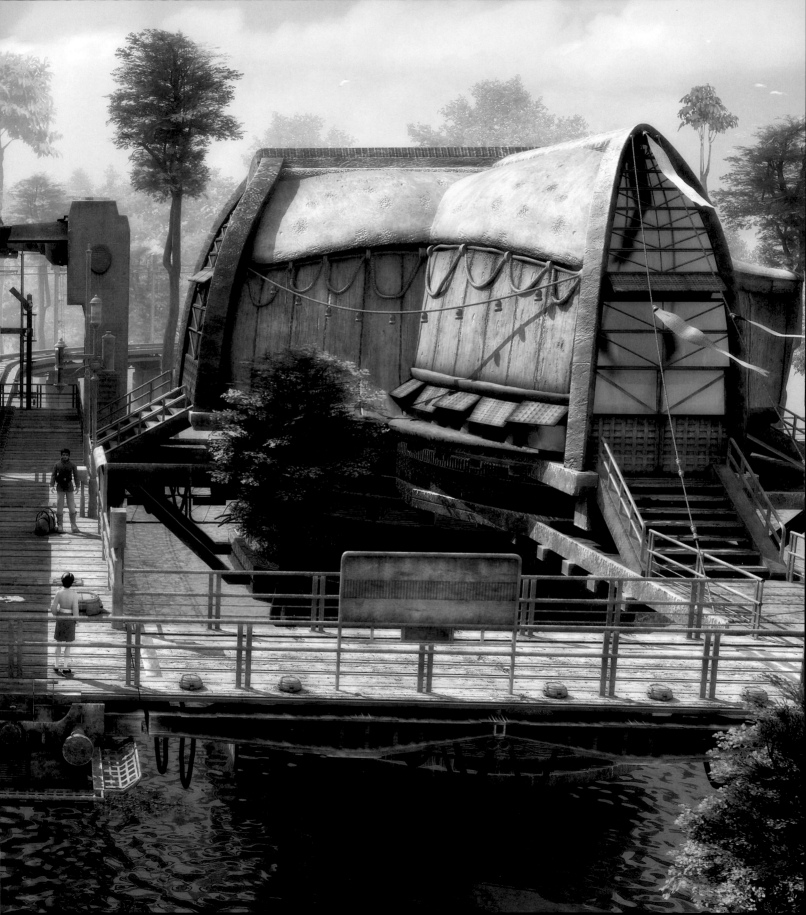

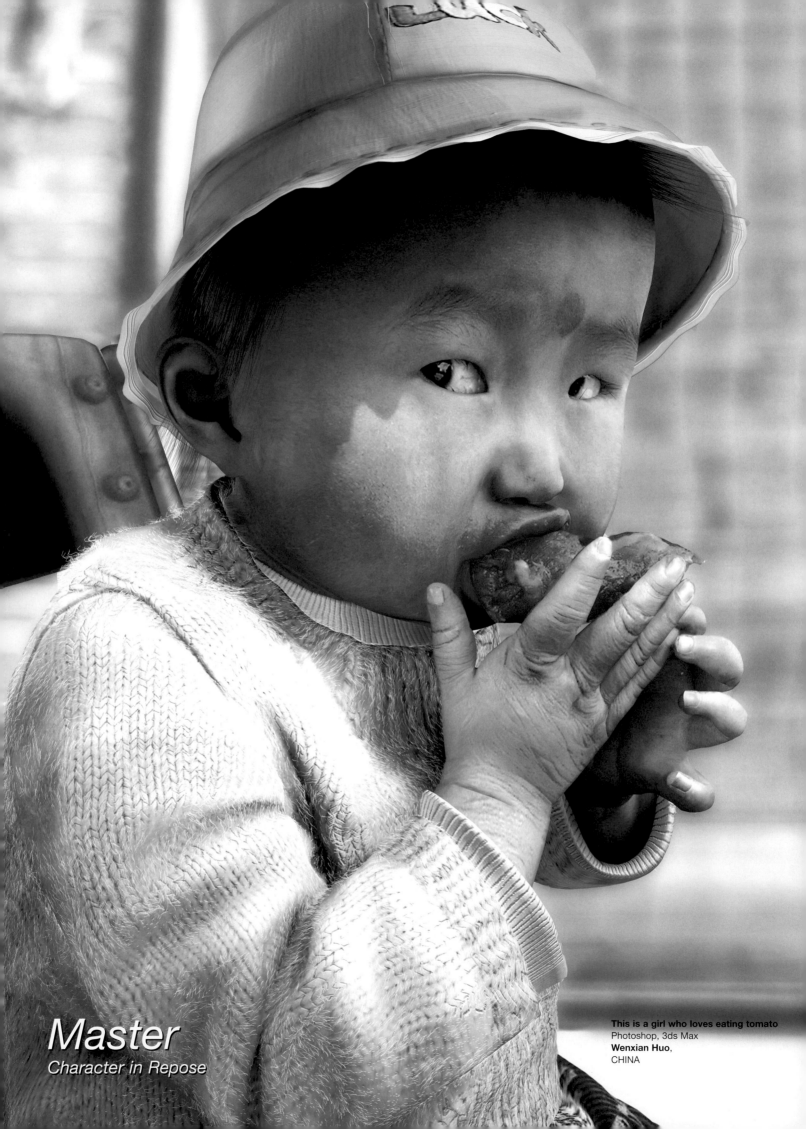

Master
Character in Repose

This is a girl who loves eating tomato
Photoshop, 3ds Max
Wenxian Huo,
CHINA

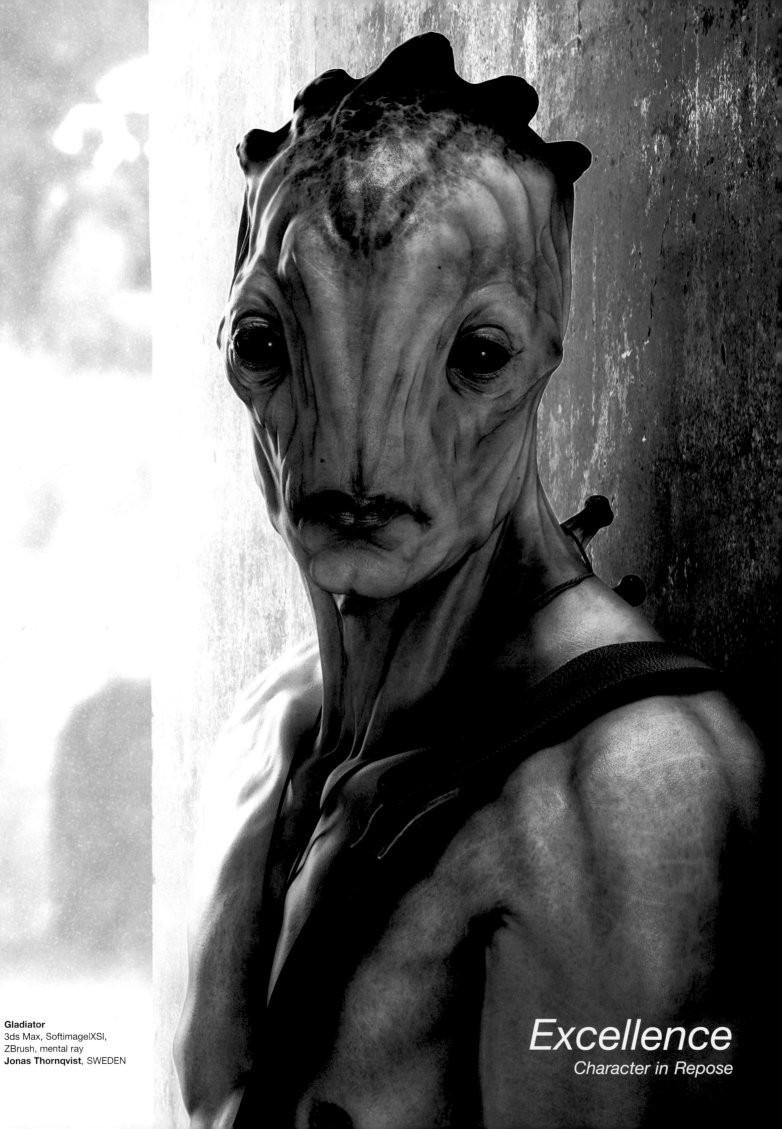

Gladiator
3ds Max, Softimage|XSI,
ZBrush, mental ray
Jonas Thornqvist, SWEDEN

Excellence
Character in Repose

Female anatomy study
3ds Max, finalRender
Marek Denko,
SLOVAK REPUBLIC
[above]

Inaé
3ds Max
Olivier Ponsonnet,
FRANCE
[left]

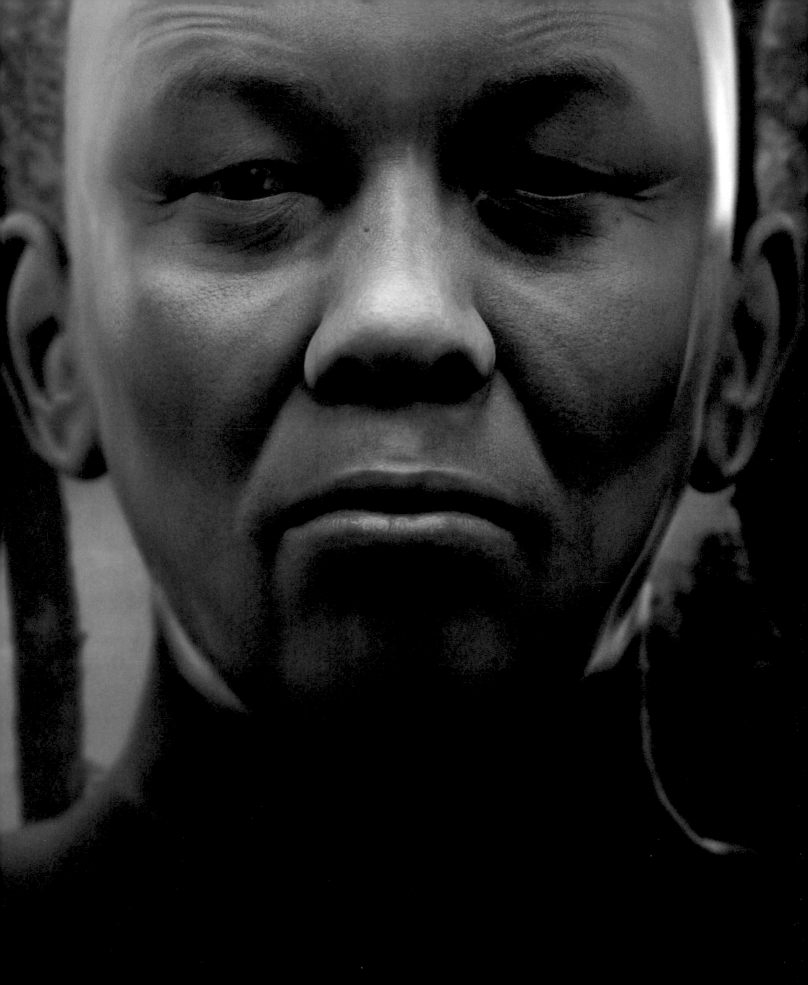

Excellence
Character in Repose

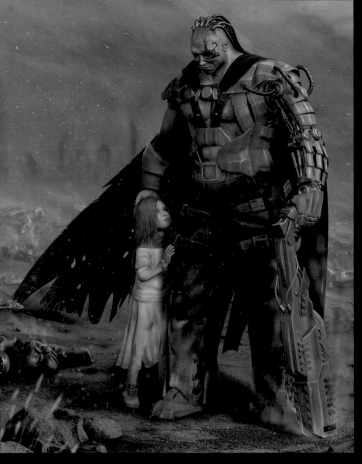

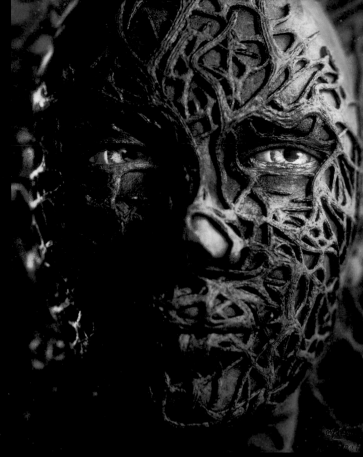

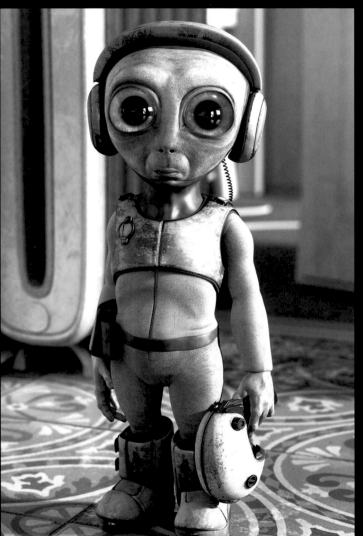

Fate
3ds Max, Photoshop
Zubuyer Kaolin,
BANGLADESH
[above left]

Tree Face
Digital Fusion, 3ds Max
Greg Petchkovsky, Monkeylab,
AUSTRALIA
[above]

Small Invader
3ds Max, Photoshop, VRay
Fred Bastide,
SWITZERLAND
[left]

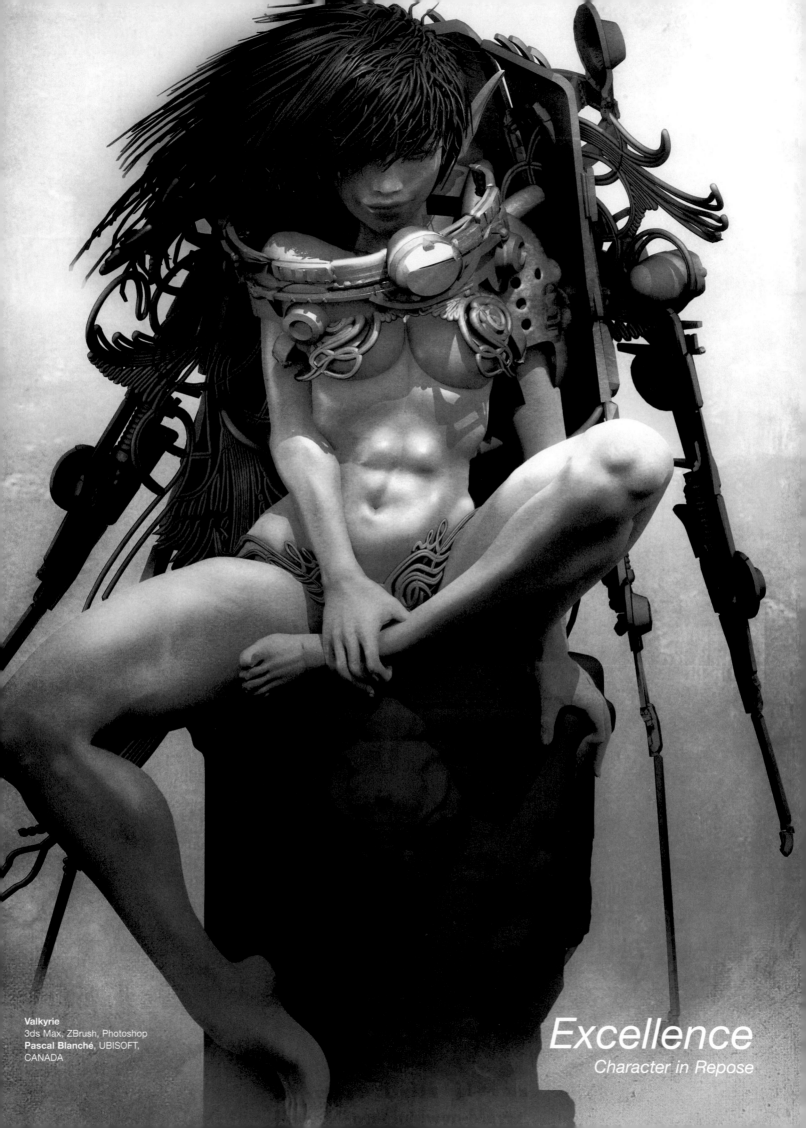

Valkyrie
3ds Max, ZBrush, Photoshop
Pascal Blanché, UBISOFT,
CANADA

Excellence
Character in Repose

My Lovely Whore, Miss Burton
3ds Max, mental ray, Photoshop
Jonathan Simard, Ubisoft Montréal,
CANADA
[above left]

Eva Byte
3ds Max, Brazil r/s
**Marcio Bukowski, Alex Paiva,
Luiz Amaral and Thiago Pires**, TV Globo,
BRAZIL
[above]

Ms.Crabapple
3ds Max, Photoshop
Tony Mesiatowsky,
CANADA
[left]

Kill The Chicken
ZBrush, Brazil r/s, 3ds Max, Photoshop
Laurent Pierlot, Blur Studio,
USA
[right]

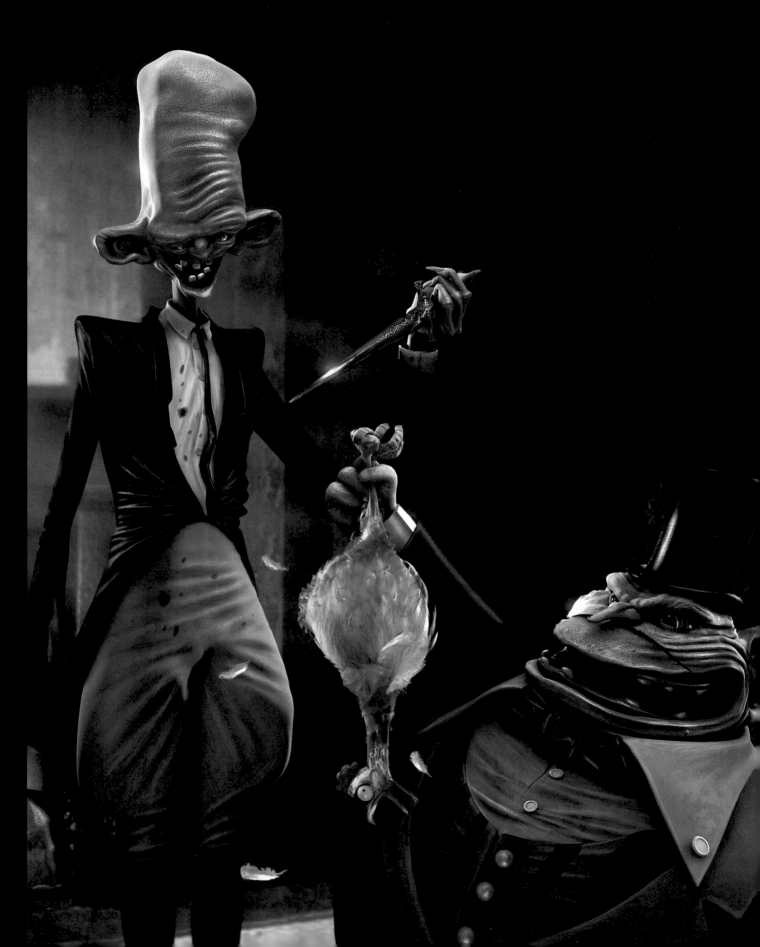

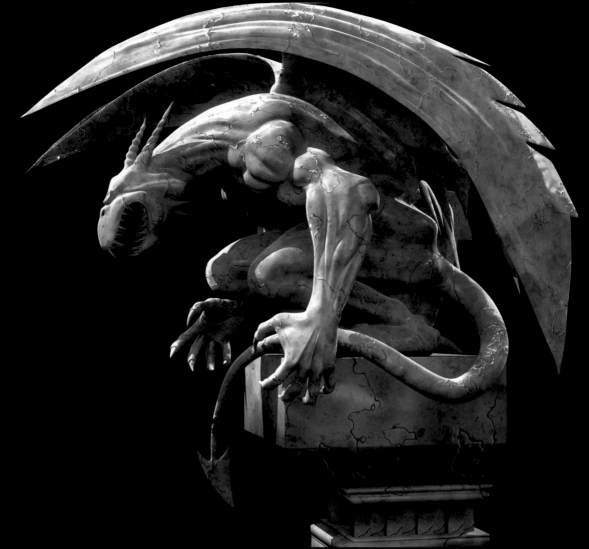

Gargoyle
3ds Max, Photoshop
Client: Blue Dream Studios
Peter Starostin, USA
[top]

QP2
3ds Max, Photoshop
Cyril Verrier,
FRANCE
[above]

Heady
3ds Max, Photoshop, ZBrush
Jocelyn Da Prato, Ubisoft Montréal,
CANADA
[above]

Hellgate: London -
Female Templar Full Armor
3ds Max, Brazil r/s, Digital Fusion
Client: Flagship Studios,
Blur Studio Inc., USA

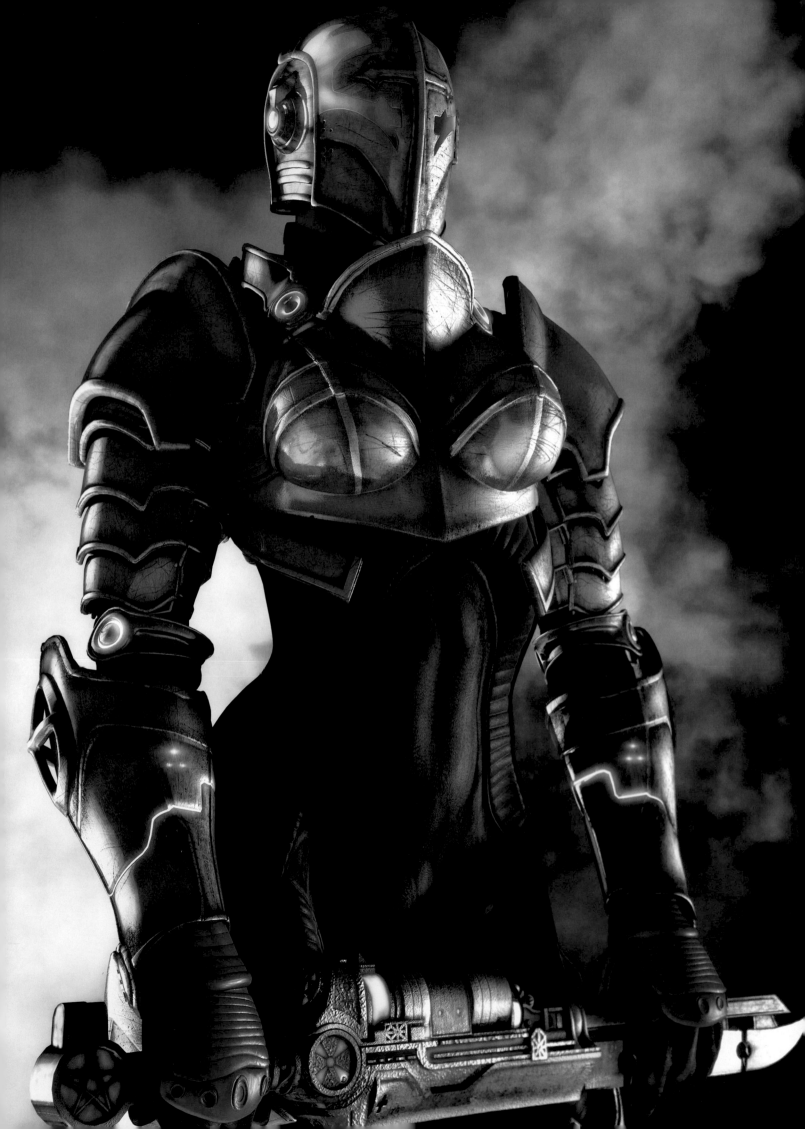

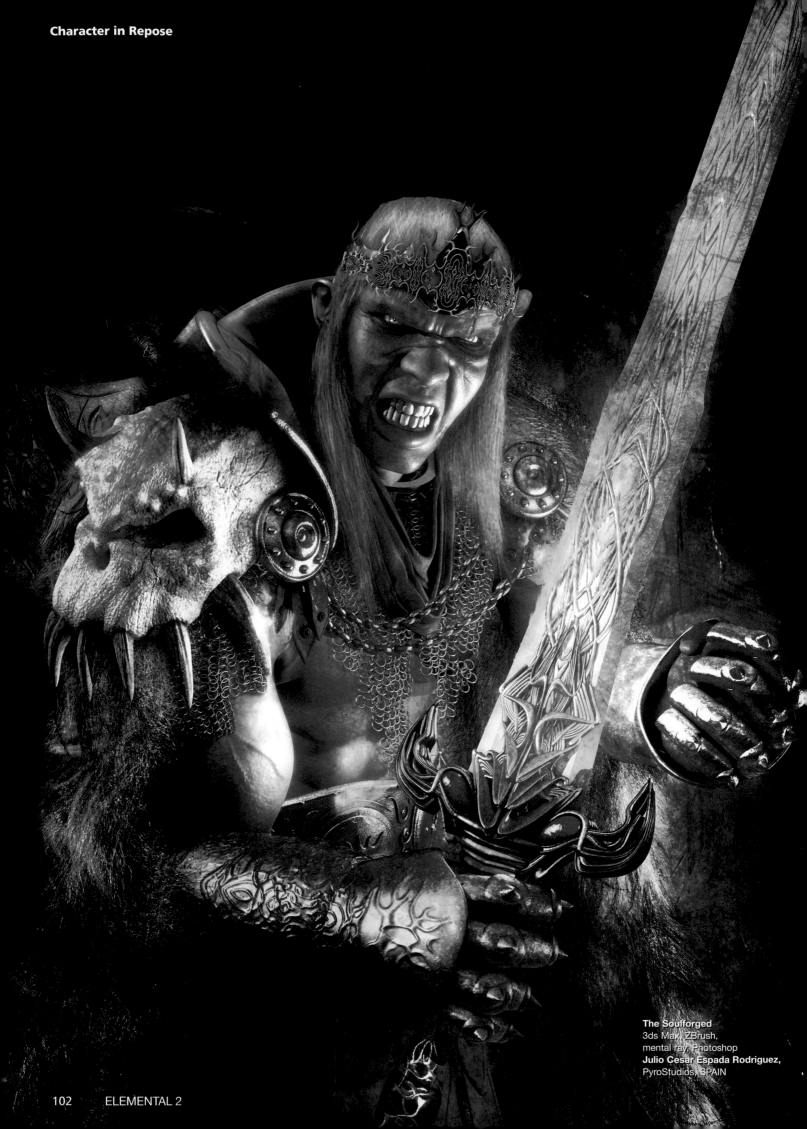

The Soulforged
3ds Max, ZBrush,
mental ray, Photoshop
Julio Cesar Espada Rodriguez,
PyroStudios, SPAIN

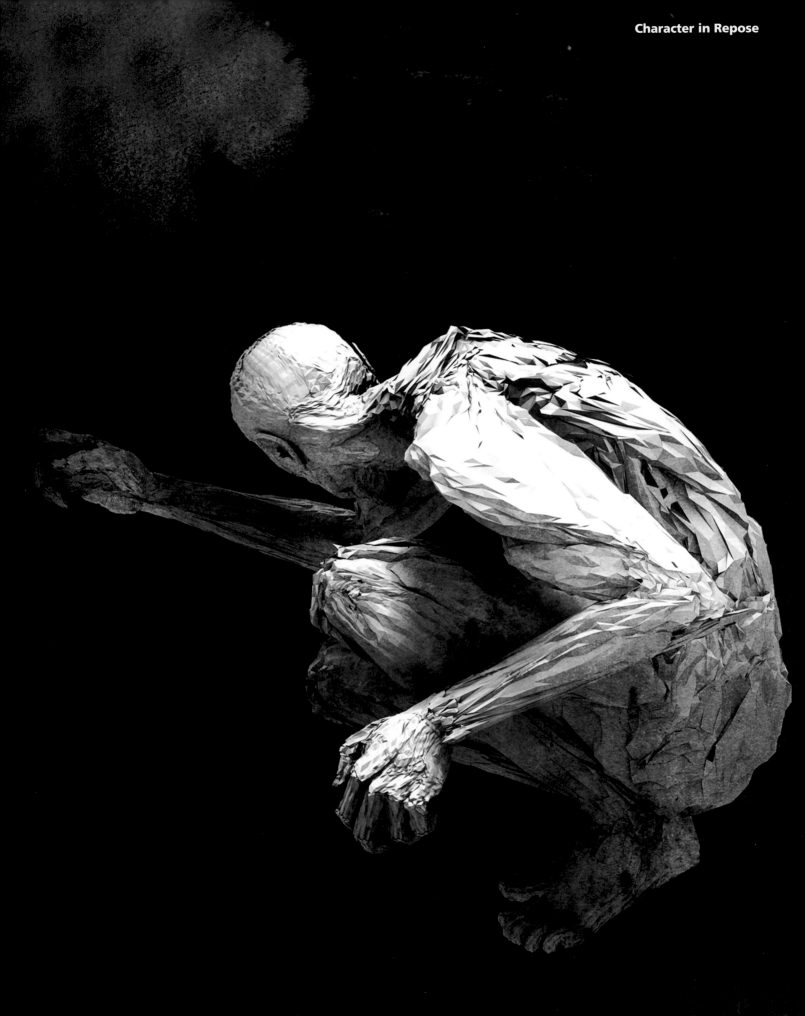

Chrysalide
3ds Max, Combustion
Damien Serban and Yann Bertrand,
FRANCE

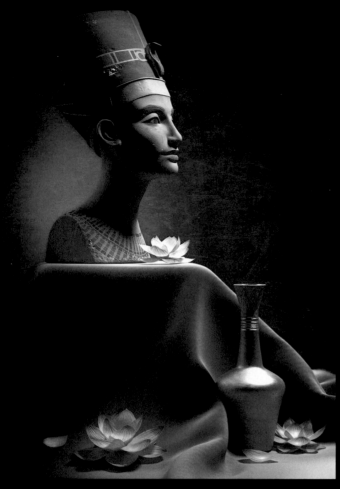

Ancient Beauty
3ds Max, VRay, Photoshop
Zoltán Pogonyi,
HUNGARY
[above left]

Dowager
3ds max
Jiri Adamec,
CZECH REPUBLIC
[above]

My Uncle Cthulhu
3ds Max, Photoshop, VRay
Fred Bastide,
SWITZERLAND
[left]

Pink Sugar
3ds Max
Olivier Ponsonnet,
FRANCE
[right]

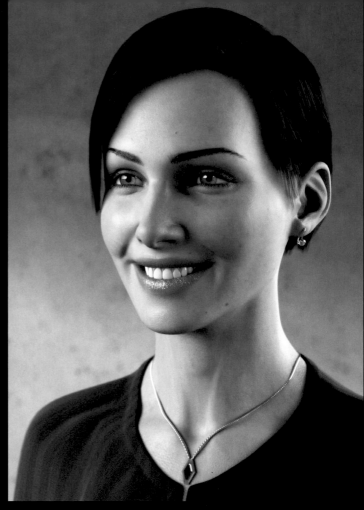

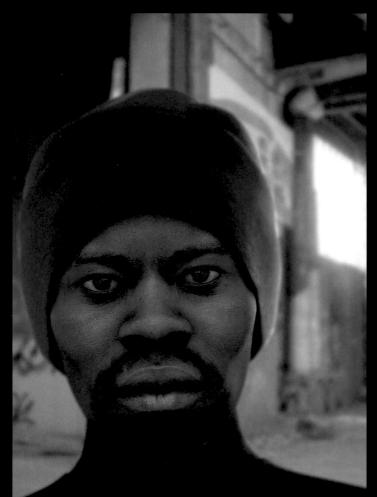

ReVisions
3ds Max, Photoshop
Kenn Brown and Chris Wren,
Mondolithic Studios,
CANADA
[above left]

Sandra
3ds Max, Photoshop
Mihai Anghelescu,
ROMANIA
[above]

Friday
3ds Max, Photoshop
Alexis Smadja,
FRANCE
[left]

Pétales de Lune
3ds Max
Olivier Ponsonnet,
FRANCE
[right]

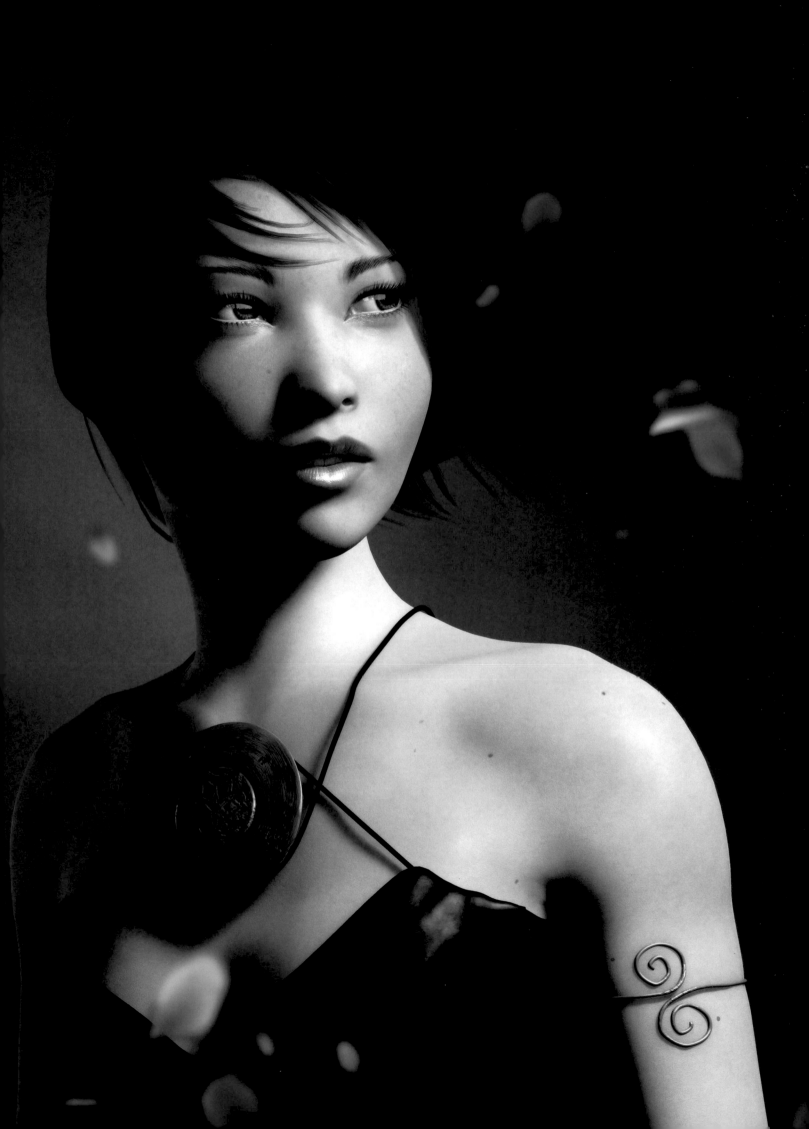

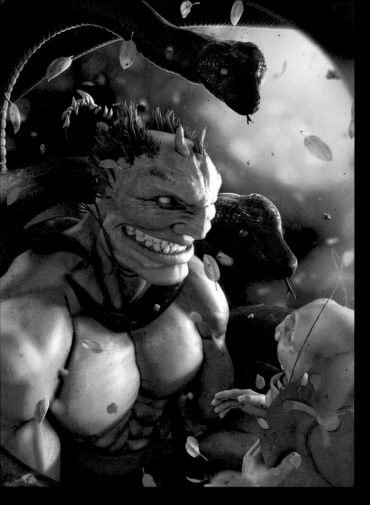

Molnar, the saver
3ds Max, Photoshop, ZBrush
Jocelyn Da Prato, Ubisoft Montréal,
CANADA
[above left]

Biker
3ds Max, Combustion, Photoshop
Andrea Bertaccini, Tredistudio,
ITALY
[above]

Sissi princess
3ds Max, Photoshop, Brazil r/s
Baolong Zhang, Ubisoft (Shanghai),
CHINA
[left]

Urban Sniper
3ds Max, Brazil r/s, Photoshop
Nareg Kalenderian,
LEBANON
[right]

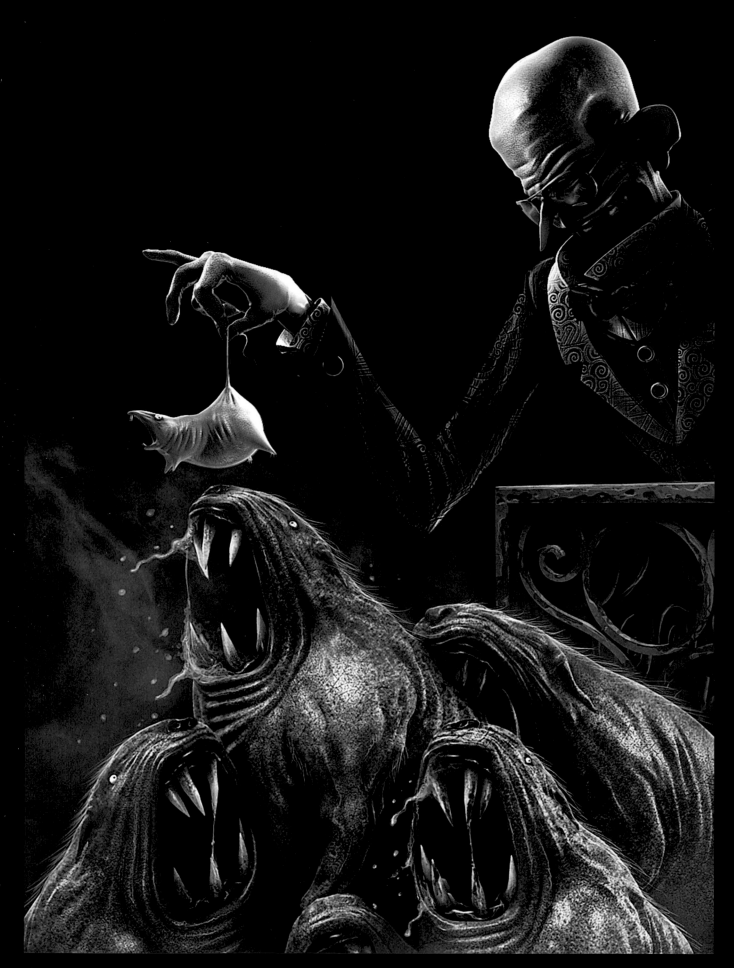

Master
Character in Action

Dogs
ZBrush, 3ds Max, Brazil r/s, Photoshop
Laurent Pierlot, Blur Studio Inc.,
USA

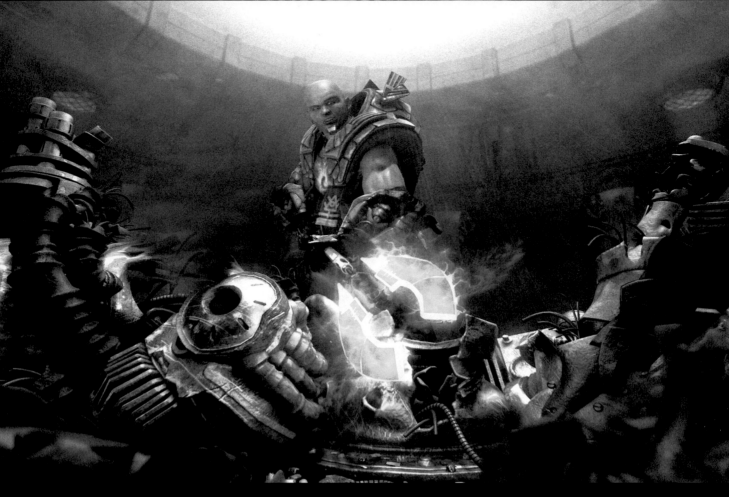

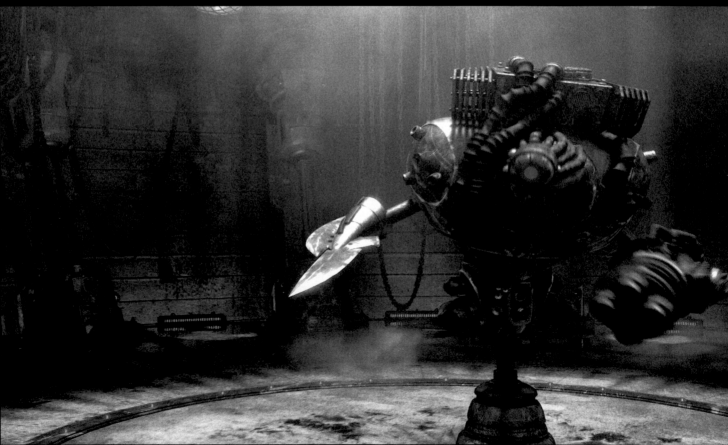

Unreal TV Spot
3ds Max, Digital Fusion, Photoshop
Client: Unreal TV
Blur Studio Inc., USA

Excellence
Character in Action

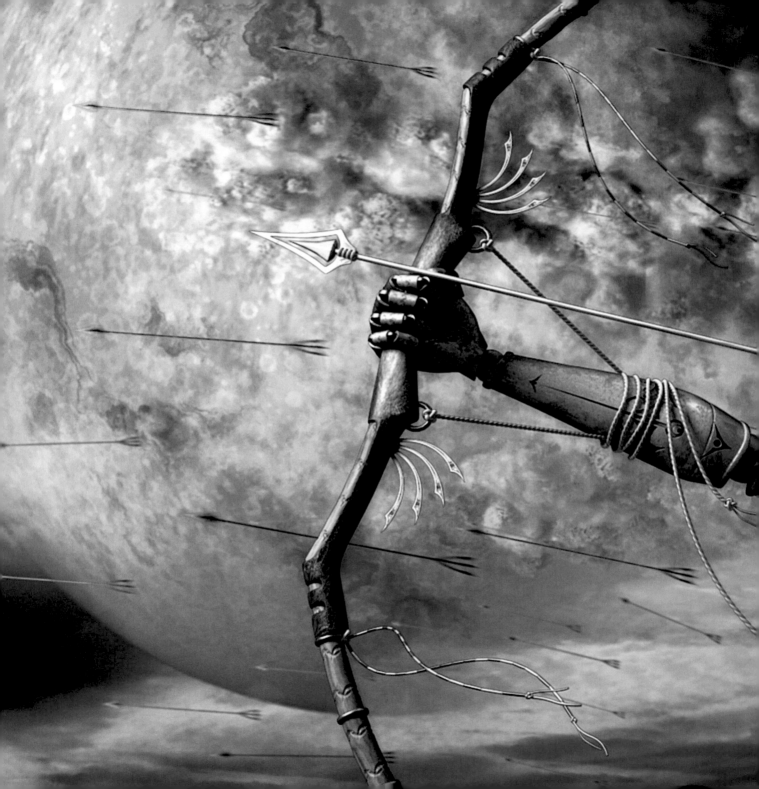

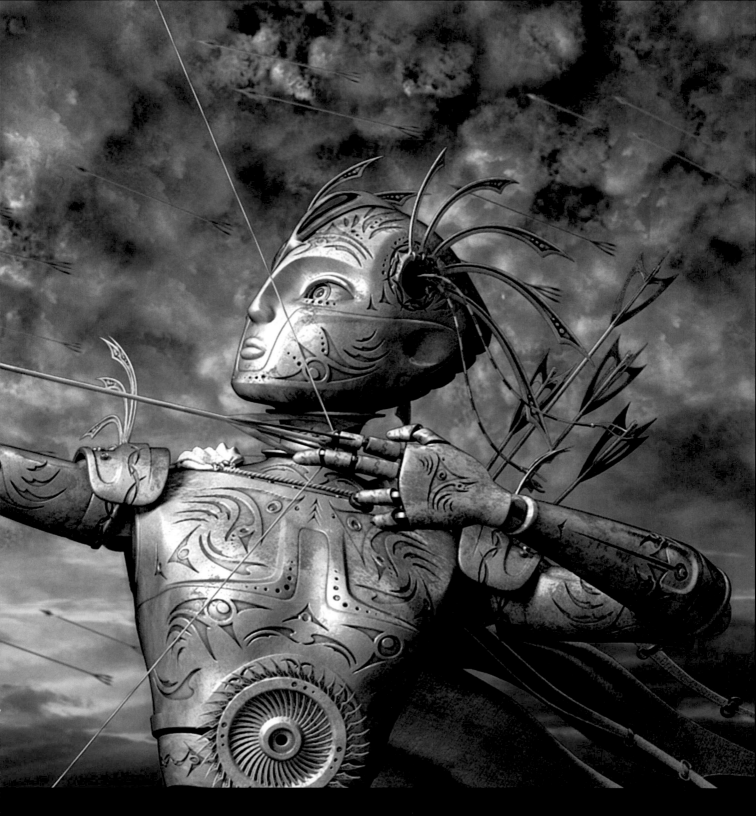

The Escape
3ds Max, Photoshop
Julien Ollier,
FRANCE
[above]

Desperados
3ds Max
**Virgin Lands Animated Pictures
GmbH**, GERMANY
[left]

**Warhammer 40k,
Dawn of War opening cinematic**
3ds Max, Digital Fusion, Photoshop
Blur Studio Inc.,
USA
[right series]

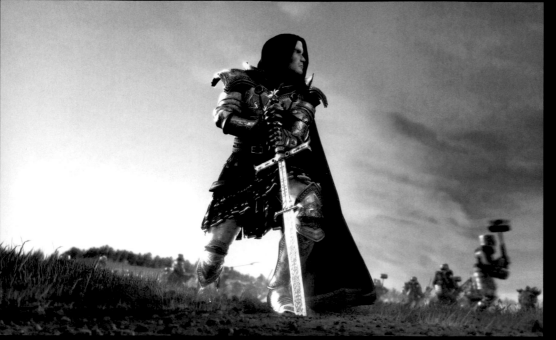

Prince Thrommel
3ds Max, VRay, Photoshop
Client: Troika Games for Atari
Michael Tigar and Dave Hare,
Tigar Hare Studios,
USA
[left]

Tin Knight
3ds Max
Fabio Oscar Corica,
ITALY
[right]

Fairy World
3ds Max
Olivier Ponsonnet,
FRANCE
[left]

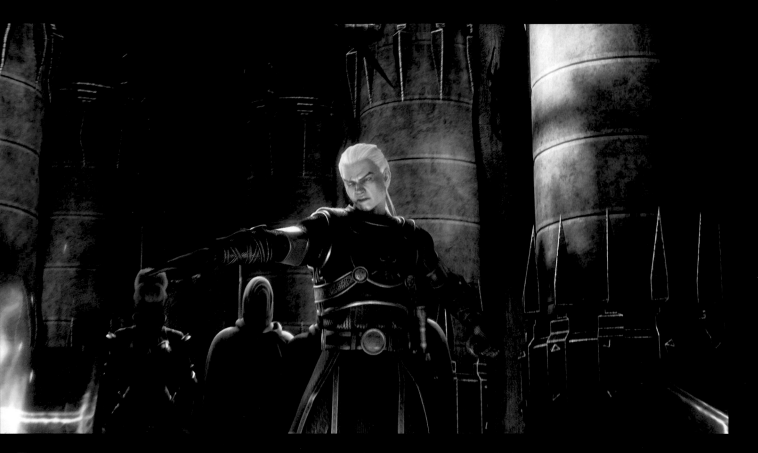

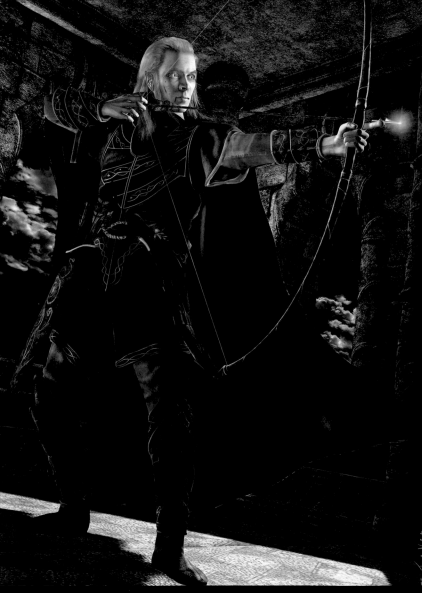

Everquest 2 Trailer
3ds Max, Digital Fusion, Photoshop
Blur Studio, Inc.,
USA
[above]

Elf hero
3ds Max, Photoshop
Norbert Fuchs,
HUNGARY
[left]

The final steps of Lord Kagekatsu
3ds Max, Photoshop
Alexander Preuss,
GERMANY
[right]

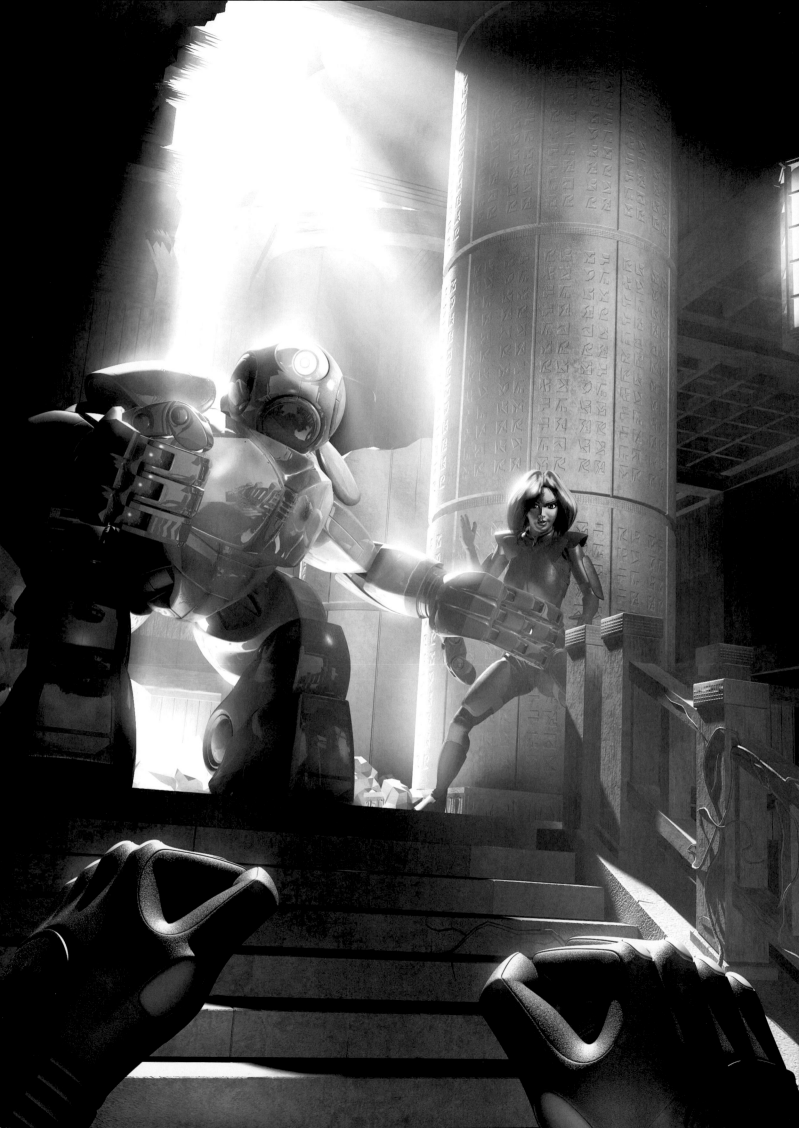

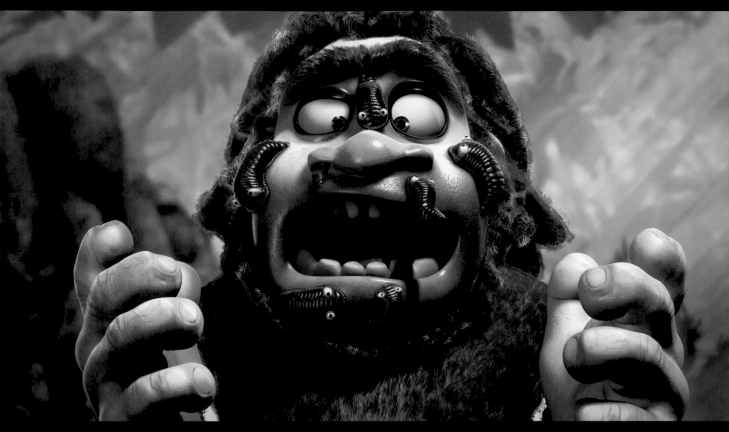

In The Rough
3ds Max, Digital Fusion, Photoshop
Blur Studio Inc.,
USA
[*above series*]

Gopher Broke
3ds Max, Digital Fusion, Photoshop
Blur Studio, Inc.,
USA
[above series]

Chauliodus sp.
3ds Max, Photoshop
Joana Garrido,
PORTUGAL

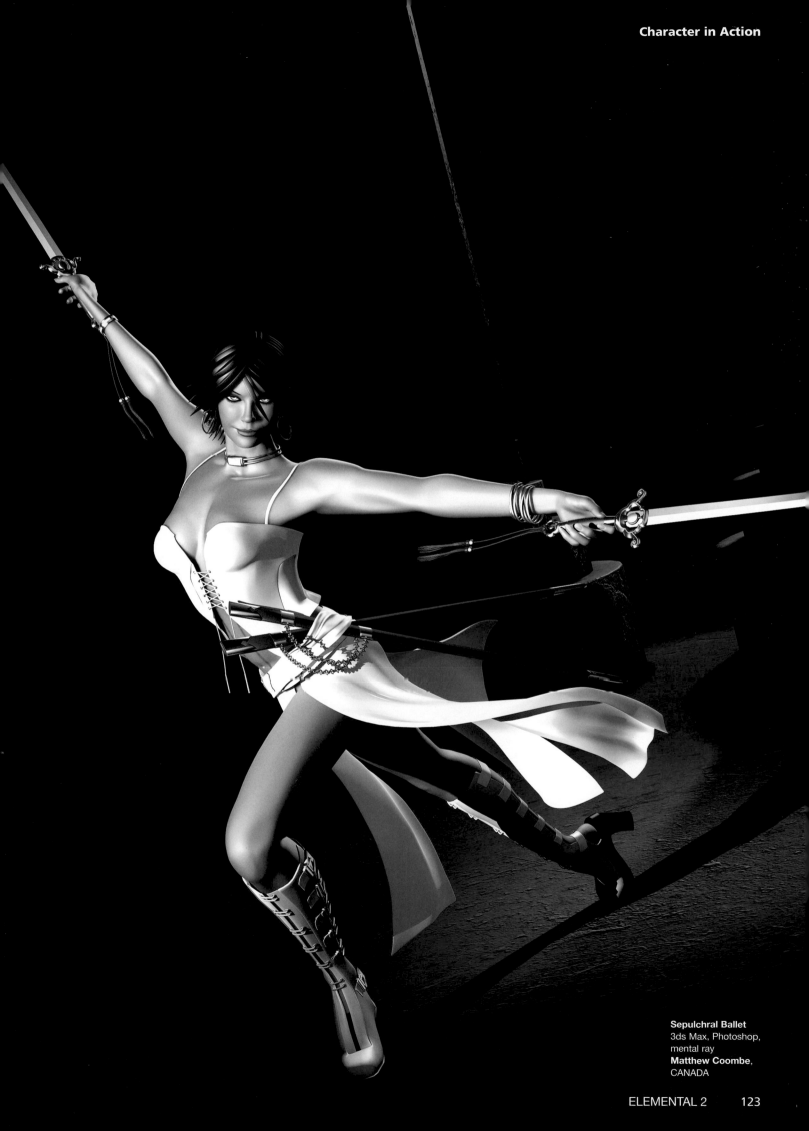

Sepulchral Ballet
3ds Max, Photoshop,
mental ray
Matthew Coombe,
CANADA

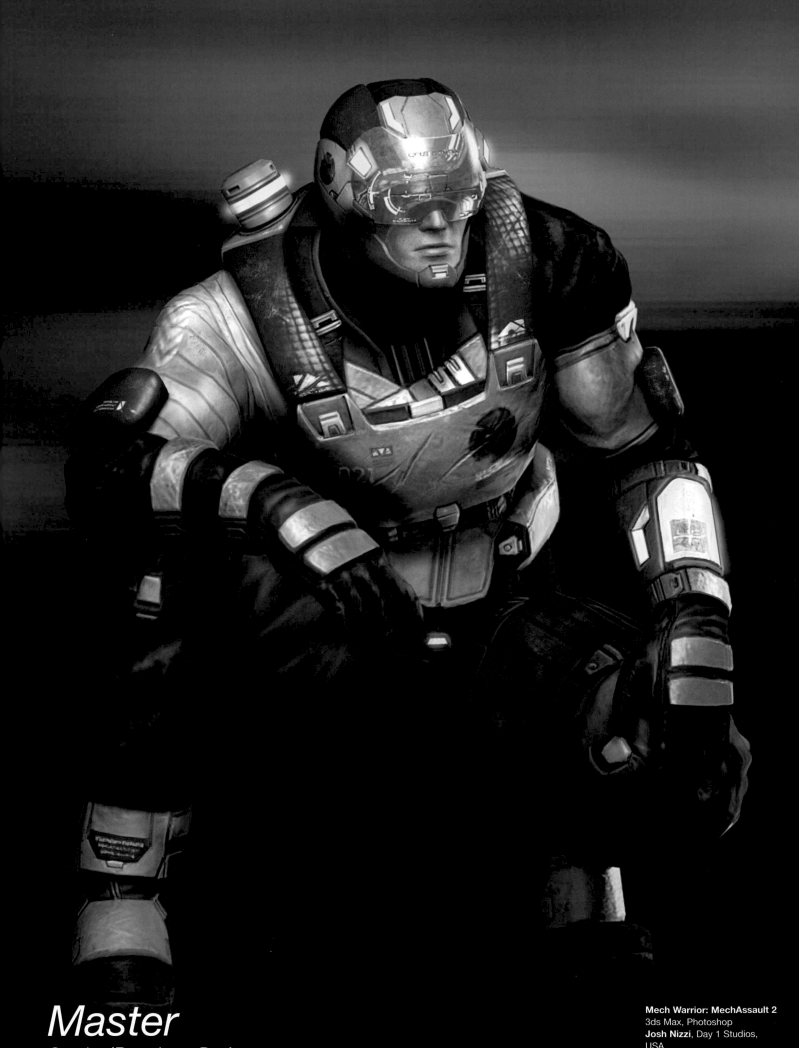

Master
Gaming/Broadcast Design

Mech Warrior: MechAssault 2
3ds Max, Photoshop
Josh Nizzi, Day 1 Studios,
USA

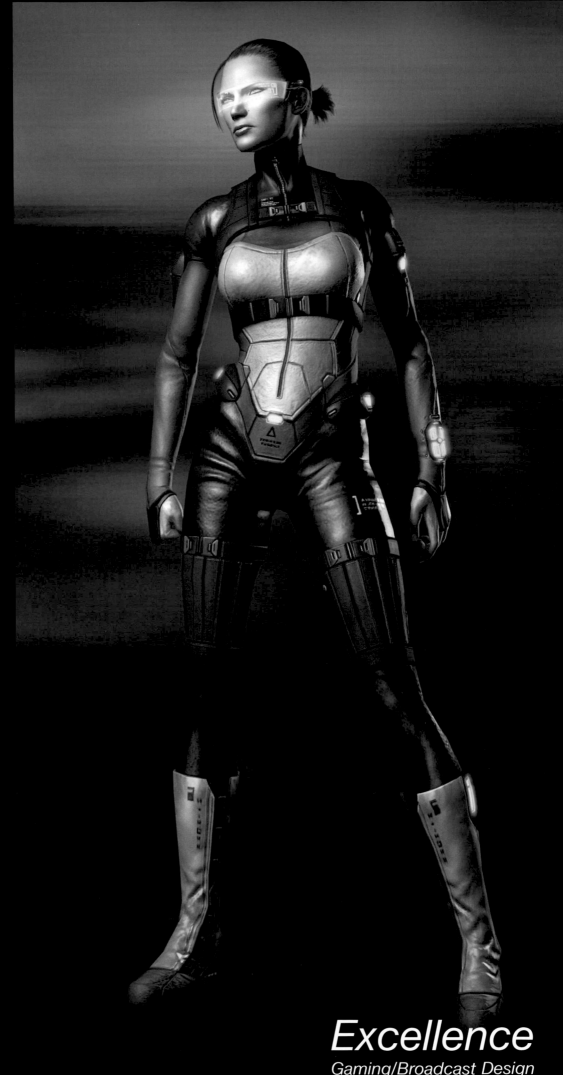

Natalia Pilot Uniform: MechAssault 2
3ds Max, Photoshop
Josh Nizzi, Day 1 Studios,
USA

Excellence

Gaming/Broadcast Design

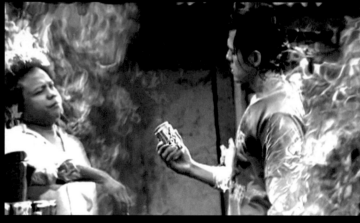

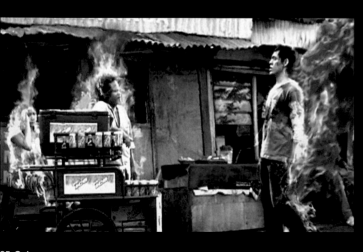

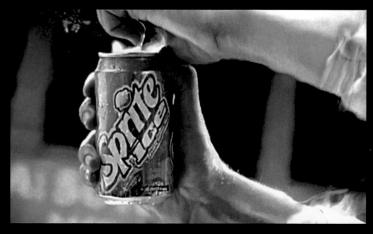

35-Calo
3ds Max, After Effects
Thierry Canon, Specimen,
FRANCE

Sprite Ice
Inferno
Rohit Misra,
INDONESIA

Mexus Marines
3ds Max, Photoshop
Antonio Avila Membrives,
Studio Stortuga,
SPAIN

Excellence

Gaming/Broadcast Design

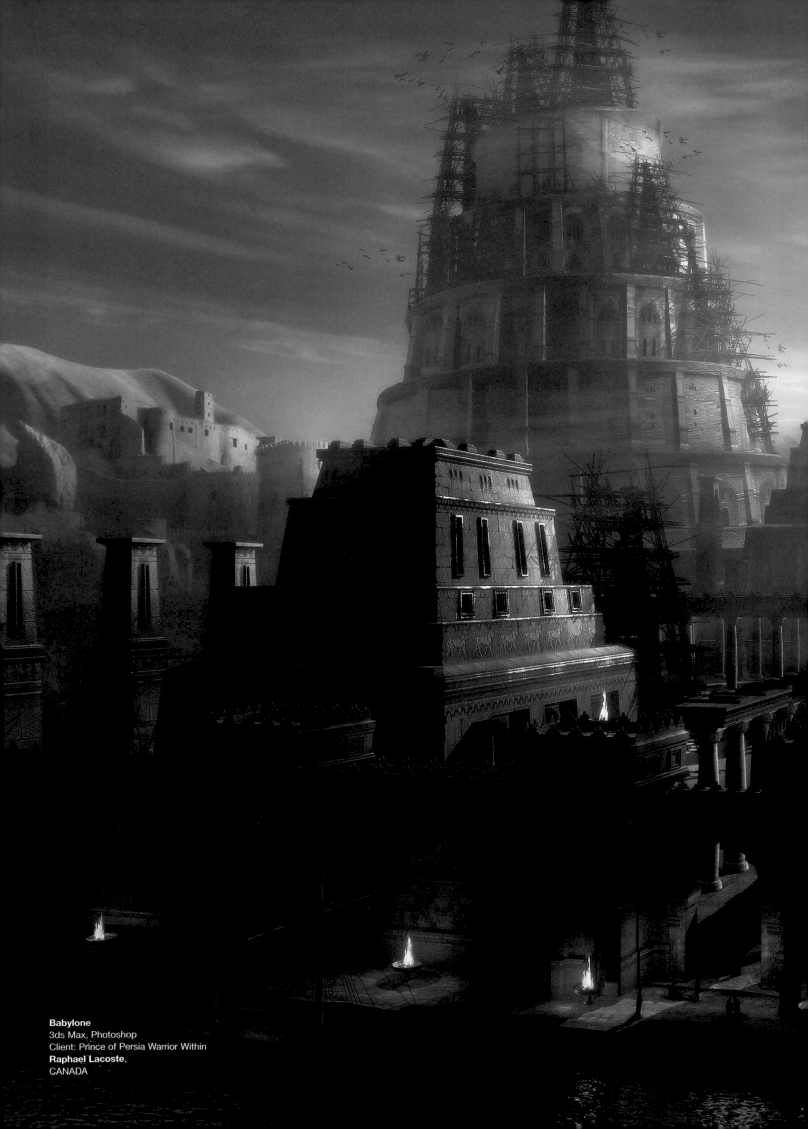

Babylone
3ds Max, Photoshop
Client: Prince of Persia Warrior Within
Raphael Lacoste,
CANADA

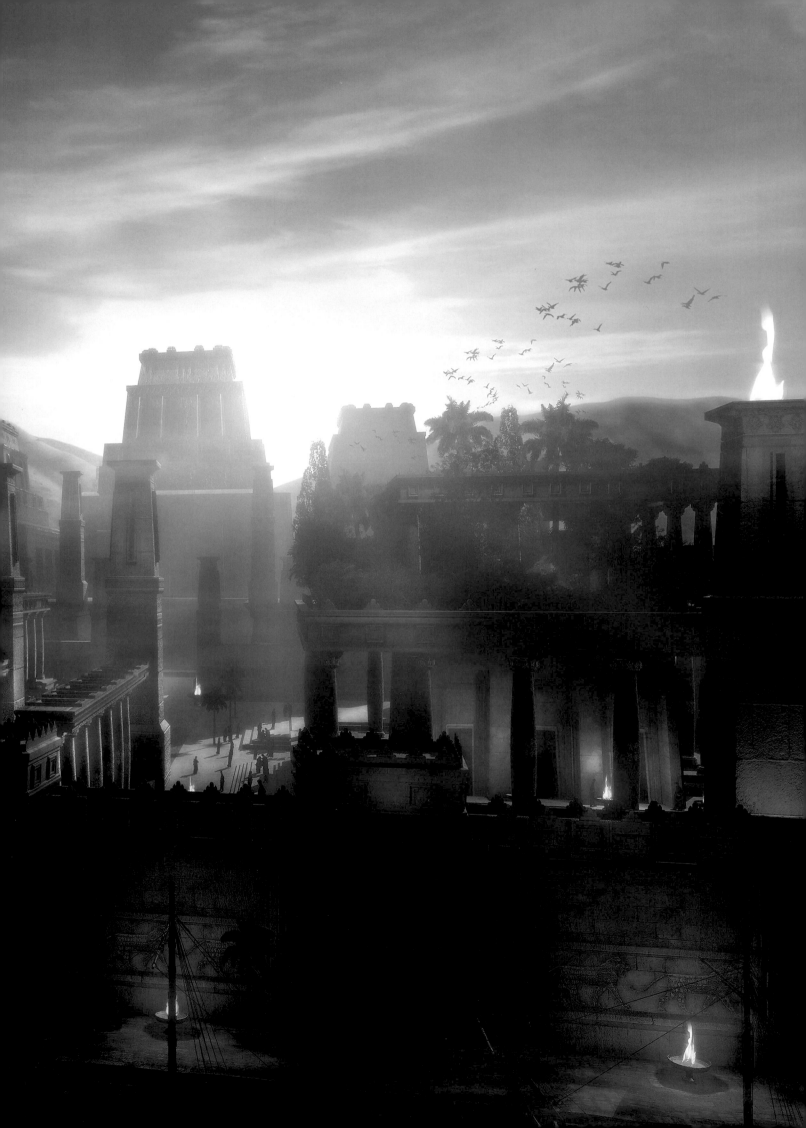

Warhammer 40k:
Dawn of War opening cinematic
3ds Max, Digital Fusion, Photoshop
Blur Studio, Inc.,
USA
[left series]

Shattered Union 01
3ds Max, Photoshop
Todd Bergantz, Steve Mohesky,
Arne Schmidt, Brian Feldges
and Nathan Harris,
PopTop Software, Inc.,
USA
[right]

San Guo
3ds Max
Weiye Yin,
CHINA
[above series]

Women of MechAssault 2
3ds Max, Photoshop
Josh Nizzi, Day 1 Studios,
USA

General Morder
3ds Max, ZBrush, Photoshop
Shawn Woods, Relic Entertainment,
CANADA
[top left]

Adrienne - The Outfit
3ds Max, ZBrush, Photoshop
Claire Roberts, Relic Entertainment,
CANADA
[above]

Allies Scout - The Outfit
3ds Max, ZBrush, Photoshop
Shawn Woods, Relic Entertainment,
CANADA
[left]

Alexander the Great
Photoshop, 3ds Max, ZBrush
Copyright Firaxis Games, Inc.
Ryan Murray,
USA
[right]

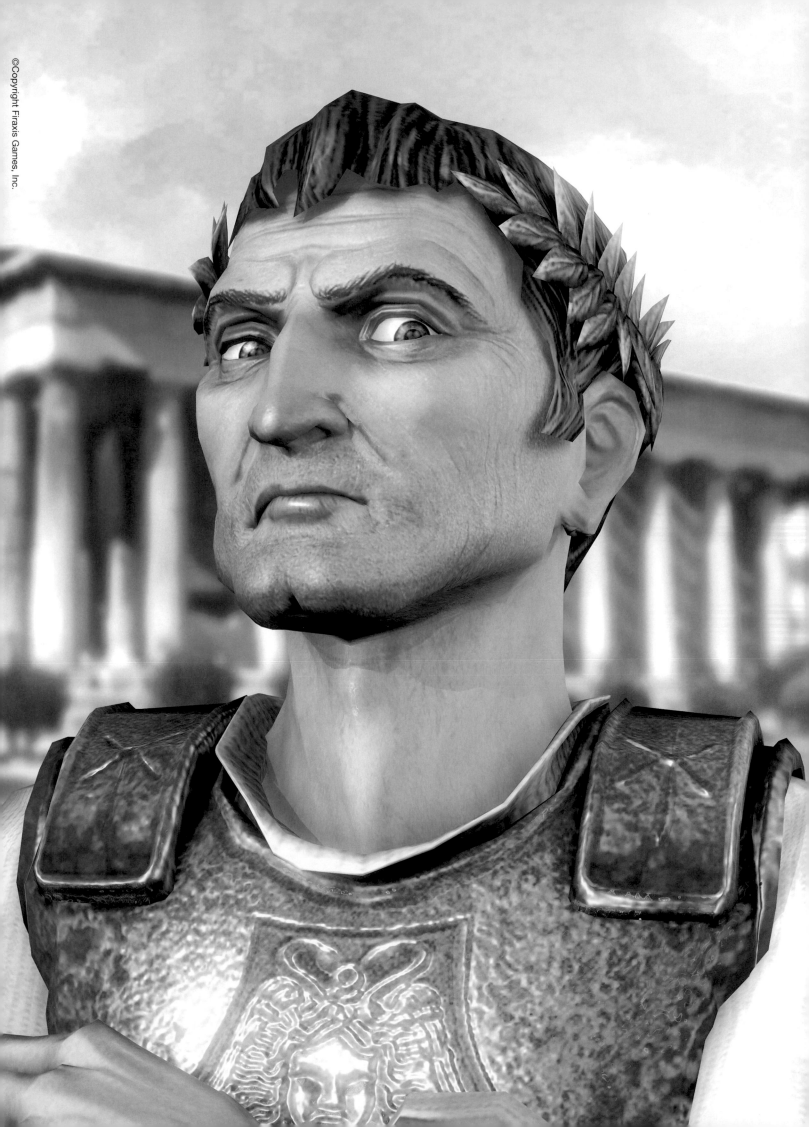

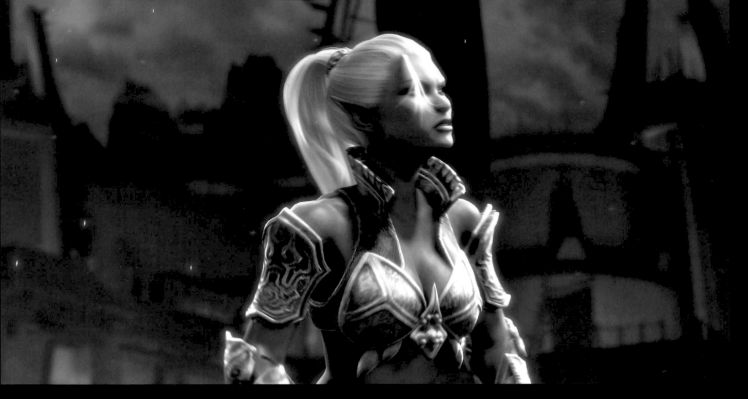

Everquest2 Trailer

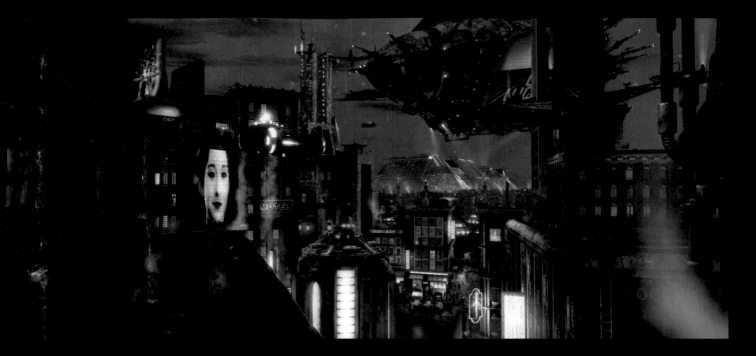

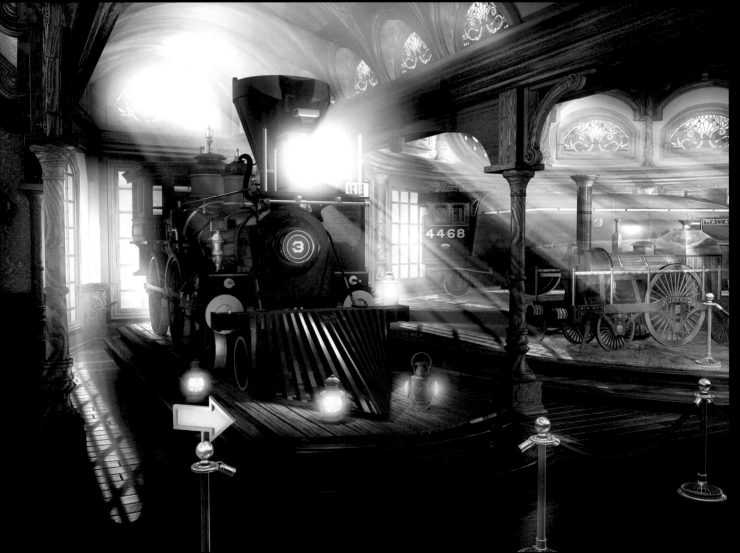

Science Fiction Vista
3ds Max, Combustion, Shake, Photoshop
Client: Paul Allen's Science Fiction Musuem and
Hall of Fame in Seattle, WA.
Mark Valentine, Peter Jivkov,
Chris Crowell and Britt Anderson,
Effect Design,
USA
[top]

Railroad Museum
3ds Max
Client: Railroad Tycoon 3
Steve Mohesky, PopTop Software Inc.,
USA
[above]

Natalia magazine cover, MechAssault 2
3ds Max, Photoshop
Josh Nizzi, Tim Twica, Day 1 Studios,
USA
[right]

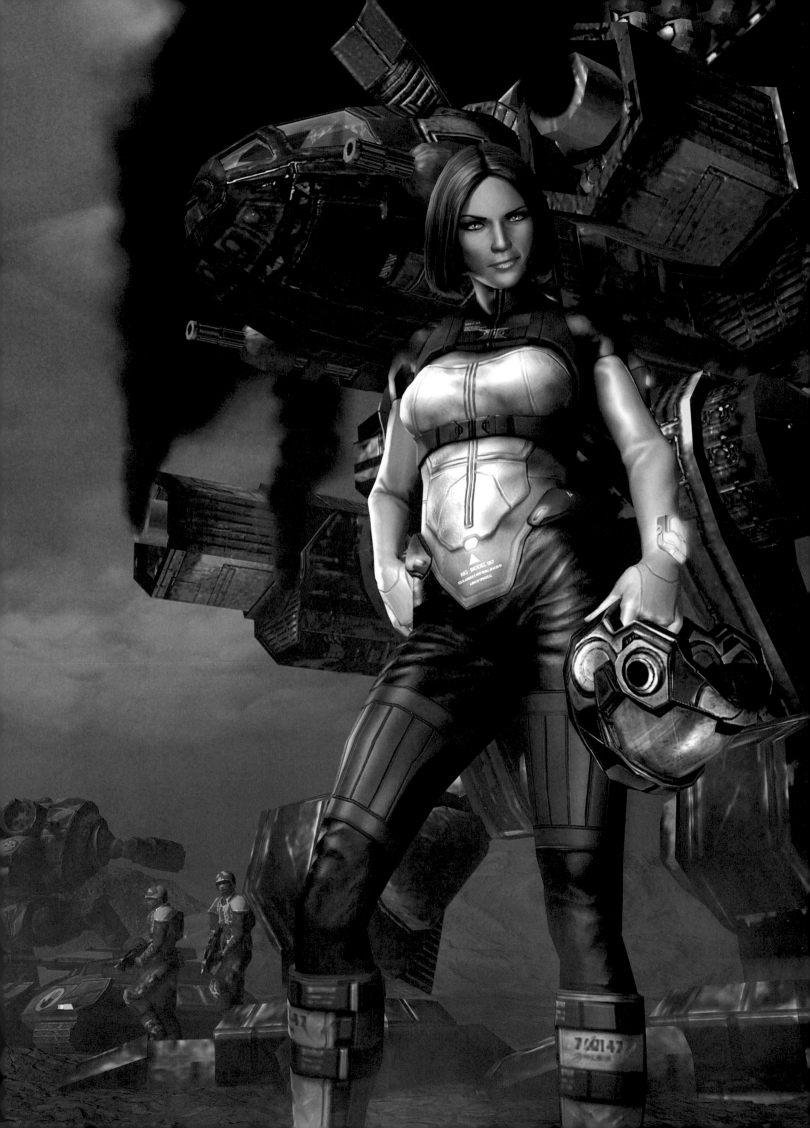

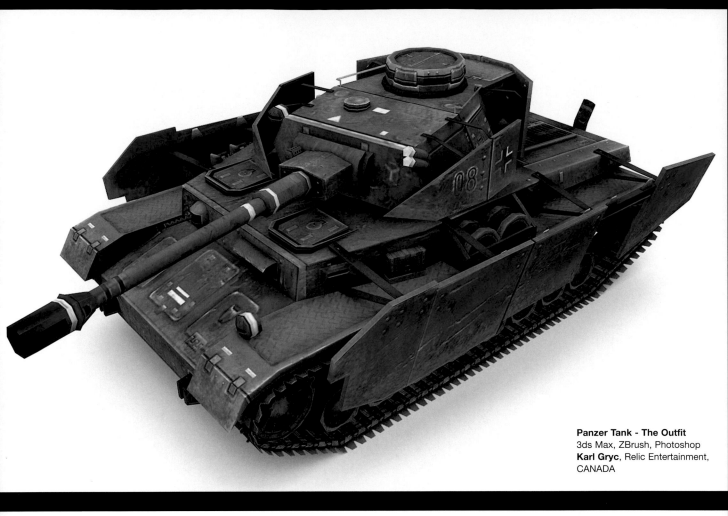

Panzer Tank - The Outfit
3ds Max, ZBrush, Photoshop
Karl Gryc, Relic Entertainment,
CANADA

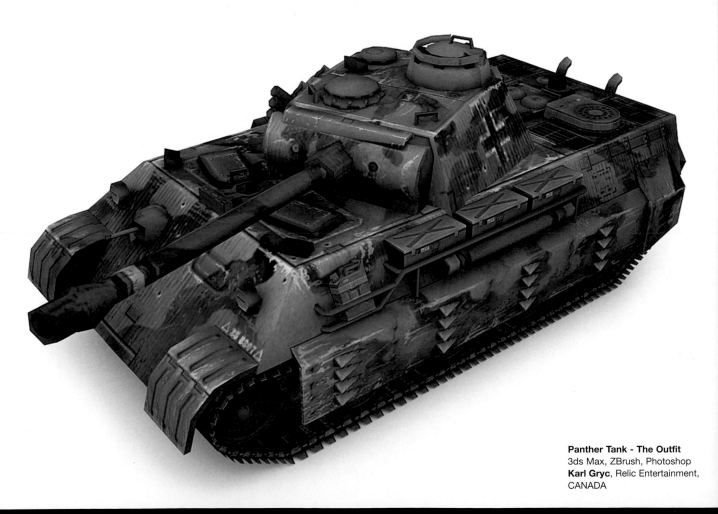

Panther Tank - The Outfit
3ds Max, ZBrush, Photoshop
Karl Gryc, Relic Entertainment,
CANADA

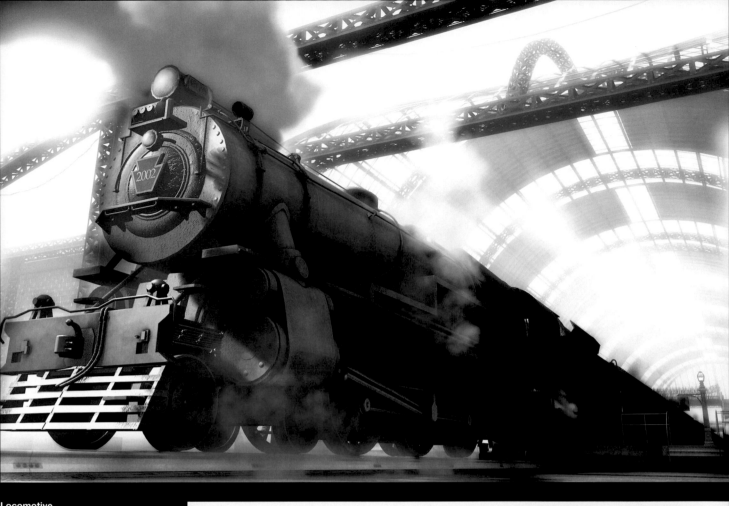

Locomotive
3ds Max, Photoshop
Client: Railroad Tycoon 3
Todd Bergantz,
PopTop Software, Inc.,
USA
[above]

RedDevil
3ds Max
Client: Railroad Tycoon 3
Steve Mohesky,
PopTop Software Inc.,
USA
[right series]

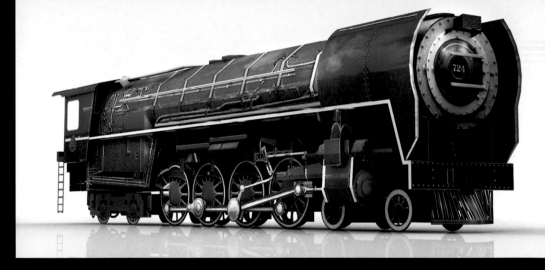

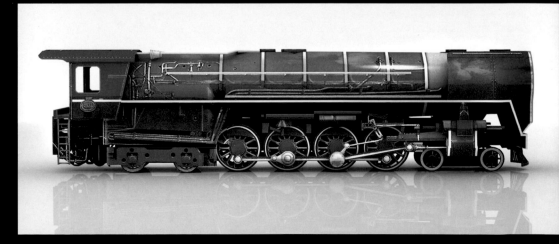

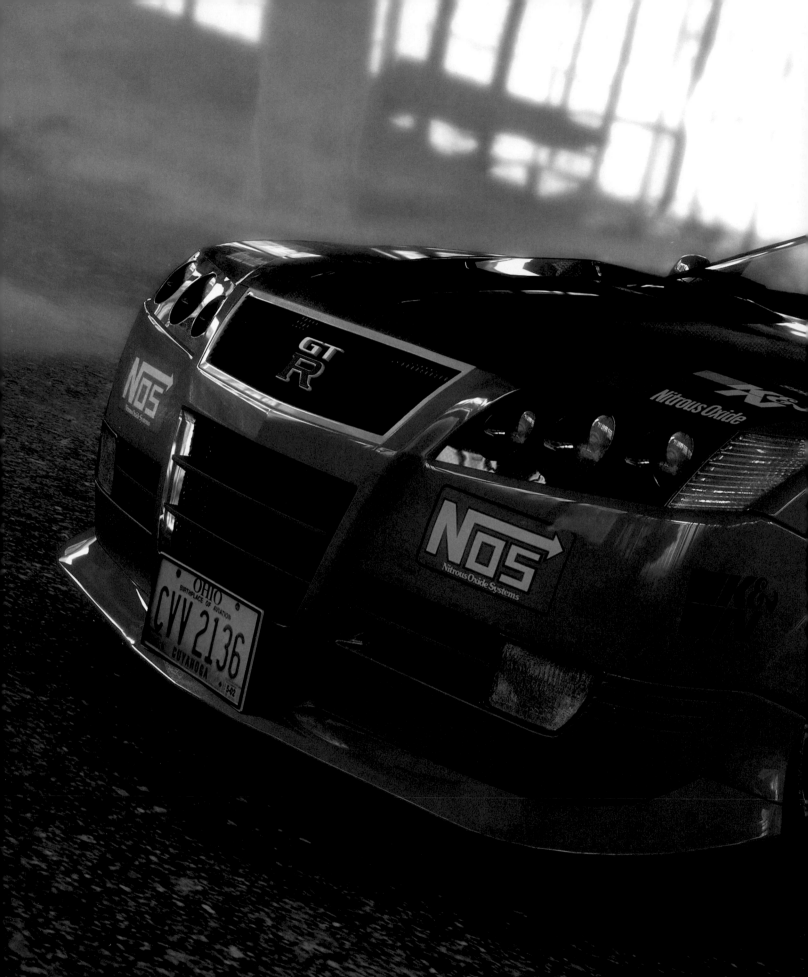

Master
Transport

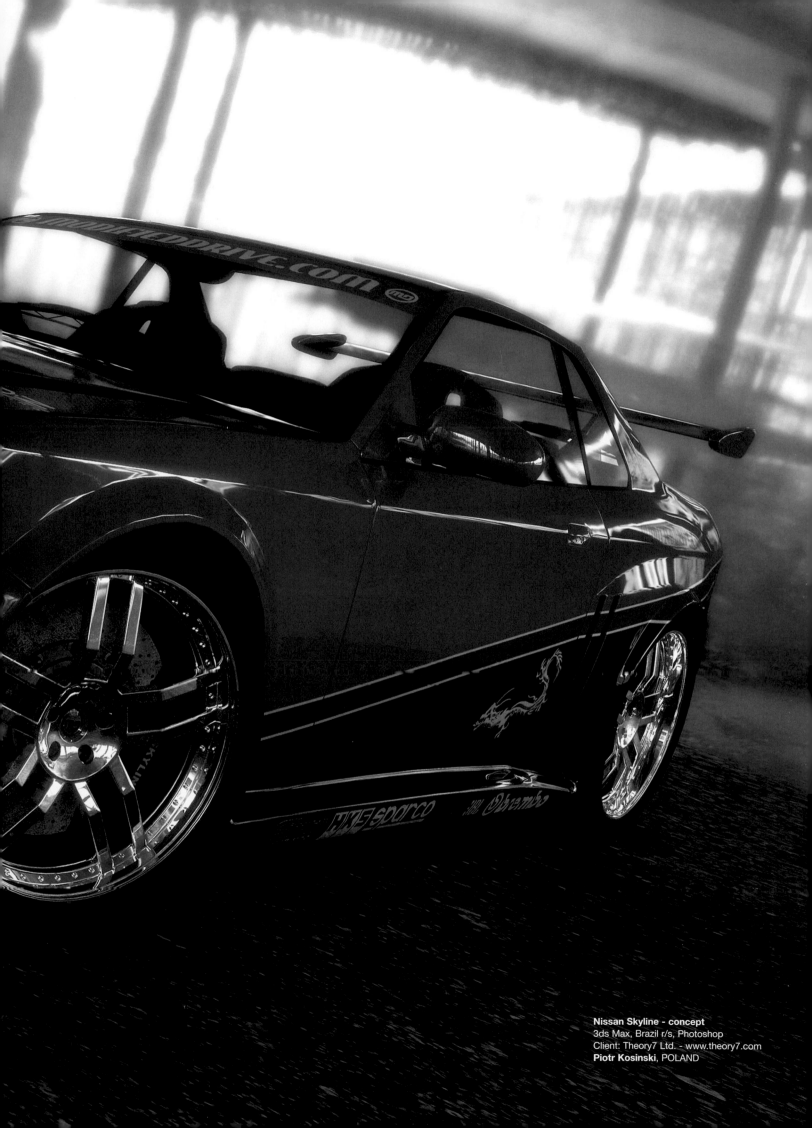

Nissan Skyline - concept
3ds Max, Brazil r/s, Photoshop
Client: Theory7 Ltd. - www.theory7.com
Piotr Kosinski, POLAND

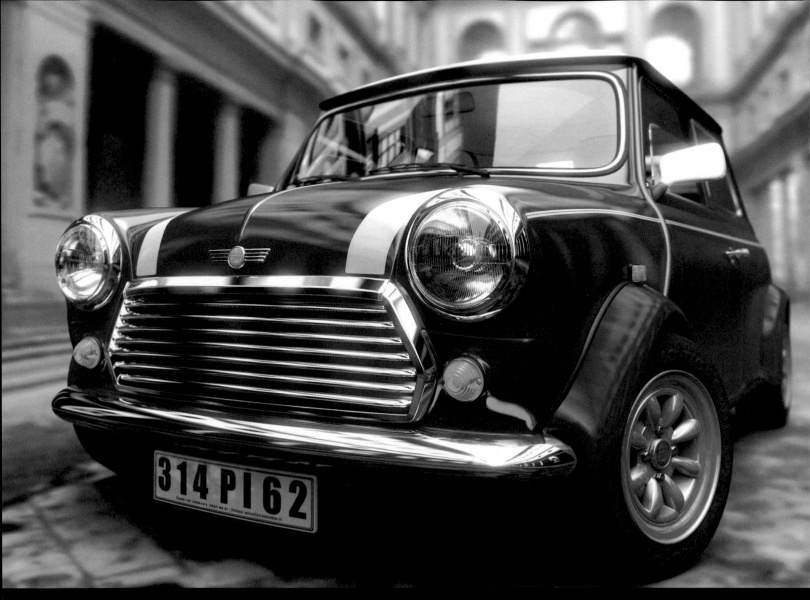

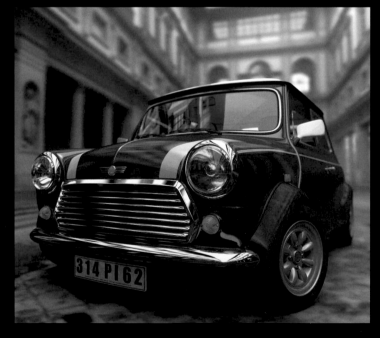

Excellence

Transport

Romance
3ds Max, Brazil r/s, Photoshop
Thibaut Milville,
FRANCE

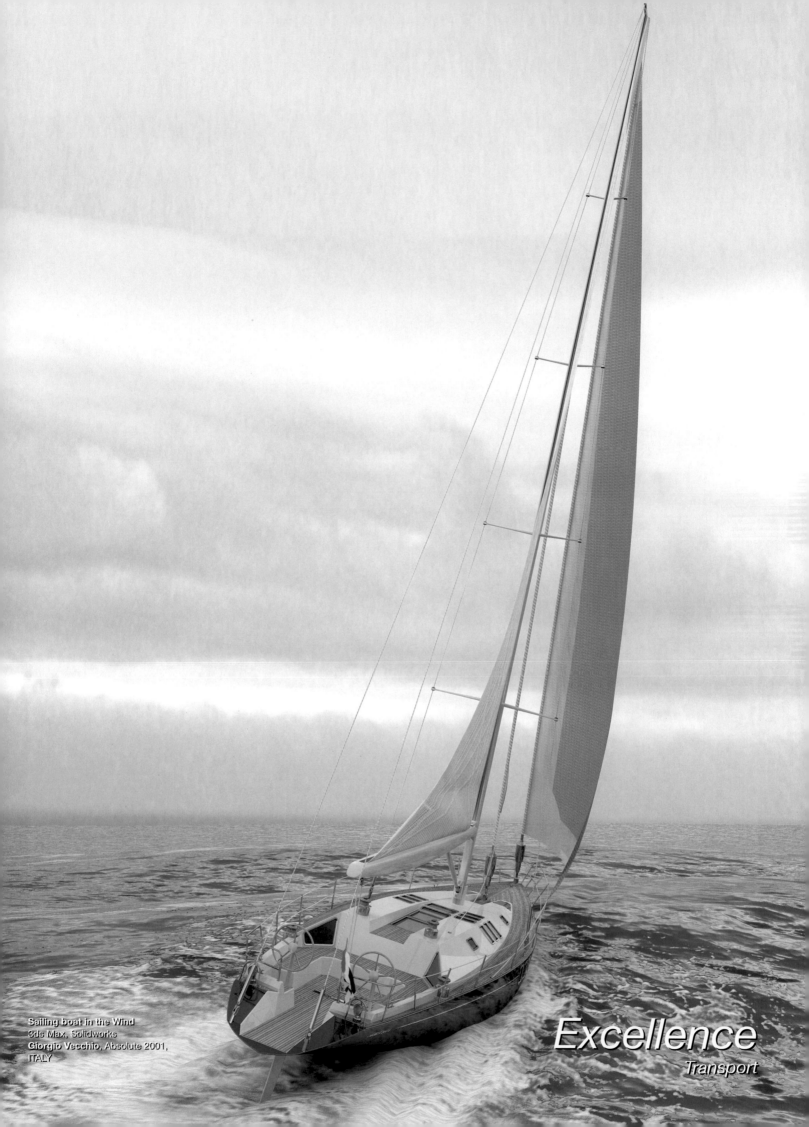

Sailing boat in the Wind
3ds Max, Solidworks
Giorgio Vecchio, Absolute 2001,
ITALY

Excellence
Transport

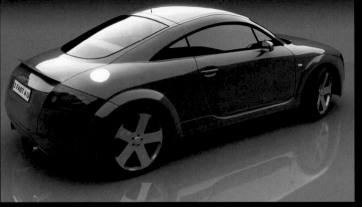
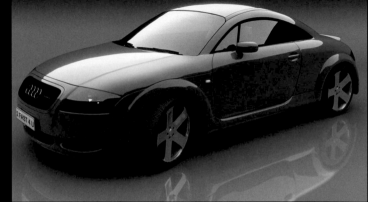

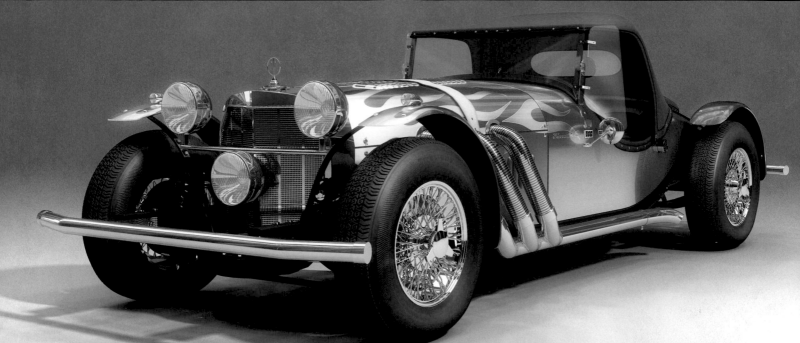

2005 Ford Mustang GT
3ds Max, Maya, HDRShop, VRay
Mark DeRidder,
Cenveo Armstrong-White,
USA

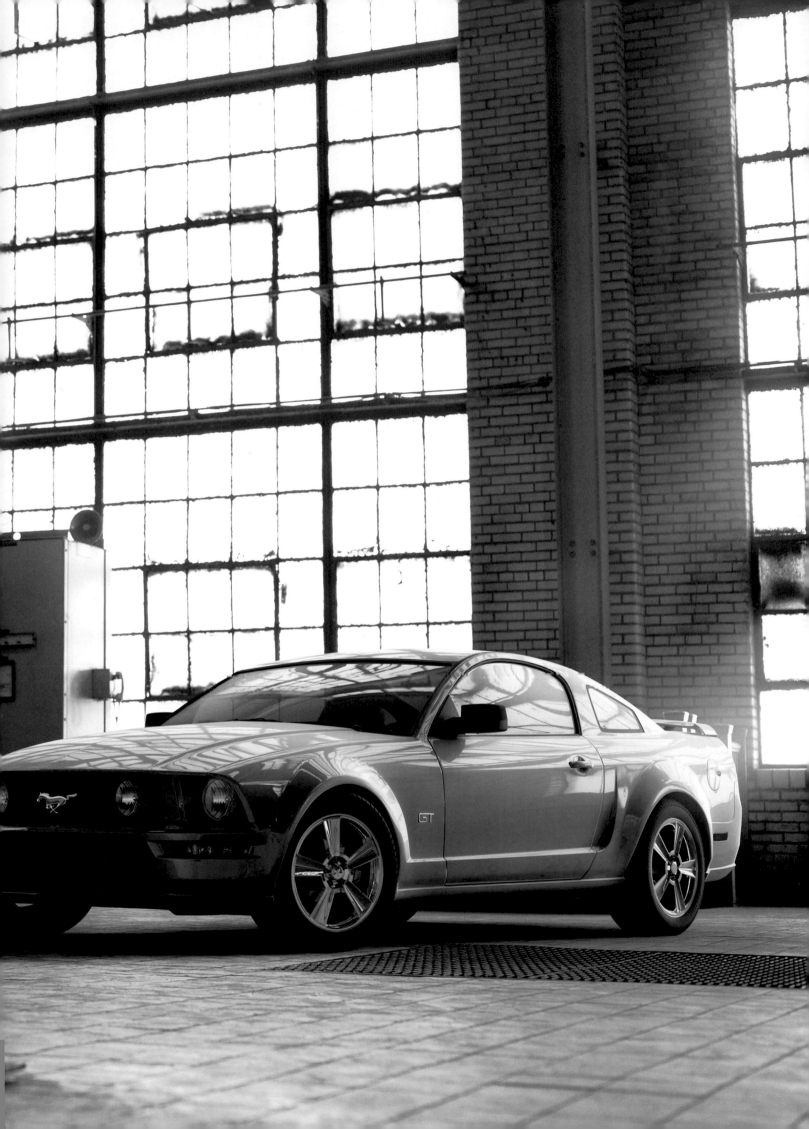

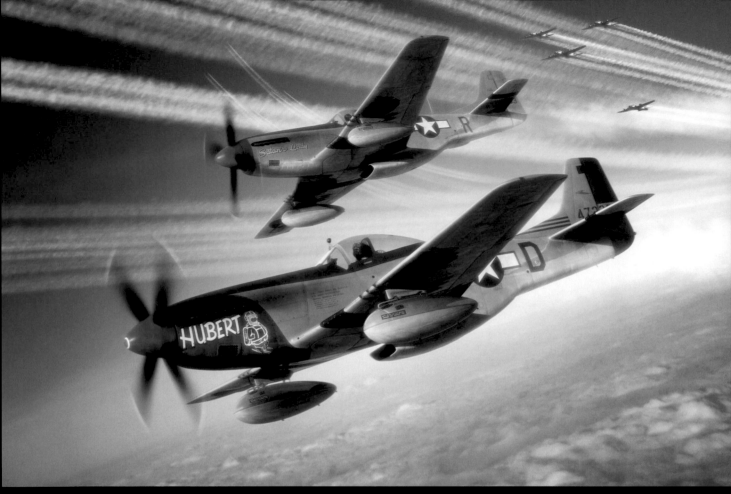

Little Friends
3ds Max, Photoshop
Ronnie Olsthoorn,
GREAT BRITAIN
[top]

Silver Beauty
3ds Max, Photoshop
Ronnie Olsthoorn,
GREAT BRITAIN
[above]

Unborn jet fighter
3ds Max, Photoshop
Ronnie Olsthoorn,
GREAT BRITAIN
[above]

Daddy's Girl
3ds Max, Photoshop
Ronnie Olsthoorn,
GREAT BRITAIN
[right]

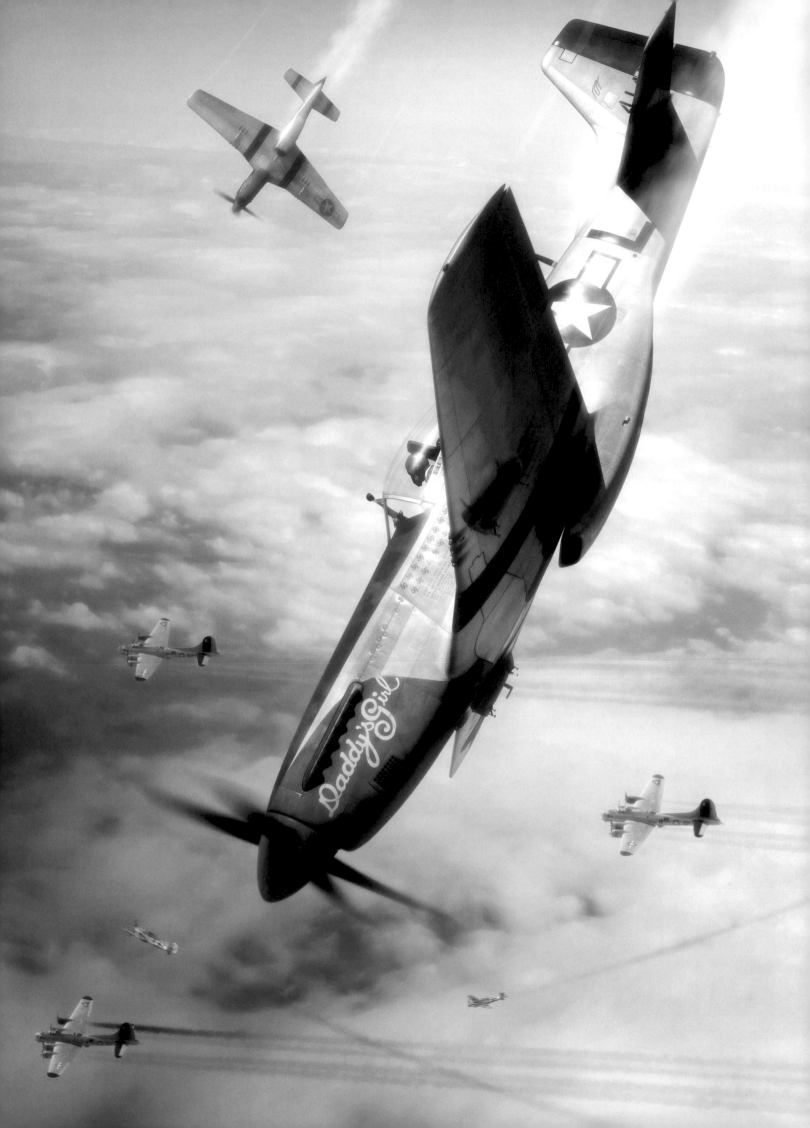

BMW 3 Series
3ds Max, Photoshop, Brazil r/s

Peugeot 307
3ds Max

Car
3ds Max

Mercedes M-class
3ds Max, Photoshop, Brazil r/s, StudioTools

Waiting for Spring
3ds Max, finalRender
Marek Denko,
SLOVAK REPUBLIC

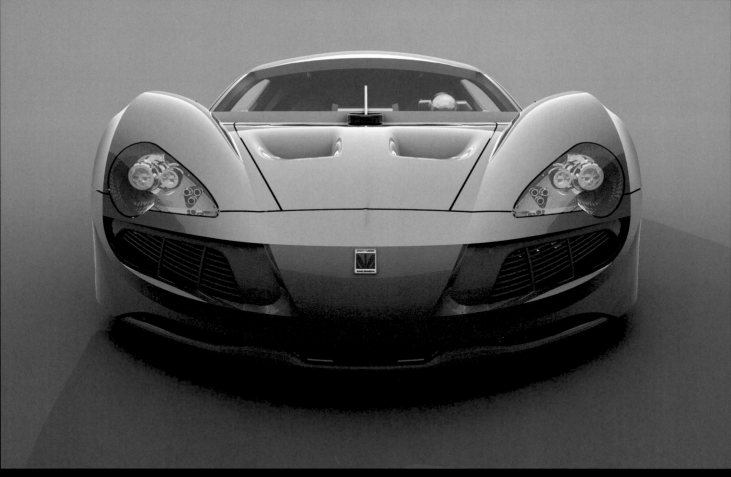

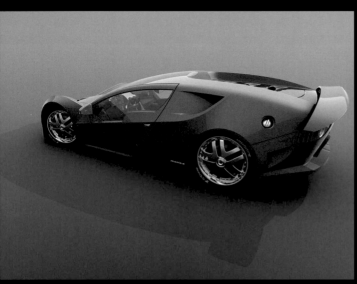

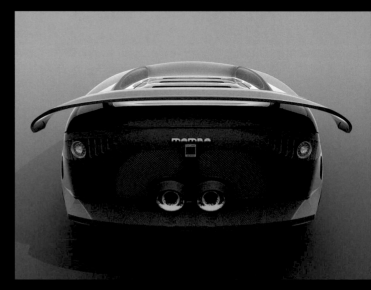

Mamba Concept Car
3ds Max, Brazil r/s, Rhino
Wyatt Turner, Wyatt Turner Design,
USA

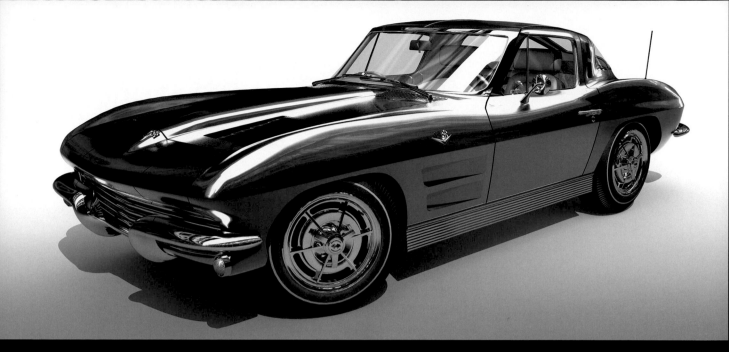

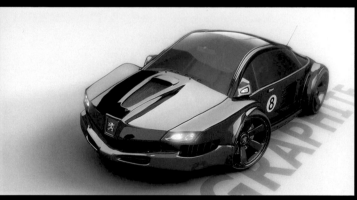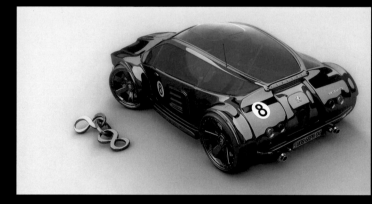

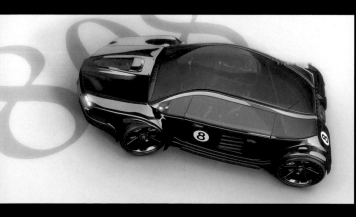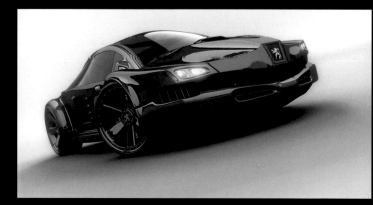

1963 Corvette Stingray
3ds Max
Mark Van Haitsma,

Graphite
3ds Max, mental ray, Photoshop
Daniel Trbovic,

OHVXtreme Project CJ7
3ds Max, mental ray, Deep Paint

The Humvee
3ds Max, Photoshop

Refueling
3ds Max, Photoshop
Ted Terranova,
USA
[above]

Truck
3ds Max, PhotoPaint
Client: Volkswagen - Brazil / IT
Luciano Neves, INFINITE CG,
BRAZIL
[right]

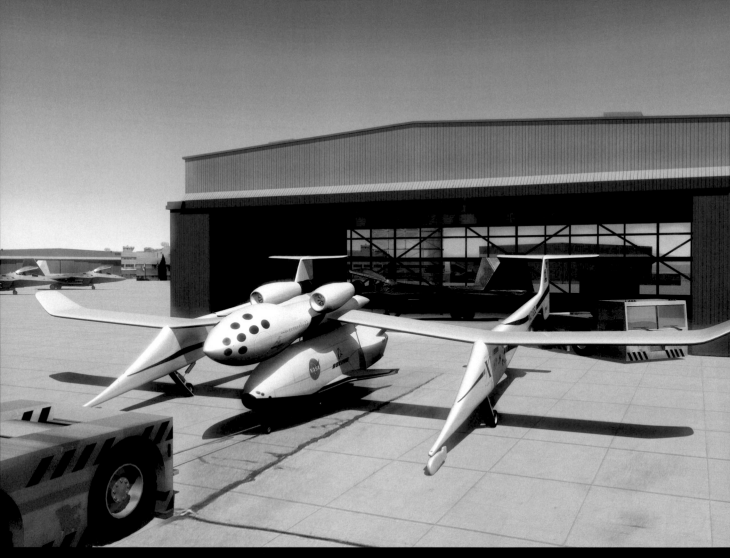

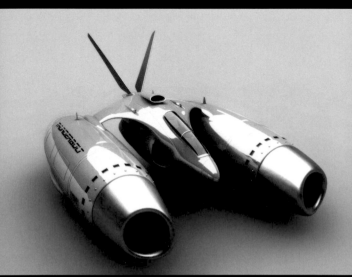

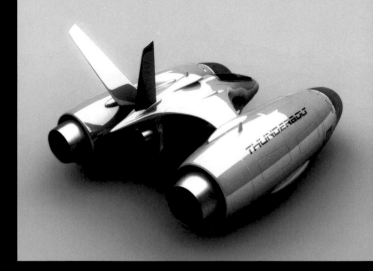

White Knight and X-37
3ds Max
Kareem Marquez,
USA
[top]

Thunderbolt
3ds Max, Brazil r/s, Photoshop
Nick Deligaris,
GREECE
[above series]

Front Runner
3ds Max, Photoshop
Damien Thaller,
AUSTRALIA
[right]

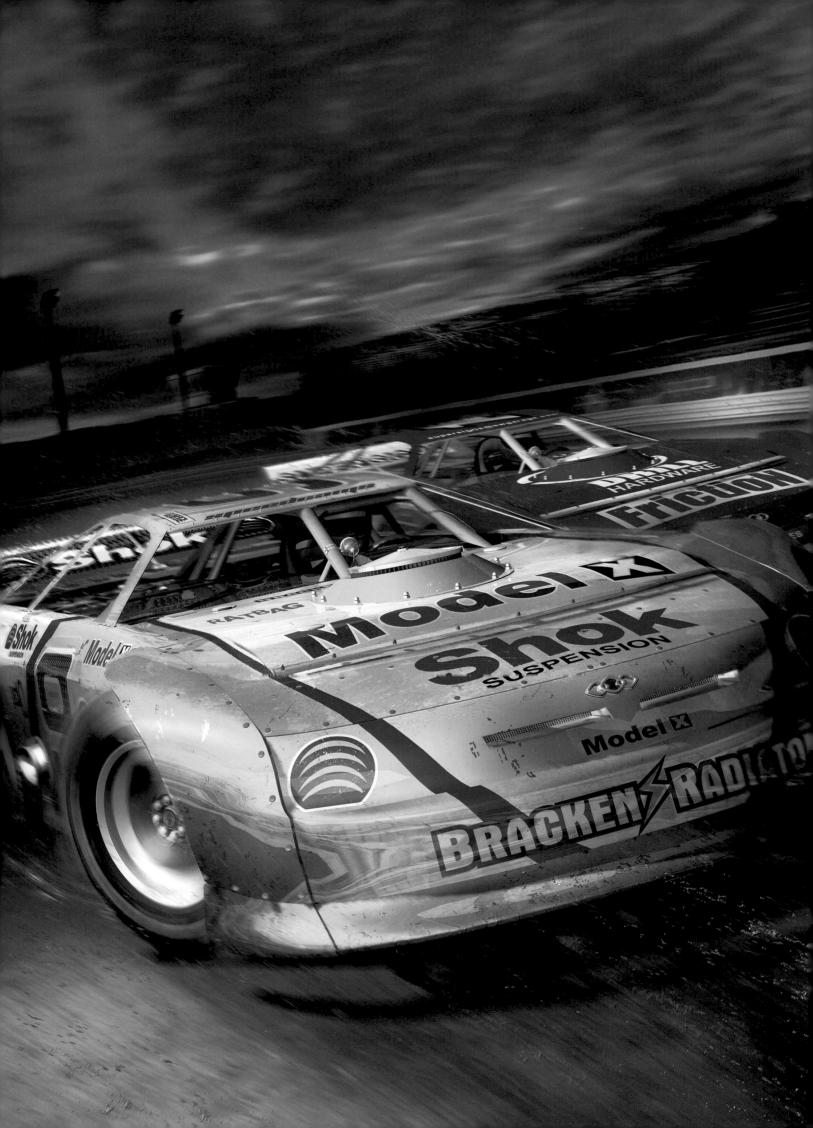

Master
Product Design

Architecture of Color and Coded Identity
3ds Max, VRay, Photoshop
Le Richard Minh,
AUSTRALIA

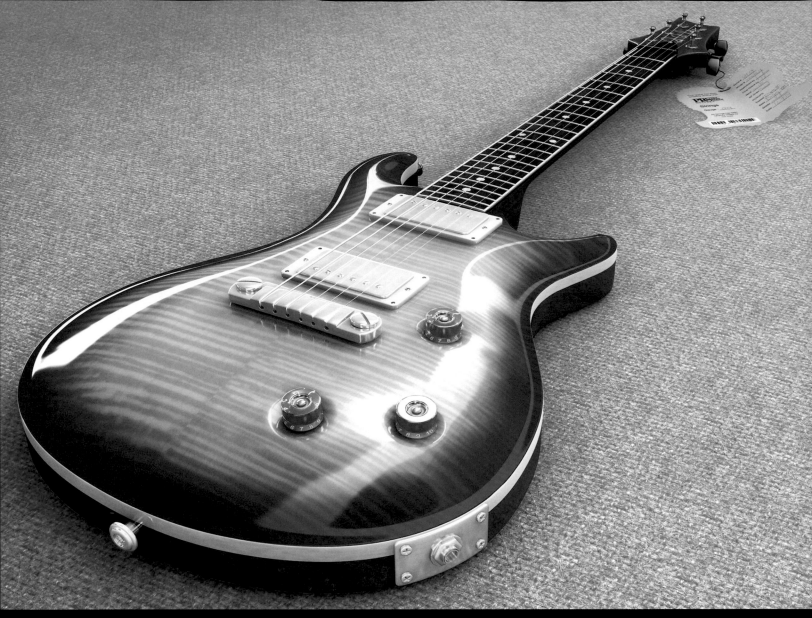

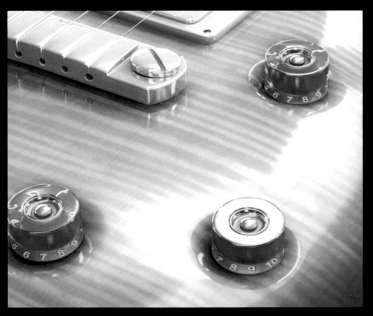

Excellence
Product Design

PRS-GN Guitar
3ds Max, VRay, Photoshop
Daniel Alejo.
SPAIN

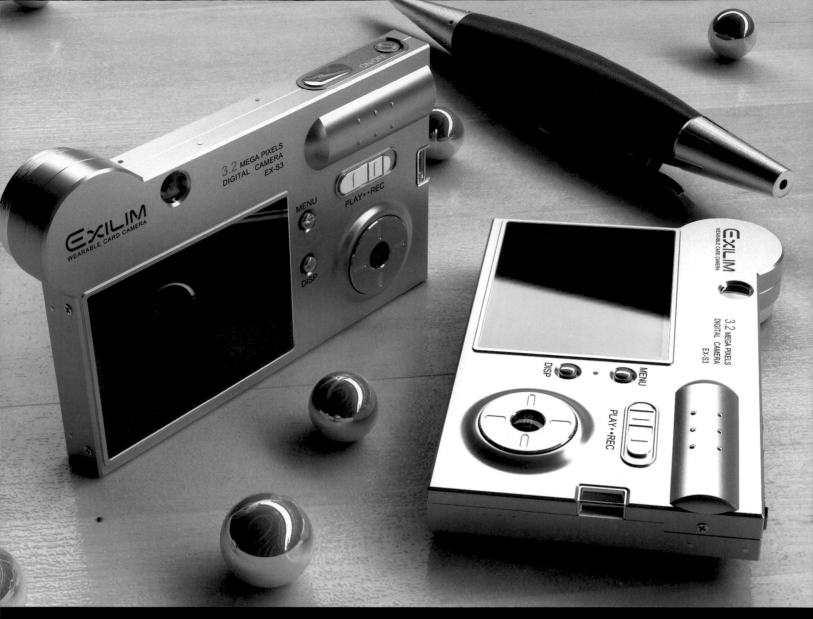

Exilim Rear
3ds Max
Roberto Cardile,
ITALY

Excellence
Product Design

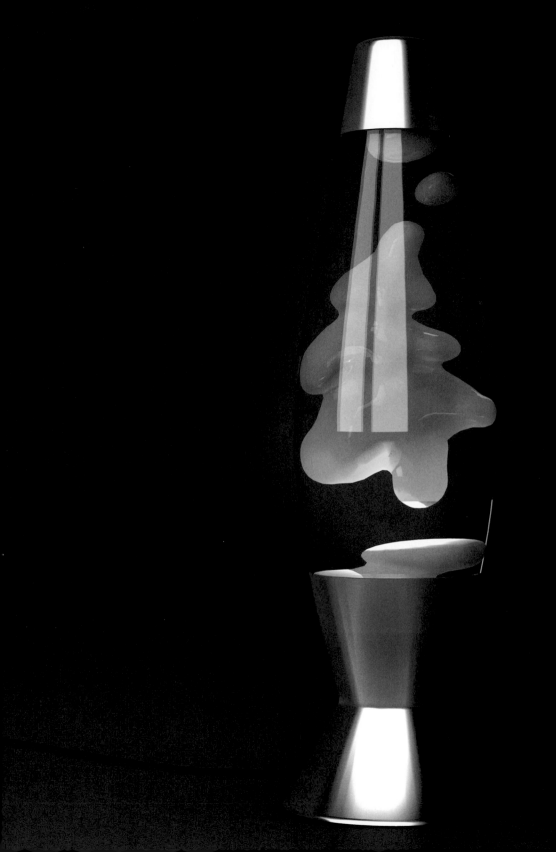

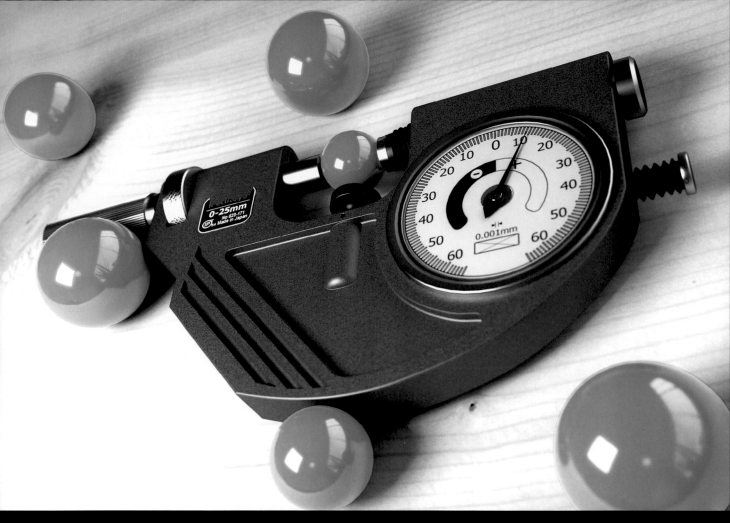

A Sliding Gauge
3ds Max, VRay
Fraisse Etienne,
FRANCE

Excellence
Product Design

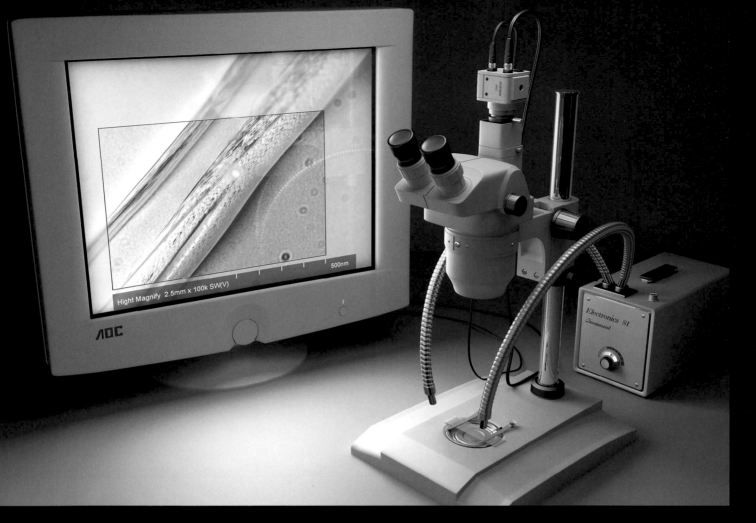

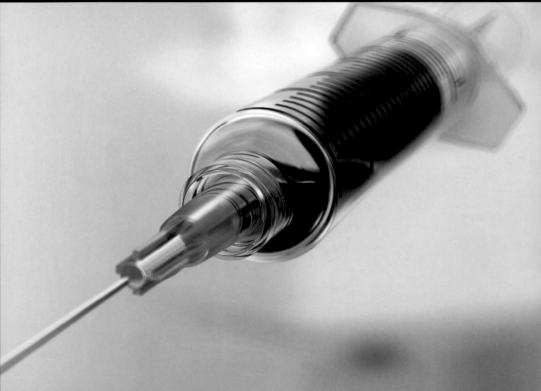

Electronic microscope
3ds Max, VRay, Photoshop
Adrian Cristea,
ROMANIA
[above]

Syringe
3ds Max, Brazil r/s, Photoshop
Brandon Pletsch,
Radius Medical Animation,
USA
[left]

Siemens VS06
3ds Max, mental ray, Photoshop
Andre Kutscherauer
and Frank Messlinger,
Studio Messlinger Gmbh,
GERMANY
[right]

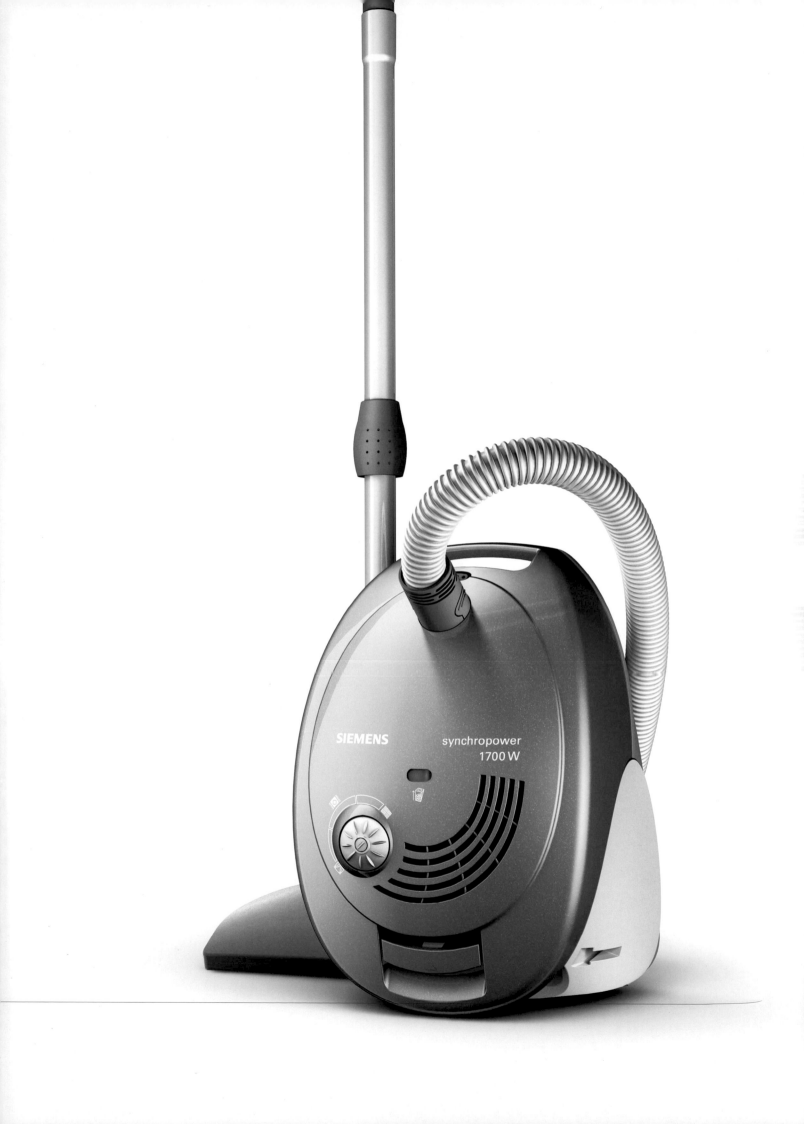

At my feet
3ds Max, Photoshop, BodyPaint
Juan Siquier, SPAIN
[top]

The Digitech RP6
3ds Max, Photoshop, BodyPaint
Juan Siquier, SPAIN
[above series]

The Boss CS2
3ds Max, Photoshop, BodyPaint
Juan Siquier, SPAIN
[above series]

Nike Soccer Collection
3ds Max, Photoshop, Brazil r/s
Asif Siddiqui, Code Freaks,
PAKISTAN

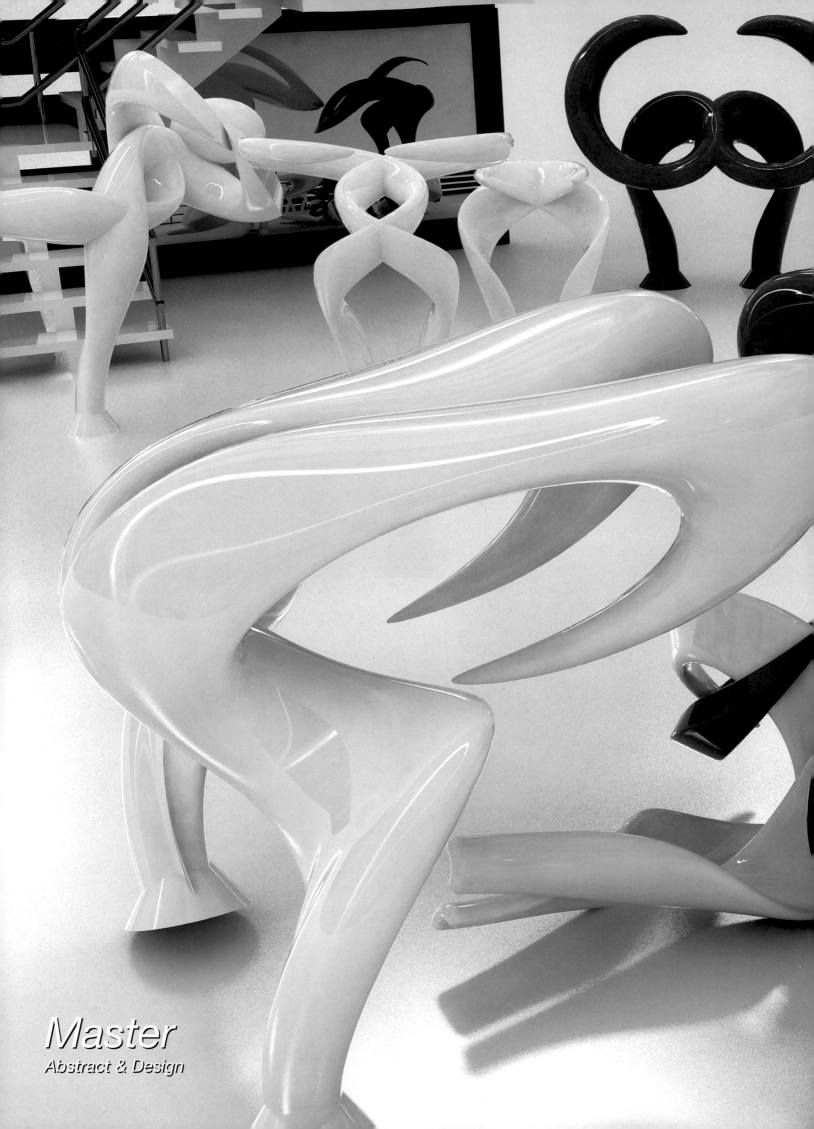

Master
Abstract & Design

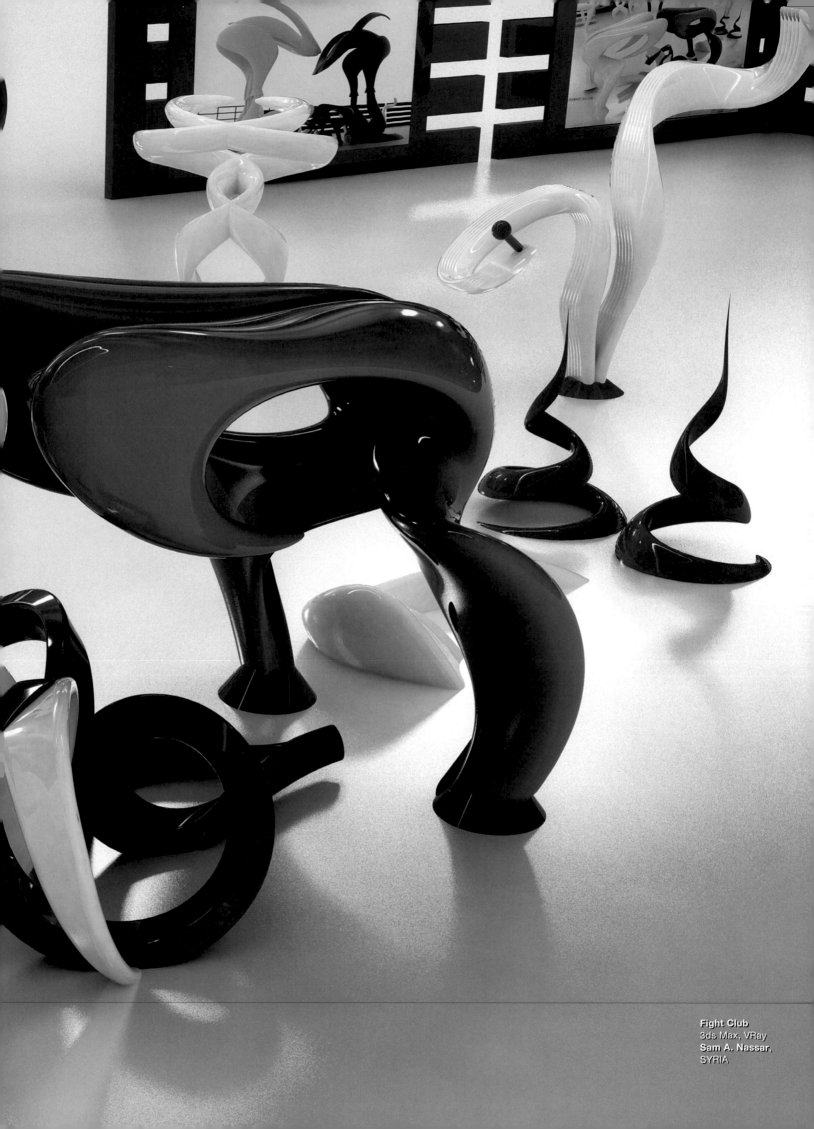

Fight Club
3ds Max, VRay
Sam A. Nassar,
SYRIA

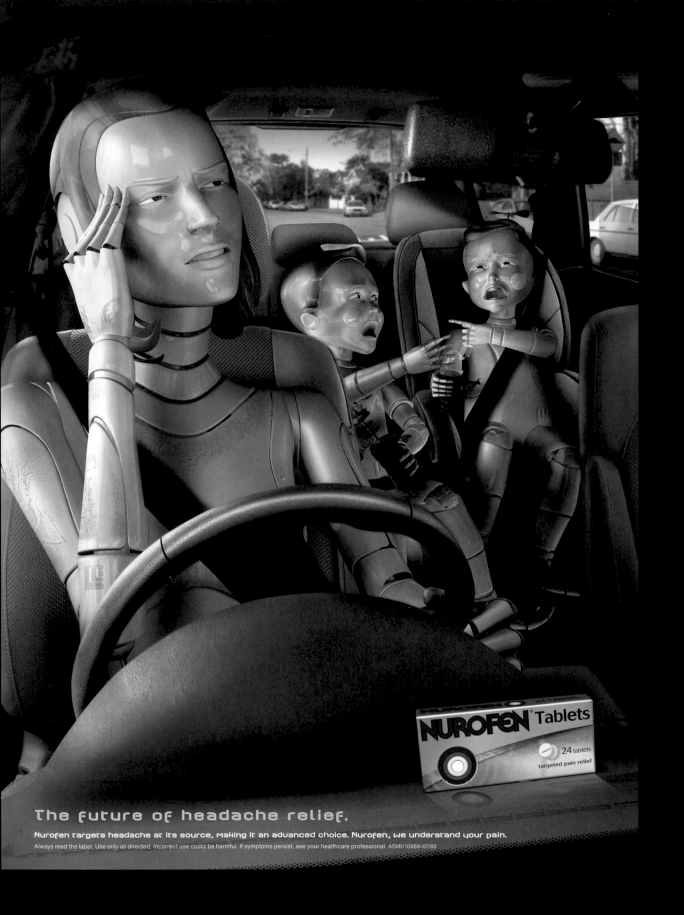

The future of headache relief.

Nurofen targets headache at its source, making it an advanced choice. Nurofen, we understand your pain.

Always read the label. Use only as directed. Incorrect use could be harmful. If symptoms persist, see your healthcare professional. ASMI/10989-07/05

NUROFEN® Tablets
24 tablets
targeted pain relief

Excellence
Abstract & Design

Nurofen Car Robot
3ds Max, Photoshop
Lee Lam, Nick Hunter and
Eric Wadsworth, Emerald City
AUSTRALIA

Autumn
Photoshop, 3ds Max
Client: 365-Calendar, UK
Christos Magganas, GREECE

Excellence
Abstract & Design

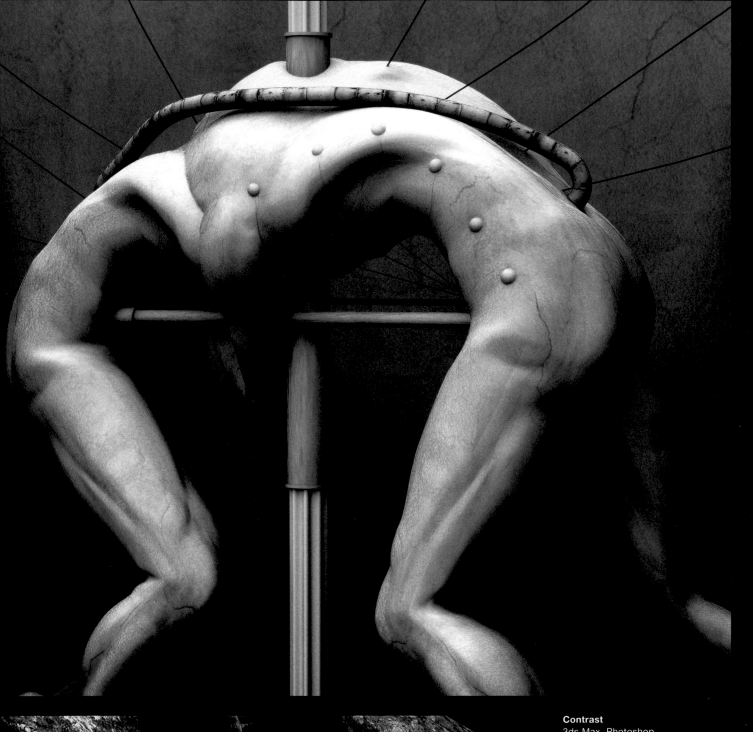

Contrast
3ds Max, Photoshop
Edoardo Belinci, 3DJuice,
ITALY
[above]

Probe
3ds Max
Alexander Preuss,
GERMANY
[left]

Broken Mind
3ds Max, mental ray, Photoshop, ZBrush
Andre Kutscherauer,
GERMANY

Excellence
Abstract & Design

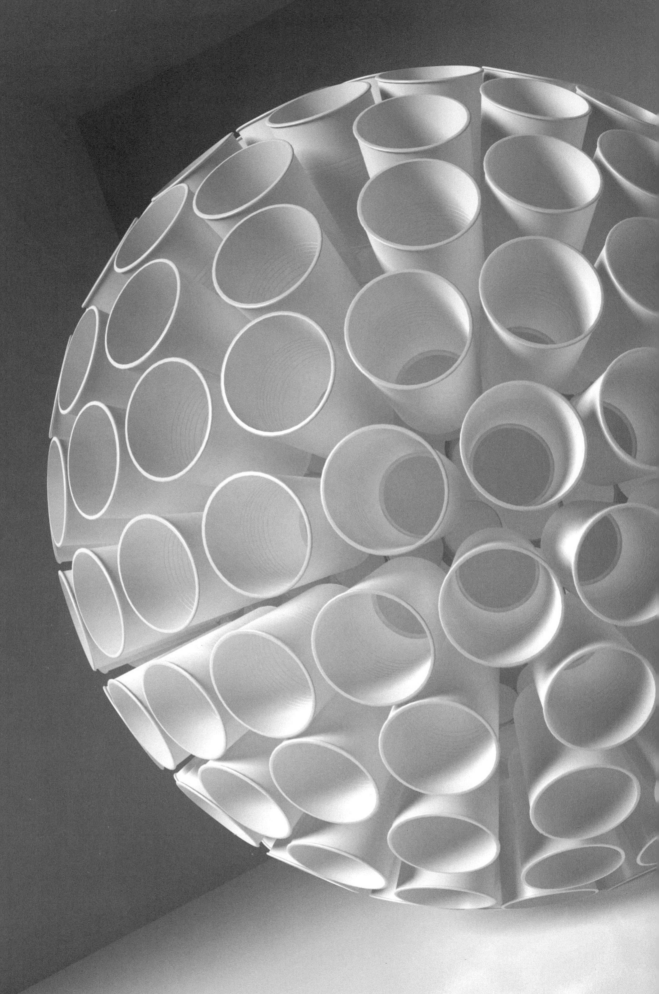

Ball of Cups
3ds Max, mental ray, Photoshop
Andre Kutscherauer,
GERMANY

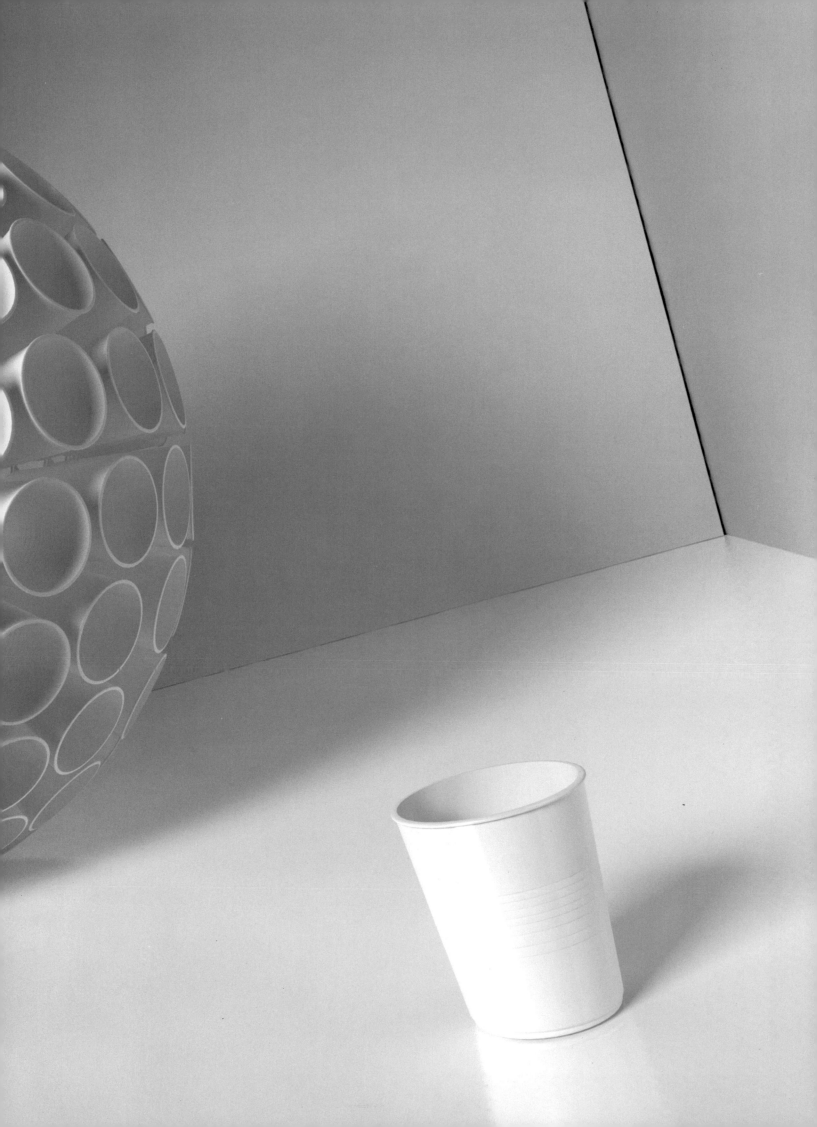

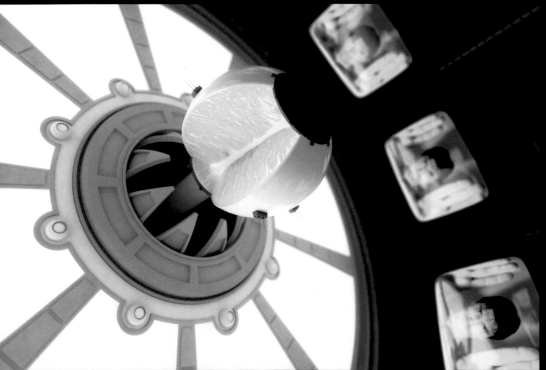

Typosphere
3ds Max, VRay
Franck Farget,
FRANCE
[above]

Digital Orange
3ds Max, Photoshop
Krystian Polak, Arterra Design,
AUSTRALIA
[left]

Orchid Series 03 - Frame 59
3ds Max
John Vega,
USA
[right]

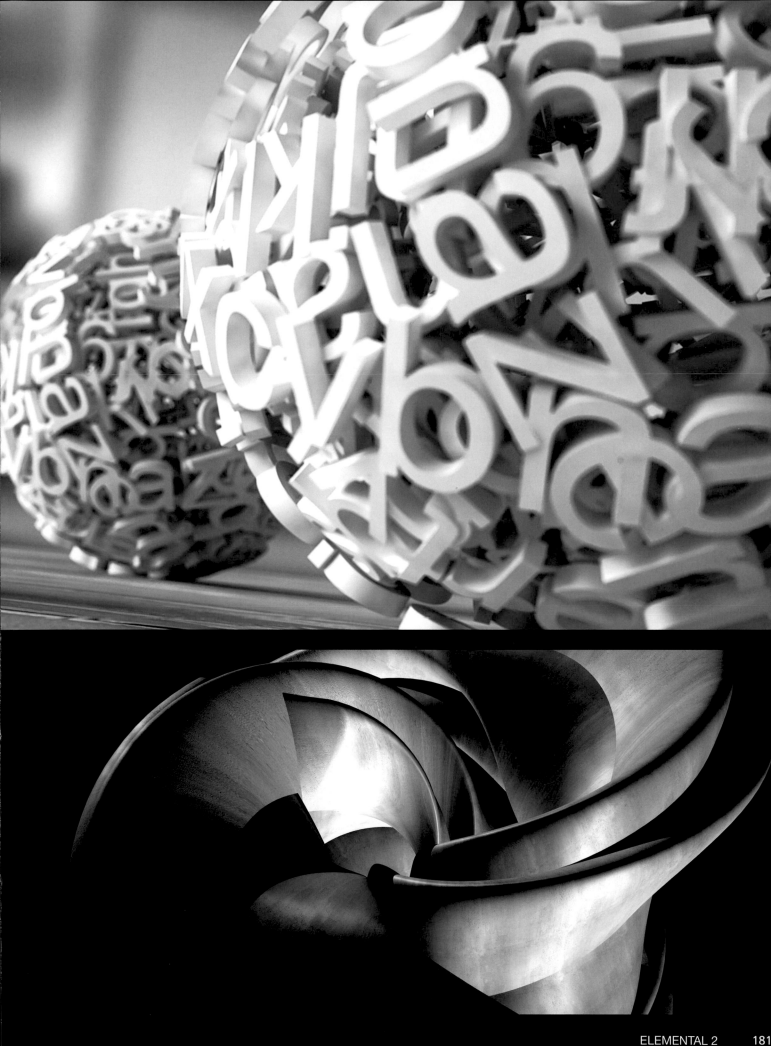

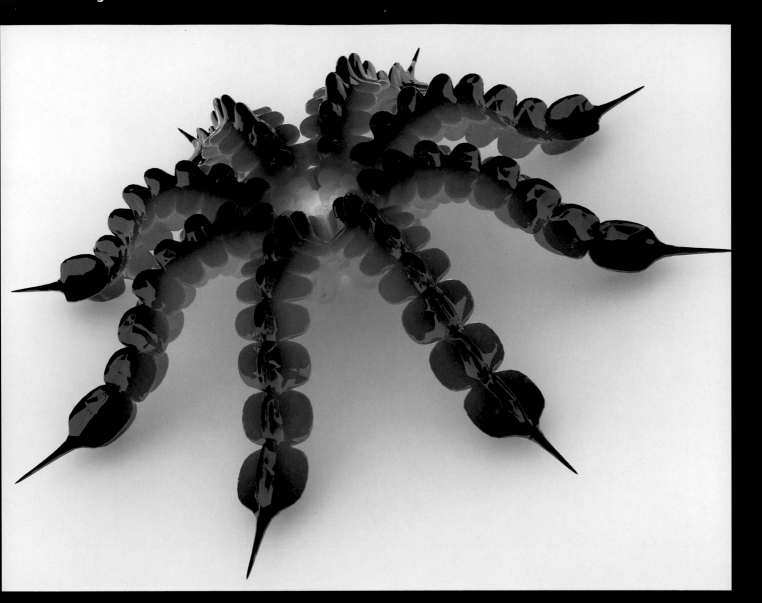

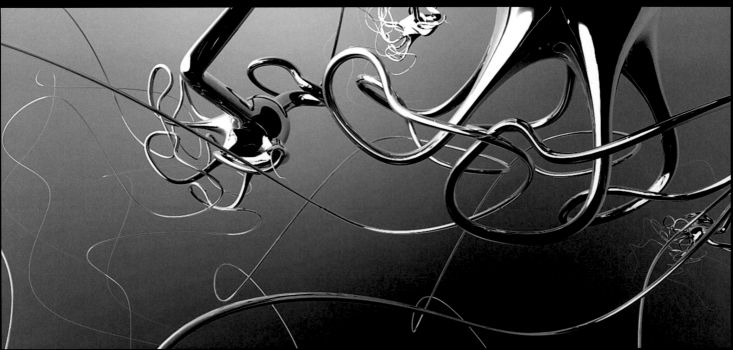

Spidy
3ds Max, finalRender
Joe Gunn, Autodesk Media &
Entertainment,
USA
[*top*]

Metal Squids
3ds Max, HDR Shop
Kevin Gironda,
USA
[*above*]

Flux
Photoshop, 3ds Max
Vincent Lai, HONG KONG
[*right*]

COLLAPSE RATE 24.81T/S

COLLAPSE RATE 21.97T/S

COLLAPSE RATE 90.53T/S

COLLAPSE RATE 23.7T/S

COLLAPSE RATE 11.48T/S

DISINTEGRATION SEQUENCE

Product rendering: LED lights
3ds Max, finalRender
Edwin Wong,
AUSTRALIA

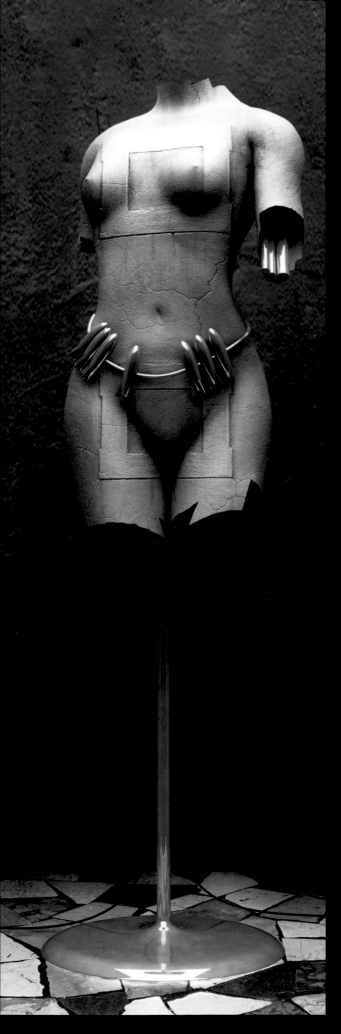

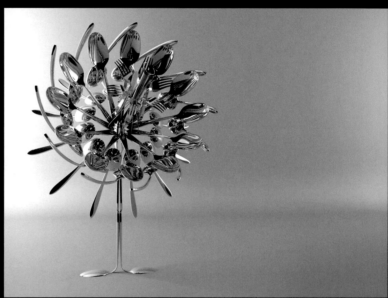

Old Power Pump
3ds Max, Photoshop
Edoardo Belinci, 3DJuice,
ITALY
[top]

Venere Kamikaze
3ds Max, Photoshop
Edoardo Belinci,
ITALY
[left]

Spoonflower
3ds Max, mental ray, Photoshop
Andre Kutscherauer,
GERMANY
[above]

Nurofen Party Robot
3ds Max, Photoshop
**Lee Lam, Nick Hunter
and Eric Wadsworth**,
Emerald City,
AUSTRALIA
[right]

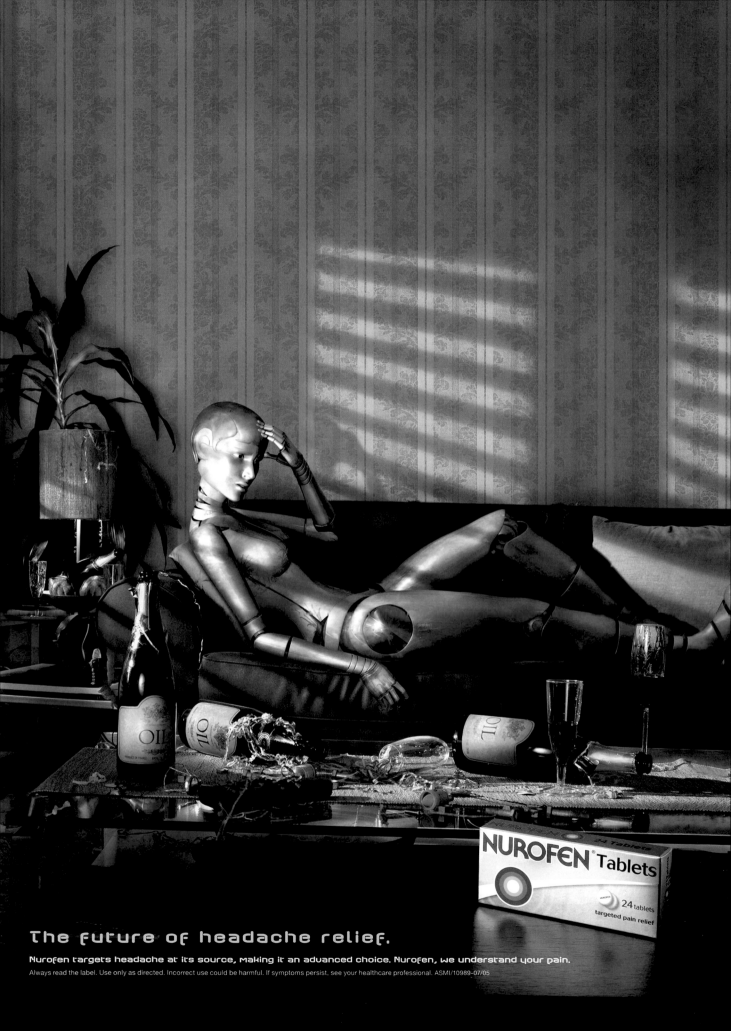

The future of headache relief.

Nurofen targets headache at its source, making it an advanced choice. Nurofen, we understand your pain.

Always read the label. Use only as directed. Incorrect use could be harmful. If symptoms persist, see your healthcare professional. ASMI/10989-07/05

Index